£3.75

D0119929

Bronzino as Draughtsman
An Introduction

INSTITUTE OF FINE ARTS, NEW YORK UNIVERSITY

BRONZINO
AS DRAUGHTSMAN
AN INTRODUCTION

With Notes on his Portraiture and Tapestries

BY CRAIG HUGH SMYTH

J. J. AUGUSTIN PUBLISHER, LOCUST VALLEY, NEW YORK

THE PUBLICATION HAS BEEN ASSISTED BY
THE INSTITUTE OF FINE ARTS REVOLVING PUBLICATION FUND
GIVEN BY THE BILLY ROSE FOUNDATION

TO

ALEXANDRA SMYTH
EDWARD LINFORTH SMYTH

Table of Contents

Preface

THIS ESSAY IS called an introduction because it attempts to lay certain foundations for studying Bronzino's drawings. It deals with drawings undeniably connected with paintings and tapestries unanimously accepted, and acceptable, as Bronzino's independent work—drawings consistent at the same time, in my judgment, with Bronzino's style in his paintings and tapestries and with each other. The restriction to very well documented examples excludes drawings I should have much wanted to include. Elsewhere I intend to discuss some drawings whose attribution to Bronzino is supported by less undeniable external grounds or is based mostly or solely on style alone, and various such drawings are cited in the notes. If, however, the selection of drawings for consideration in this volume has been wise, it should be a useful reference in an area where it is difficult to get one's bearings.

Over a long period of interest in Bronzino I have had aid in studying him from many people. I want to name and thank here those who helped me in gathering the material in this particular essay: Giulia Sinibaldi, Anna Forlani Tempesti, and Maria Fossi Todorow of the Gabinetto Disegni e Stampe at the Uffizi for their kind assistance on many occasions there; Jaqueline Bouchot-Saupique and Roseline Bacou of the Cabinet des Dessins at the Louvre for their equally kind help; Philip Pouncey, with whom I have talked about Bronzino's drawings on various occasions and who has been generous with information acknowledged specifically in the notes; James Byam Shaw for information concerning drawings at Christ Church, Oxford and his kindness and help on my visit there; Kenneth Garlick of the Ashmolean Museum, Oxford for helpful letters in reply to questions; John A. Gere for information he thoughtfully volunteered; Edward Sanchez for confirming my reading of the document in Appendix II and for sharing information from documents he has discovered and I hope will publish (he has found items con-

cerning the start of the tapestry manufactory at Florence, which I have not used but have found reassuring to know); Gino Corti for transcribing a document at my request; Günter H. Kopcke and Hans Jucker for responding to questions on the condition of the *Idolino*; Marjorie Licht for supplying a measurement and other points of information from Florence; and Nanette Salomon and Deborah Wilde for help with some references. I owe a great deal to Count and Countess Castelbarco Albani, whose kind permission to study the decorations at the Villa Imperiale has enabled me to learn much about Bronzino.

For the opportunity to complete this essay I am indebted to an invitation from The Institute for Advanced Study in Princeton. The support for my stay there came from a grant to that Institute from the Samuel H. Kress Foundation. I am exceedingly grateful to both. I want also to thank particularly Professor Millard Meiss for his part in the invitation and his encouragement. I appreciate very much the use of the library of the Department of Art and Archaeology at Princeton University during my stay. To Elizabeth I. Horton and Margaret Van Sant of the Institute I owe special thanks for their kind help in typing the manuscript for publication. Similar thanks are due Stephany Haines and Linda Pleven for their help afterwards in typing additions and revisions and Miriam Koren for editorial corrections.

Kathleen Weil-Garris Posner and Richard Krautheimer looked at the plan for this essay, and the latter as well as Rensselaer W. Lee and James Byam Shaw made comments on the text that were very helpful. Malcolm C. Henderson confirmed several numerical conversions and advised me well on the wording of one paragraph. I am most grateful to all of them. Barbara L. Smyth has heard and read much of the text and given salutary judgments, in addition to contributing the observation referred to in Appendix I. My thanks to her are very many.

C. H. S.

New York, N.Y.
5 August 1971

THE THEMES OF the present essay are several. The first focuses attention on some drawings that can serve as a reliable basis for studying Bronzino's draughtsmanship, about which there is a good deal of disagreement. The second is inseparable from the first; it stresses his range as a draughtsman, the variety of his modes. Related to his range is the variety of his sources. This is a third theme, which has two aspects: Bronzino as heir to traditions central to Florentine draughtsmanship, and Bronzino as one who looked beyond Florence with understanding and receptivity. A fourth theme is our hesitancy to recognize Bronzino as the draughtsman he is. His name became separated in the past from most of the drawings we shall encounter. Although some began to be connected with him again early in this century, realization of what they tell about his work in drawing has been late in coming.

The origins of our difficulty lie partly in the misfortune that no group of Bronzino's drawings has come down to us under his name, partly in the misapprehension, owing to a misreading of Vasari, that Vasari had labeled Bronzino a poor draughtsman,[1] and especially in Bronzino's capacity for variety in the ways he drew. Very little ability or variety was expected of him by Bernard Berenson and Arthur McComb in their catalogues of Bronzino's drawings,[2] which did most to establish the picture of his draughtsmanship in modern times;[3] and thus they excluded several drawings related to his paintings and tapestries that, if heeded, could have provided a key. Their view has been hard to put aside, as I know from my own experience in not recognizing Bronzino's range in drawing when writing of him first. Later a different corpus from theirs formed my catalogue of twenty-four Bronzino drawings, in which only five remained from the thirty-two Berenson listed as his or possibly his and four from McComb's twenty-two.[4] But although it is the basis of the present essay it was not entirely free of old prejudice. In the meantime new evidence has come from drawings that others have brought to light or returned to Bronzino.[5] More drawings will certainly be found as know-

1

ledge of the character and range of his draughtsmanship grows, and some can be expected to appear under names of artists one would never think of in connection with Bronzino, as in the case of two included here.

As explained in the preface, we shall be concerned in this essay with some drawings that are undeniably connected with Bronzino's work in painting and tapestry. The order is approximately chronological, though not rigidly. We shall not be dealing with drawings that present difficulties in distinguishing Bronzino's hand from Pontormo's. The opportunities for perceiving his own qualities as a draughtsman are better if for the present the problem of identifying Bronzino when imitating Pontormo is temporarily set aside.

* *

*

From all of Bronzino's career up to 1539/40, when he went into the service of Duke Cosimo de' Medici,[6] only two drawings have emerged so far of which it can be said without reservation that attribution to him is supported by an undeniable connection with paintings that are both unanimously accepted, and acceptable, as his own independent work. To be sure, in the case of one of the paintings concerned there has not been unanimity about dating it within this span of time. Nevertheless, on the score of dating there is not much room for doubt.

One of the drawings (*Fig. 1*) is the familiar study in black chalk for the Christ Child of the signed Panciatichi *Holy Family*, done in all probability in the 1530's.[7] Once given to Pontormo, the drawing was identified years ago by Frederick Mortimer Clapp.[8] It represents a stage preliminary to the painting and was evidently made from life. As one of the two drawings stated in the lists of Berenson and McComb to be for signed or documented works by Bronzino,[9] it has long been a principal starting point for study of his drawings and has not seemed to offer much to contradict the view that Bronzino was a weak draughtsman. It is modest and rather literal. But it does attest a capacity on Bronzino's part for recording observations realistically, and it has positive aspects that are worth noting for a knowledge of

2

his draughtsmanship, among them the soft even light in the shadows, giving translucency, the effect of luminousness in the unshaded areas of the upper arm, chest, and face, and the distribution of the light in patches. The shading may seem tentative, but it is in keeping with its subordination to the effects of light. Although "without the calligraphic animation of Pontormo's line,"[10] the main contour has a steady indeflectibility, which is maintained even while it expresses the pudgy flesh or infant skull and which imbues even so humble a study from the model with some abstract value.[11]

The second drawing is of another kind, the well known study in black chalk at Chatsworth (*Fig. 4*), now unanimously accepted as Bronzino's, for the *Portrait of a Man with a Lute* in the Uffizi.[12] Although the picture is not signed or documented, there are no doubts about Bronzino's authorship, and it is normally dated in the first half of the 1530's, after he returned to Florence from Pesaro, where he had worked for the court of Urbino. The drawing did not come to be accepted easily or quickly. Probably this was due in part to the prejudiced view of Bronzino's draughtsmanship arising from the misreading of Vasari, but certainly just as important was its difference from other drawings given to Bronzino. Credited to Pontormo in the catalogues of Berenson and Clapp—"the quality is of P.'s best," Mr. Berenson commented— it was ascribed to Bronzino by Archibald Russell in 1925 and A. E. Popham in 1931, but it was not mentioned by McComb and still appeared as by Pontormo in Berenson's list of 1938. Then, in the 1940's, several observers (Becherucci, Gere, and myself) asserted Bronzino's claim, and the issue has since been closed.[13]

The Chatsworth drawing still remains different from most other Bronzino drawings known so far. It accords, however, with the aspect of his art most familiar to us, the portraits, especially those normally assigned to the 1530's—and among these the portrait from the Havemeyer Collection in the Metropolitan Museum (*Fig. 3*)[14] even more than the *Man with the Lute* itself. The outline, varying in strength and accent, conveys the precise, subtly changing edge of the silhouette. Light and shade play in angular patches across the tunic, making an interior structure of ordered complexity. The smooth ivory of the hands, the sober geometry of the face, its full lips shaped in planes of shade, the eyes dark under evenly curving, well stressed lids—these are equivalents in drawing of what we know in painted portraits.

But what distinguishes it above all is the disciplined placement of the figure on the page and its upright, motionless, almost geometric form, again reminiscent of the portrait at the Metropolitan.

Bronzino must have been aware of Michelangelo in making this study, because the pose invites comparison with his Giuliano de' Medici[15] and the precision of touch with his drawings around 1530. John Shearman has suggested that Bronzino's *Portrait of Ugolino Martelli*, rather similar to this drawing in pose and character, is based on Rosso's portrait of about 1525 in Naples.[16] Rosso's picture is an ancestor of the Chatsworth drawing, though now rather remote. There is certainly a debt to Pontormo, too, as represented in his study for a portrait of Ippolito de' Medici.[17] But the effect Bronzino achieves is new compared to Pontormo,[18] bearing out the view that the distinctive character of his portrait style in the 1530's did not simply come to him from Pontormo but that in this case influence also went the other way, to Pontormo from Bronzino.[19]

The distinctiveness of Bronzino's portraiture becomes clearer if we take note of what it owes to his experience outside Florence. That it had non-Florentine sources, in addition to the Florentine, is a subject broached here in Appendix I. The almost geometric discipline of the Chatsworth drawing reflects, I think, one part of Bronzino's experience away from Florence in Pesaro at the court of Urbino. Curiously, the face in the drawing seems to bear some resemblance to faces by Piero della Francesca.[20] If so, it is not a coincidence; for, as the last part of Appendix I explains, it is to Piero that the discipline distinguishing the Metropolitan portrait and, to a lesser degree, the drawing is likely to owe most.

There are external, objective grounds, besides style, for connecting other drawings with Bronzino during his career up to 1539/40, but not such undeniable external grounds as in the case of the *Christ Child* in the Uffizi and the portrait drawing at Chatsworth. Our concern both with drawings that provide only the most indisputable basis for studying Bronzino's draughtsmanship and with those in which Bronzino did not try to be very close to Pontormo excludes discussion for the present of all but these two.[21]

* *

*

From 1540 on the drawings that are undeniably connected with entirely accepted and acceptable works of Bronzino are more numerous. The one other drawing besides the *Christ Child* that Berenson and McComb catalogued as preparatory to undisputed work by Bronzino is the study in the Uffizi of a nude (*Fig. 5*) for the fresco of the *Crossing of the Red Sea* on one wall of the Chapel of Eleonora in the Palazzo Vecchio.[22] It should date from 1541, near the start of Bronzino's service as court painter to Duke Cosimo de' Medici and his duchess, Eleonora of Toledo, because the fresco was begun, as we now know, on 6 September 1541 and finished on 30 March 1542.[23] Again attributed previously to Pontormo and first identified correctly by Clapp,[24] it and the *Christ Child* (*Fig. 1*) long served together as the prime standards for other attributions to Bronzino. This was unfortunate, since the nude is drawn in the same medium as the *Christ Child*, black chalk, and did not seem to enlarge the picture of Bronzino's range very much.[25]

But in fact it does have something more to tell. Although testifying to great care with anatomy, the figure is idealized and polished—yet not "dead," as once described. The continuous line of the contour is taut, resilient, varied. Remarkable are the purity and continuity of the form, the translucency of the shadows, and the intensity and distribution of the patches of light. The way the body is built up as a volume within the contour and the muscles of the back are elaborated suggests drawings by Michelangelo—earlier ones rather than later.[26] Yet one also senses other precedents, both from the late quattrocento and from more recent date: a hint of Signorelli in the modeling and lighting[27] and of Rosso Fiorentino in the refinement of shading, light, and contour.[28] There is doubtless a debt to Pontormo, too,[29] accounting for the former attribution of the drawing to him, though it is not so easy to see. For, most important, the figure reflects a decidedly classical sculptural ideal, which Bronzino had known at first hand in 1530/32 in the famous *Idolino* (*Figs. 6* and *7*). The influence is striking, even though it is modified by the conventions of cinquecento *maniera*.

Students of Bronzino have not noticed that the *Idolino* was unearthed on land adjacent to the Villa Imperiale outside Pesaro—the summer residence of Duke Francesco Maria and Duchess Eleonora of Urbino—and that Bronzino must have known it well. It was discovered by

chance in the autumn of 1530,[30] just after or just before Bronzino arrived to work on the villa's decorations. Vasari says Bronzino left Florence for the Villa Imperiale once the siege of Florence was over in the summer of 1530 and the "accordo" made, the "accordo" being presumably the pact of August 12.[31] He stayed long enough to contribute considerably to the decorations and paint at least three pictures besides, before returning home to help Pontormo with his second commission for Poggio a Caiano. The evidence indicates that his departure from Pesaro for Florence was probably not much later than 2 April 1532 and points principally to the spring or summer of 1532,[32] a stay then of as much as a year and a half or more. Hence Bronzino was present to share in the initial excitement of the find, and he had months to study it.

Whether the *Idolino* is a Greek original of the late fifth century as once generally thought or a Roman version from the Greek as now seems likely,[33] to this day it is one of the rare bronze sculptures that survive from antiquity to show what large Greek bronzes were like. Its freshness still charms a modern eye, and the feeling for bronze still seems remarkably "sensuous and fastidious" among works representing the Polykleiton tradition.[34] At its discovery it must have been a revelation. Certainly it was prized at the Villa Imperiale. The duke had it mounted on a specially designed base carrying an inscription written for it by Pietro Bembo,[35] and it remained at the villa until the seventeenth century, probably in the vaulted chamber just inside the arcade that opens on to the villa's beautiful sunken court.[36]

During his stay at Pesaro Bronzino learned from painting and from painters he came in touch with, as we shall have several occasions to observe. As a result he was henceforth in many respects a very different artist. But the impression made upon him by the *Idolino* was one of the most telling for his art from then on. His new interest in classicizing grace, refinement, and polish becomes much more understandable in the light of his encounter with this figure in the atmosphere of the court of Urbino, where by Castiglione's testimony concern for the graceful and refined was native. And not only was Bronzino thereafter much more under the spell of antique sculpture, but he showed an unusual predilection for neo-Greek ideals[37]—even if he incorporated them in the context of the *maniera* idiom, whose principles have their roots in Roman relief.[38]

6

The nude of the drawing (*Fig. 5*) for the *Red Sea* goes back to the *Idolino*'s pose (*Fig. 6*) in the turn of the head, the tilt of the shoulders, the curving back, the fall of arm and wrist,[39] the "hip-shot" position. At the same time the *Idolino*'s classic stance is modified by the angularity preferred in cinquecento *maniera*: the arm raised to the head, the bent leg, the position of the hip exaggerated almost to dislocation.[40] The very handling seems to reflect the *Idolino* with cinquecento modifications. Anna Forlani Tempesti once compared the drawing's finish to "polished stone or smooth bronze."[41] Indeed, the modeling does appear to share some of the subtle continuity of the bronze surface, something of the feeling for the distinction of flesh and bone in decidedly sculptural terms. Yet simultaneously, the drawing departs from the *Idolino*, not only toward the Michelangelesque in the muscular back, but to simplified *maniera* surfaces in the upper legs. The contours catch the *Idolino*'s sculptural hardness and precision, as in the calf and ankle, and the undulation of its silhouette in the torso. But they exaggerate the undulation. They flow with more overt elegance (perhaps combining a little of Michelangelo with Perino del Vaga in this respect[42]) and intensify the figure's edges, minimizing its three-dimensional continuation into depth.

It would be fair to say that in itself the drawing for the figure in the fresco of the *Red Sea* tells us much about the formation of Bronzino's formal figure style in his maturity. And it is a type of drawing with which Bronzino could prefigure the final "plastic idealism" of the figures in his pictures.[43]

A study I came upon in the Louvre several years ago for the *Saint Michael*, in one compartment of the ceiling of the same chapel, represents a somewhat different mode (*Fig. 8*), even though it is also in black chalk, deals again with the nude, and must date from only very slightly earlier.[44] It is among drawings classified under the name of Lomazzo,[45] and one can see how the delicate *sfumato* of the modeling might have occasioned the separation from its Florentine origin and suggested a Milanese draughtsman. This mistake goes back a long time. The drawing was already attributed to Lomazzo in Baldinucci's collection, attesting the unfamiliarity of Bronzino's draughtsmanship in this vein even to a Florentine connoisseur as early as the seventeenth century.

The drawing is obviously a study from the living model. *Pentimenti* are visible in the raised arm, the leg at left, and the heel at right.

7

Below, the figure's left hand is restudied in a position closer to the final version than above and is holding a scepter, as in the ceiling. Since this scepter is not yet present in the *modello* for the ceiling (*Figs. 11 and 14*), to which we shall come shortly, the study of the figure must have been done after the drawing of the whole composition. Bronzino posed the model in the difficult posture he had decided upon; and even though the figure was to be clothed, he studied it from the nude in conformity with old Florentine practice. It seems safe to conclude from this that he regularly made nude studies from life, both for clothed and unclothed figures, however few survive.[46] Afterwards he turned to the final formalization of the *Saint Michael* as represented on the ceiling itself. We may imagine another drawing for this last stage, more like the idealized nude for the *Red Sea* in the Uffizi.

There seems to be more of the late quattrocento in the Louvre drawing than in the *Red Sea* nude. No doubt this is due to its combination of close observation, precision, and delicacy, to the subtle appreciation for surface quality rendered with dainty, restrained modeling, giving almost the effect of metal point. One may think of drawings by Bronzino's early master Raffaellino del Garbo. But is there some distant remembrance of Credi or of Leonardo here, of Leonardo's silver point and delicate chalk studies from the nude?[47] There is enough of Leonardo perhaps to have helped suggest a Milanese origin for the drawing. Evidence exists that in painting Bronzino concerned himself with Leonardo,[48] and he had a slender connection to Leonardo through Pontormo, who studied with Leonardo for a time as a youth.[49] The contours, however, have an arbitrary elegance belonging to Bronzino's time, akin to those of the nude for the *Red Sea*, though more flowing. They adhere to an ideal of grace that reminds one perhaps of Pontormo, but more of Perino del Vaga.

A very different kind of drawing for the Eleonora Chapel is represented by another in the Louvre (*Fig. 9*), for a female head at the far left of the *Miraculous Spring of Moses*.[50] It, too, had been in Baldinucci's collection, but this time as a Bronzino, and Voss published it under Bronzino's name in the 1920's, though not as a drawing connected with the frescoes. Nevertheless, Berenson did not include it in his subsequent catalogue. In 1935 it was exhibited at the Louvre as Bronzino's, but otherwise remained under the name of Bronzino's pupil Alessandro Allori until 1955, when it appeared in an exhibition

at the Louvre, and in my catalogue, as Bronzino's study for the head in the fresco.[51] Doubtless the hesitancy of Berenson and McComb to credit it to him was due to the unexpectedness for Bronzino of this type of drawing, but its quality and beauty may have stood against the attribution as well.

Despite the impression it gives of luxuriance the drawing has the refinement and steadiness of contour, the reserved purity and continuity of surface, the precision we know in Bronzino's nude for the *Red Sea*. Meanwhile, there is a reason for its elaborateness and difference from other drawings. Cut out and mounted on another sheet, it has the appearance of a cartoon fragment. And this is what it must be, for its measurements and those of the frescoed head turn out to coincide.[52] It must be the final rendition of the head before painting.

The drawing in the Louvre tells us that Bronzino followed the high standards of traditional Florentine practice and executed the cartoon with all the exactitude and nuance he wanted in the fresco. The fragment is as completely realized as the head of the Virgin in Leonardo's cartoon in London,[53] and it bears comparison. The suggestion has been made that the Louvre head resembles drawings of heads by Michelangelo around 1530. True, there is something similar in the precision and shaping of details. But there is a greater resemblance to Leonardo's Virgin—in the form of the face, the gradations of tone, the smile, the revery, the delicacy, the finish. Bronzino is much more likely to have seen his precedent on this occasion in Leonardo, the other great pillar of Florentine drawing. Of course in Bronzino's hands the tradition is altered by insistence on elegance and clarity, by the more intense, pervasive light and absence of deep shadows, "in which elusive but nonetheless real feelings might lurk."[54] His ideal of humanity is both less exalted and less profound. At the same time the head is tinged with the look of a fourth century Greek head in sculpture. Certainly the drawing was meant to serve a sculptural ideal, for it was preliminary to a painted head intended to be sculptural in effect, though endowed with the color, texture, and light of painting. Nonetheless, we are dealing here with a masterly draughtsman just as surely as we are face to face with "a superb painter"[55] in the fresco for which the drawing served. The standard exemplified by both has to be kept in mind when trying to define Bronzino's oeuvre in drawing.

9

At the Uffizi there is a handsome drawing in black chalk representing the two male figures in the lower left corner of this same fresco, but showing marked differences from them. In the drawing the older man of the fresco is a nude youth, and this suggests an original study from life. On the *verso* is a drawing of the drapery around the hips of the nude in the left foreground of the *Miracle of the Manna*, the other fresco on the same wall of the chapel.[56] The attribution at the Uffizi has been to Alessandro Allori. Although responsible for pointing out the connection with Bronzino's decoration, I labeled it a copy by the young Allori after a Bronzino drawing.[57] Giovannoni has agreed in her catalogue of the exhibition of Allori's drawings just concluded.[58] To be sure, it is squared, suggesting a preparatory study. Yet in total effect the drawing on the recto lacks the containment we shall find normal in Bronzino's draughtsmanship. The shading is looser and more restless than appears to be true of his. The verso is in a different mode, not one that can be readily associated with Bronzino, in my view. Hence, despite its connection with the *Miraculous Spring of Moses*, this sheet is not put forward here as a basis for studying Bronzino's hand.

* * *

One of the most instructive drawings for knowledge of Bronzino's draughtsmanship and range is the study in Frankfort showing the whole composition for the ceiling of the Chapel of Eleonora (*Figs. 14, 10, 11, 12,* and *13*). Once attributed to Giulio Romano, it was identified by Voss as Bronzino's in his book of 1920 on late Renaissance painting. But he did not include a photograph, and it was not recorded at all in the subsequent catalogues of McComb and Berenson or by other students of Bronzino. It is to the credit of Würtenberger that he did publish a photograph with the attribution to Bronzino in 1940, in his article on mannerist ceiling painting.[59] Its neglect was no doubt due largely to the lack of any published reproduction before Würtenberger's, but probably also to the drawing's difference from anything expected of Bronzino in modern times. Bronzino was evidently thought by Berenson and McComb to have drawn mostly in black chalk,

10

occasionally in red, but not pen and wash. This and the misapprehension that Vasari considered Bronzino a poor draughtsman did not accord with a drawing of such sureness and fluency, in the medium of pen and wash over black chalk and heightened with white on blue paper. But it had an undeniable claim to be by Bronzino. It shows many divergencies from the ceiling, as Voss noted, and obviously represents a preliminary solution, while the numerous *pentimenti* are so fundamental—for example in the *Saint Jerome (Fig. 12)*—as to make it as certain as such evidence can that the drawing is an original.

The Frankfort drawing is a *modello*, yet it did not come at the end of Bronzino's studies for the fresco. The many differences from the finished work and the indications noted earlier that the nude study in the Louvre followed it testify to its having been done well before Bronzino finished his preparations for painting. Possibly it served for preliminary approval of the decoration. Nevertheless the *pentimenti* show that Bronzino used it to work out parts of the composition as he drew.[60] The differences from the ceiling include a different emphasis in style: relative fluency and slenderness of figure as compared to the relatively isolated clarity and monumentality of figures in the finished vault. In Bronzino's work in painting the closest parallel stylistically is the *Nativity* in Budapest[61] (a picture that by itself should have given a strong clue to the range and ability of this artist as a draughtsman). The kinship accords with the *Nativity*'s position shortly before the Eleonora Chapel in Vasari's chronology of Bronzino's work. Meanwhile, the development from *modello* to ceiling is like a harbinger of the changes of emphasis in Bronzino's style from fresco to fresco in the chapel within a short span of years.

The medium of pen, wash, and white heightening was an important part of Bronzino's Florentine heritage. He was heir to it from Filippino Lippi by way of Filippino's assistant Raffaellino del Garbo, who was Bronzino's early teacher. To be sure, his later master Pontormo used it very rarely. But Bronzino's connection with the medium was probably reaffirmed in 1530/32 at Pesaro. There he worked with Raffaellino dal Colle of Borgo San Sepolcro,[62] and parts of the decoration that Bronzino painted with him at the Villa Imperiale are like large drawings in pen and wash heightened with white.[63] Raffaellino had been Giulio Romano's favorite assistant in Rome[64] and was with him for a time, according to Vasari, in Mantua.[65] He had also been

associated with Rosso Fiorentino just before coming to the Imperiale.[66] Hence, besides drawings of his own, he could have had with him and shown to Bronzino drawings of the Raphael School, especially Giulio's, and possibly of Rosso as well.[67] He owned Giulio's cartoon for the altarpiece in Sta. Maria dell' Anima,[68] so it is plausible to assume that less notable items from Giulio were part of his working equipment. We can see touches of Giulio's influence in the Frankfort *modello*. Yet, even though once attributed to him, it makes one think first of Florentines. Its line is lithe and springy by comparison with Giulio's, the forms more slender, the whole demeanor more refined and less cold.

There is surprising variety within this single sheet. The types of face and figure are a case in point. Saint Jerome (*Fig. 12*) recalls late quattrocento figures, Saint Michael (*Fig. 11*) has a modern, mannerist air, and neither is like Saint Francis and his companion Brother Leo (*Fig. 10*) or Saint John (*Fig. 13*). Moreover remarkable differences of treatment are evident, especially between the compartments of Saint Francis and Saint Michael.

In the *Stigmatization of Saint Francis* (*Fig. 10*) the line is sensitive and faithful to the natural form, cogent, limber, delicate. Its kinship in Florentine and Central Italian draughtsmanship is with the classic vein from Leonardo to Raphael—with a touch of svelteness not unlike Perino's in early drawings, when his manner was still much tied to Florence.[69] Wash and white heightening are used with sureness and subtlety, not only to assist in establishing the forms, but to convey atmosphere, light, substance, texture, even an impression of color, and at the same time to achieve a notable pictorial unity. The modulations of light and shadow are liquid, as it were, their form-fusing potential understood. Bronzino's luminosity comes into its own here, especially in the figure of Brother Leo. But the hard, the sculptural, and the perfectly motionless, which we find normal to him, are excluded and foreign.

The figures, placed somewhat back in the space of the compartment, move with naturalness and fluid freedom, and the pose of Brother Leo is a dramatic diagonal into depth. But despite their movement Bronzino gives them a feeling of volume and substance: their drapery is both palpable and fluent, a pleasure to the eye. Around them and especially in the interval between them space is a positive and serene

element, holding a suggestion of lighted atmosphere. The light comes from above. It touches some of the upturned surfaces with special strength to denote the supernatural radiance that accompanies the Stigmatization. (Light is the principal symbol of the supernatural because the seraph and cross, indicated very slightly and tentatively at first, were then omitted, as later in the fresco, an exceptional step in the history of the scene outside of Venice.[70]) Before the light the saint kneels in rapt attention, and Brother Leo falls back shielding his eyes.

Since Bronzino's treatment is not only flowing, illusionistic, and pictorial but expressive of frank emotional response, it looks proto-Baroque to a degree not seen earlier in pictures of the Stigmatization, so far as I know, and makes one think a little of pictures by Correggio in the past or Barocci in the future. For a Florentine around 1540, this is remarkable. There was past precedent for naturalness, illusion, and emotion in Tuscan and Roman painting of the High Renaissance, in Sarto and Raphael especially. For Bronzino's handling of the medium of drawing in the *Stigmatization*, there was precedent in the Raphael School as seen in the *modelli* in fine pen, wash, and white heightening over black chalk for the Vatican *logge,* attributed now to Penni, Raphael's Florentine assistant.[71] But why did Bronzino turn to this mode and to a seemingly proto-Baroque conception of the scene? I think it was because of his experience outside Tuscany.

It has not been taken into account in the study of Bronzino that at Pesaro in 1530/32 he was in a region where Venetian painting was represented by examples striking and new enough to have more than routine fame, and within excursion distance. At Ancona only thirty-eight miles away, mostly along the Via Flaminia, was Titian's *Assumption,*[72] hardly a decade old, an example *par excellence* of naturalness, painterliness, and dramatic expression. At Iesi and Recanati, a little beyond, were paintings of Lotto as recent as the mid-twenties. Lotto himself was still active in the Marches around the time Bronzino was there. On various counts I believe Bronzino studied his art well.[73] (And as it happens, one of the few Stigmatizations prior to ours that Bronzino could have taken as a precedent for omitting the seraph and crucifix was Lotto's at Recanati, where, although present, they are so small as not to be visible to an observer standing before the picture.[74]) Moreover, there is good reason to believe that the Dossi

13

had already worked at the Imperiale in the spring of 1530 and left before Bronzino arrived, rather than coming after he was there as the accepted chronology for the Dossi has had it.[75] If so, some of the sketches and *modelli* for their work at the villa would have been in the possession of the duke and duchess of Urbino or Girolamo Genga, who supervised the decorations. The drawing Philip Pouncey recently attributed to Dosso Dossi about 1530[76] is handled, as he observed, like the Raphael School *modelli* for the *logge*. But it would have set Bronzino a standard of still softer, subtler modulation, and comparison with Bronzino's *Stigmatization* is worthwhile in this respect. It is not at all inconceivable, meanwhile, that when at Pesaro, in a region that had long looked rather steadily toward Venice in matters of art, Bronzino may have made the relatively simple trip to Venice itself, especially considering the connections of the city and the duke of Urbino,[77] and perhaps then on the way a visit to Ferrara with its close connection as the city of the duchess of Urbino's uncle Alfonso. It could perfectly well have been through contact with the Venetian sphere of influence, incidentally, that Bronzino came to use blue paper, favored for drawings there. Finally, there is some suggestion that as early as about 1525 Bronzino may have known Correggio's two pendant pictures in the Del Bono Chapel of S. Giovanni Evangelista in Parma,[78] both pictures in a proto-Baroque manner that the *Stigmatization* somewhat calls to mind.

But what about Bronzino's education under Pontormo? Is it evident here? It is remarkable how independent of Pontormo the *Stigmatization* is. Certainly, however, Bronzino's experience of Pontormo's fluent line, luminous modulation, and moving gesture and expression stood him in good stead in this mode.[79]

If we thought that he frequently did drawings like the *Stigmatization*, we should want to ask whether Bronzino had an influence on "anti-*maniera*" developments of the future. But nothing else quite like it has yet emerged; and, as it is, when the *Stigmatization* reached the vault (where the saint and his companion changed places), the pictorial unity, flow, and emotion were diminished. It looks as if a quattrocento version of the Stigmatization had an influence on the final conception, something like Domenico Veneziano's in Washington or Benedetto da Maiano's on the pulpit in Sta. Croce. Even so, Bronzino's frescoed *Stigmatization* is still exceptional for a Florentine mannerist painter. Both the drawn and the painted versions demonstrate how deliberate

14

was his choice when he adhered to *maniera* conventions nor-
mally—and also when he rejected them almost entirely, as here.[80]

The compartment of the *modello* showing Saint Michael (*Fig. 11*) is
no less surprising in respect to old opinions about Bronzino's draughts-
manship than the *Stigmatization*, but it shows us a very different mode.
Obedient now to conventions of *maniera*, the figure of Saint Michael is
posed in *contrapposto* yet compelled into the two dimensions of the
picture surface, with arms and legs stressed as short, flat diagonals in
angular relationships. Although the light that touches the demon
gives the impression still of natural modulation veiled by atmosphere,
the light on Saint Michael brightens chiefly planes paralleling the
picture plane. It is more the flat light of *maniera*, no longer coming
from above. If cast from anywhere, it is from some source in front
and a little to the left of the figure, but it seems rather to be what it
is in fact, an applied brightness plainly produced by white heightening,
more ornamental and enlivening than illusionistic. It contributes to
the most unexpected aspect of this compartment of the *modello*, the
sense of energy and movement on the page. Contributing, too, are
silhouette and line. A rhythm swift, fluctuating, and two-dimensional
is carried by the contours of Saint Michael, contours which are
schematic now by comparison with those of Saint Francis and Brother
Leo, formed arbitrarily of curved segments and scarcely turning into
depth.

The draughtsman all this makes one think of first is Perino del Vaga,
as in the drawing of Pope Leo X that Bernice Davidson has published.[81]
There are obvious similarities in the sprightliness and in the use both
of light and line. Three of the drawings seen so far have brought
Perino to mind. It would have been natural for Bronzino, starting in
the early 1520's, when Perino returned briefly to Florence and made
such an impression,[82] to keep track of the art of this precocious,
successful compatriot and almost exact contemporary (Perino was
only two years older)—and to be aware of him anew toward 1540,
when Perino emerged again in Rome as a leader and younger artists
like Vasari were emulating him. Giulio Romano may be recalled to
us as well, thanks to the exuberant two-dimensional movement and
double contour lines of Saint Michael's figure. But also, the drawing
reminds again of the Dossi, this time as in paintings of the 1520's like
the *Madonna with Saints George and Michael* in Modena,[83] not only

15

because *putti* accompany Saint Michael, hiding and shrinking beside him as Dosso might have had them, their pinched features oddly Dosso-like, but also because of the slightly quirky effect of Saint Michael's figure, wanting in conventional grace with its stumpy outflung limbs, and perhaps, too, because of the saint's facial expression.[84] Was Bronzino, seeking novelty, going back purposely to recollections of Dosso? He would have been very conscious of the Dossi's painting as well as their drawing if he followed them at the Imperiale and helped complete the work they left unfinished, as the evidence there indicates he did.[85] The Dossi were dismissed because their work displeased the duke, but their eccentricities would hardly have put off someone fresh from Florentine "anticlassicism" when Dosso himself was obviously a remarkable painter, from whom much could be learned. On an excursion north from Pesaro Bronzino could have made a point of seeing more of Dosso's painting in Ferrara, especially with an introduction such as the duchess of Urbino could provide him to the court.[86]

What about relations of this compartment of Bronzino's drawing to Pontormo? Certainly the caryatid *putti* flanking it, though outlined and lighted like the saint, are close to Pontormo. The *putti* give new warning of what a delicate task it should be to distinguish Bronzino's hand from Pontormo's if he wanted to be as like Pontormo as possible. Comparing the *putti*, in their stocky solidity and with their swelling craniums, to figures of the drawing at Hamburg showing the *Legend of the Ten Thousand Martyrs* or the *Study for an Adoration of the Magi* in the Uffizi should give one pause.[87] Meanwhile, it is important that Bronzino did not entirely lose touch, in his *Saint Michael*, with the inheritance of earlier Florentine draughtsmanship, which he came by legitimately in a direct line through his teacher Garbo, once assistant of Filippino, who had in turn worked under Botticelli.[88]

The compartment of Saint Michael was much altered by the time it reached the vault. With such study and refinement as is witnessed by the Louvre drawing (*Fig. 8*), the polished Saint Michael was ultimately evolved. In the end the energetic flow of movement was stopped. Bronzino chose a sculptural ideal, frozen motion, disjunction, vivid clarity of detail, and local color for the painted version.

The compartment with Saint Jerome (*Fig. 12*) shows how close Bronzino's drawing could come to the late fifteenth century in quite

16

another way. The figure bears a resemblance to Raffaellino del Garbo's Saint Jeromes of Umbrian cast, as in the *Madonna and Saints* now at San Francisco and in the predella of his altarpiece at Siena.[89] Old fashioned plasticity with a minimum of cinquecento sophistication (except in the complicated structure of leg and drapery)—this is the line Bronzino takes here, although the wash and the white give an effect of rich patina. In the white heightening he seems to make a point of reverting to a characteristic fifteenth century reliance on small distinct lines of hatching. The composition also evokes the quattrocento in its assemblage of rhythmically unrelated elements: figure, cross, and lion. He must have been aware of the blunt contrast he was making in both figure type and composition with the other compartments and with the full sixteenth century style of the caryatid *putti*. It seems inescapable that he was being deliberately varied, experimenting with juxtapositions, that in this case he wanted the archaism of the older manner. In the end he modified it. On the ceiling he made the figure grander, removed the cross, and provided more interrelation by transforming the lion, introducing the hat, and stressing the billowing clouds. The result is more in the spirit of the sixteenth century, but it still contrasts sharply with the *maniera* idiom of the *Saint Michael*.

The fourth compartment showing Saint John the Evangelist and his eagle (*Fig. 13*) is in still another vein. But the difference is not so pointed. The handling is partly as in the *Saint Jerome*, and the type of head and face remind again of Garbo, as represented by the saints at the left of Garbo's *Coronation of the Virgin* in the Louvre[90] (though the facial expression is no longer languid). But evidently Bronzino also thought back to the evangelists he and Pontormo had painted at Sta. Felicita fourteen years before, to Pontormo's *Saint John* and his own *Saint Mark*.[91] He repeated Saint Mark's arm crossing in front, his neck, his shoulders (one short and protruding, the other elongated), and the stiff drapery. But his purpose was not really Pontormesque, and what he managed in the *modello*, before further study, was slightly comic: a rather unmonumental and isolated figure facing a fierce bird worthy of Giulio.[92] Probably he wanted a figure of Giulio-like effect such as he finally achieved in the ceiling, but it came out in the drawing looking more like one of Raffaellino dal Colle's figurine-like approximations of Giulio (*Fig. 27*).

The variety in the Frankfort *modello* gives it special importance as a guide to Bronzino's range in drawing. Garbo had from the beginning set him an example of deliberate changeableness. In recent years there has been increasing awareness of the diversity of styles in drawing that artists of the sixteenth century can show, but my guess is that in this respect Bronzino will turn out to be a match for any. It may be helpful, therefore, to mention a few peculiarities of his hand as represented in this drawing and not noted here so far.

He is partial to upturned communicating faces with prominent jaws and chins, to full lips even when mouths are small, to large, big-fingered hands like those of Saint Francis and Saint John, to oversize feet with emphatic and separate big toes. But in almost everything there is variation—variation in hands for instance, including the sharp splayed hand of Saint Michael ready to emit an electric charge (*Fig. 11*), the rippling arthritic hand of Saint Jerome with acutely bent forefinger (*Fig. 12*), the graceful hand of Brother Leo slightly rippling again and tapering off indefinitely (*Fig. 10*), and the little star-shaped hands of the *putti* (*Fig. 12*). Eyes are worth particular attention, for their variety and for the control Bronzino exercises over their expression. The Frankfort *modello* shows they can be small and vivid (unlike the big dry eyes in some of Bronzino's pictures), some-times with eyelids carefully indicated like Saint John's (*Fig. 13*) and even Saint Michael's, sometimes no more than slits like Brother Leo's or smudges as in the case of the *putti* (*Fig. 11*). Saint Michael's gaze is sure and measuring, the demon's a stricken glare (*Fig. 11*), Saint Jerome's pained and aged, Saint Francis's a gentle stare of wonder, that of the *putto* between Saint Michael and Saint John (*Fig. 13*) a sly and sidelong glance. But all are contained, are kept from interrupting the integrity of the form, so to say. Drapery can fall naturally as in the *Stigmatization*, but it can also be disposed in elaborate stiff structures with thin highlighted folds as over Saint Jerome's knee. Not least, the treatment of figures can vary even when they are ostensibly similar, as the *putti* show. There is a difference between those mentioned earlier that flank the compartment of Saint Michael (*Fig. 11*) and the one seated to the left of Saint Jerome (*Fig. 12*), which is thicker of torso, more monumental, and also modeled in another way, with slightly torn ribbons of wash. Where alternative lines of composition have been tried and abandoned, in the compartments of Saint Jerome

and Saint Michael, these are visible but subdued and neat. Around the decorative elements—the coat of arms and supporting ribs—is an impression of tangible air. And over-all there is a richness of surface, a fabric of line, of wash, and of accenting, sometimes swirling white, that gives an impression of animation throughout.

This is the place to mention, after the *modello* at Frankfort, two drawings at Christ Church, Oxford, in the same medium but on paper grounded in mauve and showing different parts of the composition of the *Crossing of the Red Sea* with many variations from the fresco and many *pentimenti*. They are both clearly by one hand and were originally parts of one drawing.[93] But they cannot be classified as undeniably connected with the fresco of the *Red Sea* in the Chapel of Eleonora. For they contain differences from the fresco that occur in a new version of the composition engraved by Hieronymous Cock.[94] In all likelihood the engraving was published at least nine or ten years after the fresco and quite possibly later.[95] The engraving differs from the fresco significantly in parts of the composition and modifies its style. The modification appears to come from the reworking of the design itself, not simply from the engraving's reproduction of it. Figures and motifs are added and subtracted, part of the action is rearranged and re-routed, and there are changes of rhythm and emphasis that forgo some effects Bronzino seems very much to have prided himself on in the fresco. It is open to doubt therefore whether Bronzino himself reworked the composition for the engraving. For this reason the related Christ Church sheets do not belong in a discussion confined to drawings undeniably connected with works wholly accepted and acceptable as Bronzino's own. It should be added, meanwhile, that they present critical differences from Bronzino's draughtsmanship as evidenced in other drawings certainly his, contrasts to Bronzino's aims in the fresco, and obvious similarities to drawings by Alessandro Allori. In 1955, on the basis of a photograph, I placed them in my list of drawings not by Bronzino and thought they were probably by Allori, as have others.[96] Discussion of them belongs elsewhere apropos of problems in distinguishing between drawings of Bronzino and Allori. I am convinced they are not Bronzino's and surer than before that Allori is the author.[97]

*　　　*

*

19

Views of Bronzino's range as a draughtsman have been inadequate partly because of a general lack of familiarity with his tapestries, for which he began to produce designs in 1545. Except for two examples, the well-known *Vindication of Innocence* (*Fig. 22a*) and *Primavera* (*Fig. 22b*), they have scarcely been considered in the study of his art.[98] None has been reproduced in books or articles about him except again for these same two examples and one detail from a large tapestry. Some have appeared in publications devoted simply to tapestry, but others have not been reproduced in any publication at all. Bronzino's full range as an artist will not be realized until they are all taken into account. A few illustrations here (*Figs. 15, 21, 23, 24, 26, 30, 35,* and *36*) begin to supply the lack.

That Bronzino was the dominant portraitist in Florence from the 1530's to the 1560's is commonly recognized, but that he came to hold the leading place as a decorator in the late 1540's and kept it until Vasari arrived in 1555 is less understood. He held this place by virtue of his role as the principal designer for the series of twenty tapestries illustrating the story of Joseph that Duke Cosimo ordered for the Palazzo Vecchio. (Salviati did one of the series before leaving Florence in 1548, and Pontormo also took part at the beginning but was dropped because his tapestry designs were considered unsatisfactory.[99]) This was the great commission awarded the new tapestry manufactory upon its establishment in Florence under Flemish weavers at the duke's initiative in 1545. Bronzino was at the height of his powers. The challenge and opportunity were great: to design tapestries of monumental scale for the seat of court and government and, at a time when tapestry was increasingly in demand in Italy, to show what Florentines could do in this transalpine medium. Raphael had given tapestry designing his best in the *Acts of the Apostles* for the Sistine Chapel, providing the great example of Italian innovation in the art. That had been thirty years earlier. Flemish weavers had recently been working in Ferrara and Mantua from designs by Battista Dossi and Giulio Romano,[100] but at mid-century no comparable Italian cycle had as yet been attempted. Bronzino engaged in the new task with readiness to experiment, and the result was a virtuoso performance of remarkable variety, especially in the years from 1545 to 1549. To see his development as a designer of tapestries and—our main concern—to date the drawings for them, we need to

be as clear as possible about their chronological sequence. Hence two appendices are devoted here to the chronology of Bronzino's tapestries (Appendices II and III).

In 1909 Geisenheimer connected a number of drawings with tapestries designed by Bronzino. But apart from two, he did not consider these drawings by Bronzino himself, and the problem of their authorship has not been settled, except apparently in one case. To be sure, for years the two drawings that Geisenheimer did allow Bronzino—both connected with his tapestry of *Joseph Recounting his Dream of the Sun, Moon, and Stars* (*Fig. 35*)—were accepted almost unanimously as his.[101] But recently these, too, have been doubted and given to Bronzino's workshop.[102]

We shall start with the drawing in the Uffizi (*Figs. 16* and *17*) that represents the composition of a tapestry at the Quirinal Palace signed with Bronzino's name (*Fig. 15*). This tapestry is one of the four Joseph tapestries on Bronzino's design delivered to the ducal *guardaroba* by 15 July 1549, the first four by Bronzino to be completed (*Figs. 15, 23, 24,* and *26*). It is thought now to date from 1548/49,[103] but by the calculation given in Appendix III it was in all likelihood the first of the Joseph series, recorded as almost finished by 20 October 1546, and it was delivered probably not long thereafter. The composition shows two successive scenes from the Joseph story: in the background, Joseph in prison interpreting the dreams of Pharoah's butler and baker and, in the foreground, Pharoah's birthday banquet three days later.

The drawing (*Figs. 16* and *17*) is in pen, wash, and white heightening and in reverse direction with respect to the tapestry (as a drawing in preparation for tapestry normally is). Geisenheimer considered it a copy by Alessandro Allori, to whom it had been attributed at the Uffizi (having been classified still earlier as by an unknown sixteenth century hand). Thereafter there was no proposal to remove it from Allori's oeuvre. In 1955 I gave it to Bronzino, and Heikamp assigns it to him in his study of 1969 on the Medici tapestry manufactory. Although taking account of these two opinions, Giovannoni in her catalogue of the very recent Allori exhibition classified it as "workshop of Bronzino." In her view, even if Bronzino had a hand in it as a drawing that is almost a *cartonetto* preparatory to the final work, it was executed for the most part by a pupil, most likely the young Alessandro Allori.[104] If, however, the dating proposed in Appendix III

21

is correct, Allori was only ten years old at the time the tapestry was designed—in the fall of 1545 or very early in 1546, at the latest—and is out of consideration. (Allori was first recorded assisting Bronzino when he helped with cartoons for tapestry borders at fourteen, in 1549.[105]) At the same time it seems most improbable that Bronzino should have entrusted the *modello* for his first major tapestry, at the outset of the new manufactory, to another hand, even if we knew one in his shop capable of such quality and nearness to his own.

The drawing is clearly a *modello*, this time close to the final version—hence probably from the end of a series of many studies—but still showing a few differences from the tapestry: in the position of Joseph's arms and hands and in the arrangement of his garments, as well as in the accoutrements of the figure in the center of the foreground scene.[106] It is in bad condition, yet its essential character is clear, especially in the detailed photograph (*Fig. 17*). Except for manifest restorations the execution appears to me the work of one hand throughout. Parts of the foreground are more elaborate and stylized than the prison scene in the background. But this difference is nothing compared to the changes of mode within the Frankfort *modello* (*Fig. 14*), and it is consistent with the treatment of the two scenes within the tapestry itself. Indeed, the drawing was well suited to serve both as a demonstration piece for approval of Bronzino's design and as a basis for the full-sized cartoon.

The prison scene (*Fig. 17*) is strikingly free of stylization, particularly Joseph in his ease and naturalness, a beautiful and oddly vulnerable figure in the distance. Although different in its mode, the Frankfort *Stigmatization* (*Fig. 10*) prepares us for draughtsmanship of such sensitivity to natural form. The steadiness and purity of line, at once delicate and sure, we know in the Uffizi nude for the *Red Sea* (*Fig. 5*) and the Louvre study for the figure of Saint Michael (*Fig. 8*). Especially characteristic is the long slow curve of the upper leg belonging to the prisoner at left, to be seen in both these comparisons. Joseph's raised hand is related to the hands of both Saint Michael and the demon in the drawing at Frankfort (*Fig. 11*). His eyes are akin to Saint Michael's there, expressive now of thoughtful concentration, but comparably alive and contained. It is a touching view of Joseph and the listening prisoners, informed by human understanding as well as a command of means. To be sure, the pose of the prisoner at left, belonging to the

vocabulary of *maniera*, adds a note of artifice and caprice, but it also helps to convey on this occasion a captive's disquiet and defenselessness.

In the foreground scene (*Fig. 16*) there is more stylization in the *maniera* sense—in light, in poses, in the shaping of faces, arms, and hands—and more elaborate hair, drapery, and accessories. Yet at left the musician and the servant pouring wine are drawn much like the figures in prison. Their heads—pure in surface and contour, with long smooth cheek and long clean line of jaw and chin, dark-eyed, full-lipped—are not different from many in Bronzino's paintings[107] (for which preliminary studies could have been rendered in just this manner of drawing). The large attenuated and elegant hands of the female figure in the foreground are also unmistakably characteristic of him.[108]

The variations of mode represented in this drawing are different from those seen so far. The use in the prison scene of continuous wire-like contours in pen and ink in combination with soft wash goes back far in Florentine practice, and from the time of its popularity in the fifteenth century it was accompanied by luministic tendencies.[109] Working in this tradition and using it like Filippino Lippi, his teacher's teacher, in an elaborate compositional drawing heightened with white,[110] Bronzino developed the luministic possibilities. A clear medium, light-carrying yet pure and almost liquid, fills the prison space and bathes the figures there. In stressing this effect as well as in choosing the more elaborate treatment of the foreground, Bronzino wanted, I think, to match drawings for tapestry by Flemish designers.

Duke Cosimo had imported Flemish weavers to obviate buying tapestries abroad. In setting out to design for them Bronzino could not have avoided thinking of his designs in relation to the products of Flanders. He must have wanted both to emulate and surpass them, desires symbolized here by the juxtaposition in the foreground of the elderly Flemish figure standing near center and the up-to-date Italian nude. We can probably assume the weavers had with them characteristic tapestry designs by Flemings from the recent past to serve as examples for the Florentines who now entered upon work in tapestry. In drawings by Barent van Orley and Pieter Coecke van Aelst, designers active in the second quarter of the sixteenth century, we find both tendencies of Bronzino's drawing: relatively simple, notably luminous passages in pen and wash,[111] and on the other hand,

23

passages elaborate in drapery and accoutrements, drawn with much the same precise yet luxurious technique as the foreground scene.[112]

At the same time, however, Bronzino shows his wide experience of Florentine draughtsmanship, both past and contemporary. It is instructive to see the similarities in drawings for embroideries by his teacher Raffaellino del Garbo[113] and his contemporary Perino dal Vaga,[114] and also in a drawing by Perino for tapestry[115] and in another by Vasari for an altarpiece of 1543,[116] only two years earlier than the *modello*. Also, it appears that Bronzino was in debt here to Salviati, who had been painting near him in the Palazzo Vecchio since 1543. The manner in which Bronzino achieved elaboration in hair, drapery, and accoutrements recalls him,[117] as do the pose and back of the nude at right.[118] It was Bronzino's own neo-classical ideal, however, that gave the figures around the table their characteristic stamp.

Of the drawings Geisenheimer connected with Bronzino's tapestries, the only one on which there seems agreement concerning Bronzino's authorship has, in fact, received little notice and then only recently. It is a study in the British Museum (*Figs. 18* and *19*), again in pen and wash heightened with white and on blue paper, for the border used throughout the Joseph series (*Fig. 15*). Geisenheimer pointed out the connection to the Department of Prints and Drawings at the British Museum, but he did not do so in print. The drawing is classified under Bronzino's name but to my knowledge has been mentioned in writing only relatively recently, by Heikamp and myself.[119] It is thought the Joseph tapestries were originally without borders and that these first began to be added about 1549,[120] when the young Allori and another painter were recorded as working on cartoons for them.[121] In this case the drawing might be dated reasonably about 1549. But the evidence indicates that the Joseph tapestries had borders from the start.[122] New cartoons for borders of the Joseph tapestries did continue to be necessary as production went on because the design was continually changed at top and bottom. But the design of the sides, once established, was never changed (adjacent borders would therefore always match when the tapestries were hung together). The British Museum drawing represents a stage before the final design as seen in all the tapestries. The proportion of width to height envisaged for the tapestries in the drawing is narrower than that finally decided upon for the series. The figures in the side borders

take up much more room than they do in any of the borders as woven. And no tapestry in the series shows animals sitting illusionistically on the frame or has quite the same elements in the top border. We can only judge this drawing a preliminary *modello* and, as such, done in late 1545 or early 1546. In this case it can scarcely have been left to a subordinate.

We recognize Bronzino's images in the masks. The female mask at upper left is like those in the Chapel of Eleonora,[123] the mask in the center at the bottom reminiscent of the carved one on the table in Bronzino's *Portrait of a Young Man* at the Metropolitan Museum (*Fig. 3*).[124] The horns and rams' heads recall those of the altar in the *Pygmalion and Galatea*.[125] Even the firm interlacing design is like the carving of the table in the *Portrait of Ugolino Martelli*.[126] We know Bronzino's predilection for comparably atmospheric, almost liquid shadows in the Frankfort *modello*'s armorial cartouche and supporting ribs with fruits and leaves (*Fig. 10*). In the handling there are similarities to these Frankfort fruits and leaves, to the Frankfort *putti* (*Fig. 12*) and Frankfort *Saint John* (*Fig. 13*), also to the Uffizi *Joseph in Prison* (*Fig. 16*). Yet the style remains a surprise. Partly this may be due to a vegetal richness which Salviati's presence could have promoted.[127] Partly it is the whimsy of the monkey and bird. One thinks of Bronzino as too serious for this. Also, it is the tight, detailed richness, rather like Ligozzi a generation later.[128] (Is Ligozzi in debt directly to this kind of Bronzino drawing, so far unknown in other examples, or only to Allori?) It may be that we shall only slowly become accustomed to the indications of this drawing concerning Bronzino's range as a draughtsman. But it is clearly necessary to have it in mind as the recovery of his drawings continues, to be aware, for instance, of the palpability and vividness with which the ram's head is realized in the top border, the sureness and vigor in the handling of white, and the fancy evinced by the imagery, including the oddly caricatured *putti*.

A *modello* rather similar to that for the tapestry of *Joseph in Prison* (*Fig. 15*) must have existed for a *portiera* showing *Primavera* (*Fig. 21*), which, though much simpler than the *Joseph in Prison*, is somewhat similar in design. This *portiera* is to be identified, according to the evidence given in Appendix II, with Bronzino's very first tapestry of all, delivered 8 December 1545, a work that the document recording

it suggests was a kind of trial piece and with which "the master" was reported dissatisfied.[129] If this identification and our date for the *Joseph in Prison* are correct, they were designed at dates not far apart. They have more in common with each other than either has with other Bronzino tapestries, in particular perspectively constructed space—a definable area—inhabited by relatively upright, quiet figures. The *portiera* also shows an obvious Flemish ingredient, the garden vista in deep perspective, found in Brussels tapestries.[130] We can guess that the *modello* for this *portiera* must have put still more stress on the sense of luminous space.[131]

The *modelli* for these two earliest tapestries were probably always different from those that immediately followed. If the chronology given in the appendices is right, Bronzino quickly turned away from the style of the first two tapestries to a more up-to-date Italian one, quite different in organizing principle. On 15 May 1546, only five months after the first *Primavera*, a second *portiera* of *Primavera* on Bronzino's design was delivered, the familiar version (*Fig. 22b*).[132] It represents an abrupt change to a complex, animated design of figures with the stress on diagonals and movement across the surface—an effort, the inference is, to improve upon the first attempt, to make the subject of more complex interest, as Panofsky's description shows it is,[133] and to couch this subject in the contemporary Italian idiom of *maniera*. The delivery on 26 April 1546 of another *portiera*, the famous *Vindication of Innocence* (*Fig. 22a*), marks the same departure in a slightly different mode.[134] A like change of style is represented in the Joseph series by the *Taking and Selling of Joseph* (*Fig. 23*), which is probably the second Joseph tapestry Bronzino designed, as argued in Appendix III.[135] Here, too, the difference in manner accompanies a new complexity of subject. Whereas the first Joseph tapestry illustrated two episodes, the *Taking and Selling of Joseph* is crammed with a succession of them, starting at the upper left with Joseph approaching his brothers as they conspire against him and ending at lower right with his being led away toward Egypt. Bronzino strives for the curious and bizarre in the complexity of both subject and composition—and for the bizarre in color as well, the legs of the rider at left, for instance, changing from pink to grey, his torso from brown-grey to red.

In drawings the new direction is represented by the *modello* of the *Vindication of Innocence*, which Heikamp has identified in the Resta

26

Codex at the Ambrosiana (*Fig. 20*).[136] Looseness and spaciousness have been exchanged for surface density, and in the execution detail, which in the *modello* for *Joseph in Prison* (*Fig. 16*) attracts and slows the eye, is immersed in a new uniformity. On one side this drawing connects with the *Saint Jerome* and *Saint John the Evangelist* of the Frankfort *modello* (*Figs. 12* and *13*)—even to the animals or details of handling like the hatching, the highlighted, narrow ridges of the folds, the tactile volumes—and on the other it connects with the *modello* for *Joseph in Prison* (*Fig. 16*), most pointedly in figure types, in faces, limbs, and attitudes. But now the rendering, favoring qualities associated with sculpture, smoothes and polishes and is less personal. It subsumes the bizarre assembled oddities and the calculated eccentricities of form.[137] Panofsky's analysis shows the complication of the iconographic invention.[138] The complication, matched by the adjustment of figures and attributes on the available surface, has to be searched out visually in this rendering as well as intellectually. The less intent eye, however, glides over the intricacies with satisfaction in the qualities of line and volume and in the luminousness of surfaces, as in the nude figure of Truth and the glistening blade of Justice. What we have in the Ambrosiana *modello* is one of Bronzino's versions of mid-cinquecento *maniera* draughtsmanship in its pure form, the special purposes and conventions of which are connected in general with a concern for the sculptural in painting, on the example ultimately of antique relief.[139]

The fact that Bronzino chose this manner for a tapestry drawing in late 1545 or early 1546 does not mean he remained faithful to it in *modelli* thereafter, any more than his tapestries continued in the same vein. After the *Taking and Selling of Joseph* (*Fig. 23*) Bronzino sought a new clarity of design, and he never again showed successive incidents.[140] *Joseph Selling Grain to his Brothers* (*Fig. 24*), delivered on 16 August 1547, is relatively straightforward and readable, its coloring spare, its figures more richly modeled, more flexible, and more flowingly related—in short more reminiscent of the classic in a High Renaissance sense as we know it in Raphael's tapestries. Still more classic is the *Joseph Seizing Simeon* (*Fig. 26*). Like the other three, this is one of the four Joseph tapestries by Bronzino that were delivered before 15 July 1549; and, according to calculations from the evidence as given in Appendix III, it was the last of the four, finished some time during

27

the ten months between 1 October 1548 and 15 July 1549. It aspires again to clarity of action, fluency of movement, pictorial richness, and luminosity. It is still freer from *maniera* convention and more monumental—a surprising, beautifully realized contribution to the series.

One of the drawings Geisenheimer connected with Bronzino's Joseph tapestries is a sketch at the Uffizi showing the composition of *Joseph Seizing Simeon* (*Fig. 25*), done in pen and wash, squared, and in reverse. Geisenheimer classified it as a copy after Bronzino by Allori.[141] But it gives the signs of being a study for the composition. There are differences from the tapestry in the number and arrangement of figures opposite Joseph, in Joseph's costume, in the gesture of his raised hand, and in the background. The rendering is sketchy, also incomplete in several parts. All this suggests its acceptance as an original study by Bronzino. On the other hand, much here is most unlike him: the suppression of emphasis on contour lines, the shading in spots and blotches, the sudden, emphatic areas of dark that border and silhouette a figure like Simeon's in the foreground, the restless fabric that the treatment of shadows produces over-all, a dryness in the underdrawing, and the awkward miscalculation that makes the legs of Simeon too short. It cannot be Bronzino's, but whoever did it was certainly in on a preliminary stage of the design. This unusual circumstance points to Bronzino's chief helper with the Joseph tapestries, Raffaellino dal Colle. The style does not contradict this. It is worth considering Raffaellino, because any drawing connected with a Bronzino tapestry delivered after Raffaellino's arrival in Bronzino's studio—or even connected with a painting done during his stay—could conceivably be a candidate for consideration as his, and yet very little appears to be known about him as a draughtsman.

* *

*

In a letter of 30 April 1548 Bronzino wrote Duke Cosimo that he had invited Raffaellino dal Colle to come to Florence and help him with the tapestries, so that he could supply the weavers with cartoons

more quickly. He mentioned having worked with Colle at Pesaro and recommended him as a "huomo da bene et valentissimo."[142] What do we know of Raffaellino's style? Many paintings now attributed to him are provincial and poor and do not fit the picture of him we get from his history. If one tries to discover what works are satisfactorily enough documented to serve as reliable guides to him, one finds rather few, and their documentation is not easy to come by. Of the more solidly documented the *Resurrection* in the Cathedral at Borgo San Sepolcro (*Fig. 28*), the *Deposition* in the gallery at Città di Castello, and the *Assumption*, also there,[143] agree in showing a competent and knowledgeable painter—although the first and last of these three are more than thirty years apart and differ much in manner.[144]

Raffaellino joined Bronzino 15 May 1548,[145] early enough to have been present when *Joseph Seizing Simeon* was most likely designed, as indicated in Appendix III. In this case it was the first tapestry he would have been on hand to help with. His experience by now was long and varied, going back to his membership in the Raphael School in Rome,[146] to his association with Rosso during the last period of Rosso's activity in Italy,[147] and most recently to his service under Vasari in 1545 at Naples and in 1546 at Rome in the Cancelleria, where he helped with the decoration of one hundred days.[148] Between his stints assisting others he had been an independent artist in the regions of Borgo and Urbino. He had also been the teacher of Vasari's favorite assistant Gherardi.[149] That Vasari valued his ability is indicated by a letter Vasari wrote him in 1536, when, worried about his share of the decorations for Charles V's entry into Florence, he asked Raffaellino's help in words full of confidence that he could turn the trick.[150] The question has hardly been asked as to the effect on Bronzino of his new association with a veteran of the history of painting from classic to "anticlassic" to the latest form of *maniera*. In the present context, however, it is first the more limited question of Raffaellino's style in drawing that concerns us.

In the Louvre there is a drawing of the *Resurrection* under the name of Giulio Romano (*Fig. 27*) which is connected strongly enough with Raffaellino dal Colle's painting to stand up well as a candidate for attribution to his hand.[151] The Christ of this drawing is practically identical in pose, costume, and treatment with the Christ of Raffaellino's *Resurrection* in the Cathedral of Borgo San Sepolcro (*Fig. 28*).[152]

There is another painting of the *Resurrection* at Borgo in the Church of San Rocco, less familiar but long known as by Raffaellino (*Fig. 29*).[153] It is a version of the Cathedral *Resurrection* and has the same Christ, but the soldiers are different; and it is coarser in execution, as if an assistant had had a considerable share. The drawing in the Louvre shows the San Rocco composition, with certain specific variations. Drawing and painting agree almost exactly in four figures besides that of Christ, the kneeling and seated soldiers at left and right, one of whom in the painting, however, has been made young and beardless. The drawing varies from the San Rocco *Resurrection* in the standing figures and in the setting. In all likelihood it preserves an earlier plan for the picture and is a preliminary study for it.

The drawing in the Louvre belongs, however, with the Cathedral version (*Fig. 28*) in respect to quality. They share a similar, distinctive feeling for the tactile substance and the lighted surfaces of forms, similar facial expressions, and the same idiosyncracies: the ways lips curve, protrude, and are sharply defined by shadow and a border of light; the high cheek bones; the pointed noses (with tips accented by light and sometimes by a slight bulbousness); the tendency to shortness of proportion in the upper arm; Christ's solid lower leg and knee; the way his torso seems explicitly made of ribs and flesh, though shaded rather schematically. Both the Cathedral *Resurrection* and the drawing present a vein of the Raphael School close to Giulio, untouched by Rosso, whom Raffaellino was associated with in the late 1520's, or by the stylization of Raffaellino's later years. The Cathedral *Resurrection* is in all likelihood the *Resurrection* by Raffaellino that Vasari cited in writing of him and placed in the mid 1520's.[154] The San Rocco *Resurrection* (*Fig. 29*), on the other hand, recalls Rosso a little in one figure, the upper figure at left substituted for the corresponding figure in the drawing at the Louvre. Hence this second picture is likely to have been executed after Rosso's arrival in Borgo around the beginning of 1528. The drawing, not having the Rosso-like figure, should perhaps be slightly earlier.[155]

The study in the Uffizi for *Joseph Seizing Simeon* (*Fig. 25*) has peculiarities in common with the drawing of the *Resurrection* (*Fig. 27*), even though it was done twenty years later and the draughtsman's aim was to work with the elements of Bronzino's style. The peculiarities show clearly in the hands. The hand of the soldier who leads Simeon

away at left, with its oddly floating thumb, recalls the awkwardness of the soldier's hand at upper left in the Louvre *Resurrection* (*Fig. 27*). It was entirely changed by the time it reached the tapestry (*Fig. 26*). The raised hand of Joseph with palm outward represents a gesture favored in the Louvre *Resurrection*. This, too, was abandoned entirely in the tapestry. The head of Joseph with its prominent forelock, high cheekbones, and emphatic downward curving mouth belongs with the heads of the Louvre drawing, though it is meant to follow the type Bronzino had already used for Joseph in *Joseph Selling Grain to his Brothers* (*Fig. 24*). There is also a kinship in the handling of wash. Underlying the modeling of torsos, arms, and legs in the *Resurrection* (*Fig. 27*) wash appears to have been applied in a similarly spotty, sometimes schematic way. And in the *Resurrection* occur similar dark areas that silhouette parts of the figures: the large stain behind the arms of the soldiers at right, the smaller ones on the steps below the seated soldier there and around the figures on the left, not to mention the black depth of the tomb setting off Christ's figure the way the darkness of the building in the Uffizi study sets off the figures there—something abandoned in Bronzino's final version (*Fig. 26*).

If the attribution of the drawing for the tapestry to Raffaellino dal Colle is correct, then he took part in the preparations before the process of designing the composition was complete. Hence the possibility arises that he may have contributed to the end result. The fierce Giulio-like face of the helmeted soldier at lower right in the tapestry (*Fig. 26*) suggests this. We can also imagine Raffaellino dal Colle contributing something to the sturdy strength of Simeon's leg and knee and even the idea—though not the final design—for the shape of the splayed hands silhouetted against Joseph, in view of the gestures Colle prefers in the Louvre drawing (*Fig. 27*). But could he have contributed more than such details? A look at Bronzino's fresco of the *Brazen Serpent*,[156] painted years before Colle's appearance, proves Bronzino's own responsibility for the basic vocabulary, design, and richness. The monumentality, fluency, and pictorial qualities of the tapestry have parallels in Salviati's one contribution to the series, delivered earlier, on 16 May 1548.[157] But since Bronzino's *Joseph Selling Grain* (*Fig. 24*) was delivered still earlier, on 16 August 1547, it is not easy to say whether Salviati or Bronzino influenced the other more, or for that matter, to eliminate the possibility that the move to

31

a more pictorial and legible style for the Joseph series might have been by a shared decision. Meanwhile, just conceivably some experience of Raffaellino with tapestry in the Raphael circle may have suggested something of the monumentality and clarity of statement that the *Joseph Seizing Simeon* introduces within this new mode.

<p style="text-align:center">* *
*</p>

What Bronzino's own drawing could be like for tapestries produced after Colle's arrival is shown by a study in dark ink and brown to grey wash on darkish buff paper in the Uffizi (*Fig. 31* and *32*). It is for Bronzino's signed *Benjamin Received by Joseph* (*Fig. 30*) at the Palazzo Vecchio, delivered some time between August 1549 and September 1553, probably earlier rather than later within this span.[158] Although Geisenheimer pointed out the connection, he considered the drawing a copy and noted the attribution to Allori at the Uffizi. McComb, the only student of Bronzino to pay it heed, considered it a copy by Allori after the tapestry. In 1955 I gave it to Bronzino. In 1969 Heikamp classified it as from Bronzino's workshop.[159] It differs slightly in details from the tapestry[160] and is in reverse direction. Most important, it shows significant *pentimenti* having to do with the composition. Originally, in the underdrawing visible in the photograph, the right arm of Benjamin was at a different angle—bent lower and ending with its hand where the head of the basket-carrier now is. Benjamin's left leg was at another angle, his knee in a different position on the platform, his drapery flowing out behind. Joseph's head was farther to the right. The extended arm of the brother closest to Benjamin was in a lower position, and just below it, lightly drawn lines tested some quite different arrangement of forms in this area. The gesture of this same man's left hand was outward, toward Benjamin, instead of toward himself. The action of the man at lower left was certainly different, for his right arm was bent at a sharper angle and in no position to reach up and hold the vase, as in the finished drawing. Meanwhile, lines between this figure and the one kneeling at right indicate that at first they were to have been somewhat closer together.

The decisions represented by such changes are the kind expected of the artist responsible, not an assistant. And significantly all were kept in the completed tapestry except two: Joseph's head was returned to where the drawing originally had it, so as not to eliminate the hand of the servant on the stair, and the figures kneeling at bottom were brought closer together, in the way the lines between them in the drawing had suggested at first. The drawing can be classified as a *modello*, but as in the case of the one in Frankfort compositional changes were carried out as it was drawn. The only difference in procedure here is that we are closer to the final design.

The marks of Bronzino's authorship seem clear. The idiom on this occasion harks back to that of the Budapest *Nativity*[161]—only, at perhaps ten or more years remove, the figures in the *modello* are more massive and Roman and their arrangement much more compressed. But the similarities are many and striking, whether one concentrates on the way figures are composed, or on the handling, say, of light and shade, or on details—hands, feet, faces, hair, drapery folds. To compare drawings, the purity of contour and continuity of volume that we know in the *Red Sea* nude (*Fig. 5*) are still found here in the leg and arms of Benjamin. Simultaneously the fluctuating patches of light and shade in that earlier figure's shoulders and back are continued with new emphasis in the kneeling figure at left. The way the chest of the kneeling figure at right is treated—"painted" would be a better word—is consistent with the treatment of the chest of the Frankfort *Saint John* (*Fig. 13*). The animation of the design is anticipated in the Frankfort *Saint Michael* (*Fig. 11*), its painterliness in the *Stigmatization* (*Fig. 10*). Only now in contrast we are in the presence of more monumental figures belonging fully to the cinquecento, as we are consistently when it comes to the figures that people Bronzino's tapestries.[162]

How does it happen that Bronzino's *modello* is practically a painting in *grisaille*? There is a tradition for this in the mainstream of Florentine draughtsmanship, exemplified, on the Pontormo side of Bronzino's artistic lineage, by Andrea del Sarto's *modelli*[163] and traceable back from Sarto, Shearman points out,[164] to Raffaellino del Garbo and Filippino Lippi (and probably also Botticelli[165]) on the other direct line of Bronzino's ancestry. Sarto also stands as a precedent for Bronzino's *modello* in the treatment of the form, light and atmosphere,

33

brush stroke and *impasto*—as exemplified at full scale in Sarto's monochrome fresco of the *Baptism of the People*,[166] which is, one may say, a *modello* enlarged, available always in the Scalzo for Bronzino to study. In the present drawing Bronzino appears as heir to this brand of draughtsmanship, to its command of anatomical structure and its bold pictorial technique[167] (a technique that in Sarto's picture may owe some of its pictorialism to Venetian draughtsmanship[168]). That Bronzino held to such pre-*maniera* practice even while to some extent applying *maniera* principles in figure and composition is characteristic. He was a draughtsman who kept his roots firmly in the craft of Florentine drawing as he inherited it. In mid-cinquecento Florence he remained a faithful representative of its traditions over much of their wide range.

A part of the decoration that Bronzino executed at Pesaro in 1530/32 tells us that he must have drawn in the same medium in much the same way at that time. The male allegorical figure symbolizing Peace and Plenty in the Sala Grande of the Villa Imperiale[169] looks like a figure for this tapestry *modello* enlarged, except that almost twenty years intervene between them, and so it is not quite up to date. (In the comparison one sees, though, how striking the Pesaro figure was for its time.) That Bronzino chose this technique from his repertory for a tapestry *modello* may again have been from a wish to match drawings by Flemish designers, which can be remarkably painterly.[170] At the same time he could have been thinking of painterly developments in Venetian drawings of his own day, by Lotto for instance.[171] Yet all the while he remained faithful to a sculptural ideal for figures with emphatic anatomy, clean contours, and finished volumes in the tradition established so strongly by Michelangelo's painting, and he shared an unmistakably common ground with other middle Italians toward mid-century, such as a Jacopino del Conte[172] or a Daniele da Volterra.

We have the chance in this drawing to see Bronzino performing at the height of his activity as decorator. The display of mastery and invention were on his mind—in poses, composition, and embellishment. But uppermost were the two purposes of decoration and narrative. He was concerned with the ornamental play of the figures, and also of textures and lights and shadows, within the narrow area of the format, repeating, differing, progressing, balancing in shallow planes

of varying inclination against the stabilizing verticals and horizontals of the column, the platform, and the frame—like a Tuscan version of Venetian composition. Between drawing and tapestry, color would diminish further the separateness of forms and make a richer fabric—it is a pity we do not have even one cartoon. Simultaneously he was concerned with the story. The focus is on the greeting of Joseph and Benjamin. Pose and gesture convey its tenderness, supported by relatively more grace in form and rhythm than elsewhere in the composition. Setting off their greeting are the extravagant reactions and motions of the brothers. And by way of contrast is the domestic scene, comparatively quiet, on the stairs above.

A superbly executed drawing by Bronzino for the Joseph tapestries came to light in 1961 (*Fig. 33*), when it was purchased and published by the Ashmolean Museum as Bronzino's study for *Joseph Recounting his Dream of the Sun, Moon, and Eleven Stars* (*Fig. 35*). Andrews and Heikamp have since cited and reproduced it.[173] An entry in the records of the ducal *guardaroba* shows that the tapestry was delivered by the weaver in the few days between the inventory of 15 July 1549 and 3 August and names Bronzino specifically as the author.[174] It seems safe to assume the drawing was done in 1548 because it is so close to the final design. The differences from the tapestry are confined chiefly to the figure on the right margin, who in the drawing shows his other hand and no knee, and to the profile of the ground at the bottom edge. There are only slight *pentimenti* (in the forefinger of Joseph and that of the man in profile, speaking, near the left edge, and in the light alternative contours of the figure at top, pointing upward).

The drawing is in black chalk, yet to an extent it is similar to the *modello* for *Benjamin Received by Joseph* (*Figs. 31* and *32*) despite this difference in medium. Bronzino has succeeded in exacting from black chalk a comparable pictorial quality. To be sure, he has sought a greater degree of finality and high finish, permitted by the advanced stage of his design, whereas in the *Benjamin*, still working on the composition, he exploited like a Venetian the rougher, more dynamic paint-like possibilities of wash and white heightening. The finish of the Ashmolean drawing, with its delicate fused modeling, may recall Michelangelo's presentation drawings, but the degree of deliberate and minute precision is greater. The standard of discipline in execution

35

exemplified by the *Red Sea* nude (*Fig. 5*) has been heightened and applied to the whole. On the other hand, classic grace of a kind represented by the *Idolino* has been adulterated—whence comes some of the drawing's special impact. The incorporation of ungraceful aspects of human form and character in a context so uniformly and perfectly refined startles and holds the attention.

Bronzino aims to represent the hate and the evil reactions of Joseph's brothers, as well as his devoted father's wonder and rebuke, on the occasion when Joseph recounted to them his dream of how the sun, moon, and eleven stars made obeisance to him, signifying that his father, mother, and eleven brothers would one day bow down before him. At lower left Bronzino contrasts side by side the wonder written on Jacob's face with the expression of intense, angry distaste on the face of an elder brother. Behind them is a low-voiced exchange, a premonition of the plotting to come (Bronzino is pleased with an upturned head like the one here and in Figure 32). At top is more discussion, between two brothers characterized as young bravos in ancient dress, while an elder brother muses disagreeably as he listens to their words, and gestures to make a point of his own. At right are petulant dislike in the figure above, abstracted malevolent thought in the head just below, and at the botton corner oblivious faithfulness in the sleeping dog.

It is story-telling, and it is vivid. At least in theory Leonardo would have approved Bronzino's differentiations, the variety of responses among the listeners, as well as the close observation of life and the extraordinary mastery of hand on which his differentiations depend, the edge of caricature in their realization, even the devotion to detail, for which Leonardo himself was prized in the sixteenth century.[175] It is not too much to surmise that despite his mid-cinquecento style Bronzino saw himself as continuing here the tradition of Leonardo, just as in making the marble-like nudes he surely saw himself as continuing the tradition of Michelangelo—even though the nudes of the drawing are done in artful new terms that invite comparison at the same time with contemporary Florentine sculpture, Cellini's or Pierino da Vinci's.

The drawing reminds us again that Bronzino was also still faithful to another Florentine tradition, scrupulous and deliberate care in the preparations for a work of art. It suggests that studies made prior to

36

this drawing were rather numerous and detailed, and it shows little or no concession to the new ideal of speed, for which Vasari praised painters in the third quarter of the century in contrast to the slowness of their masters.[176] In this respect as in others Bronzino was firmly rooted in the Florentine past, a representative of its soberest traditions of craft.[177]

What purpose was the Ashmolean drawing to serve? Possibly several simultaneously: for Bronzino's own benefit before committing the design to the full-scale cartoon, but also probably as a *modello* for Duke Cosimo's approval of the design and ultimately even for presentation to the duke or to someone else—provided this was originally a complete drawing, as the tab at the top suggests it was. Indeed, of the two drawings in the Uffizi alluded to earlier[178] which Geisenheimer connected with the tapestry of the *Sun, Moon, and Eleven Stars*, one (*Fig. 34*) gives considerable evidence of having originally been the top of the drawing in the Ashmolean. It takes up the composition of the tapestry (*Fig. 35*) where the Oxford drawing leaves off, the moon being shared between them. At the same time the measurements of the drawings and their elements appear to coincide and the tab at the top of the Ashmolean sheet to fit satisfactorily into the loss at the bottom of the drawing in the Uffizi (although the right part of the loss is not present in the drawing at Oxford).[179]

The sheet in the Uffizi shows the sun, symbolized by Apollo, and the moon, symbolized by Diana, doing obeisance to Joseph in his dream, as seen in the upper part of the tapestry (*Figs. 34* and *35*).[180] The drawing differs from the tapestry in showing the sign of Scorpio with Diana (associated in mythology) and what could be the head of Leo behind Apollo. Berenson thought it "very pretty and feeble," in keeping with his opinion of Bronzino's draughtsmanship. There is certainly a difference from the Ashmolean fragment, but there is a reason: to convey the tenuous lightness of the heavenly bodies in the vision of Joseph's dream as it was to be executed in the pastel-like changing colors of the tapestry itself in sharp contrast to the forceful volumes of the "real" figures below (*Fig. 35*). Indeed, the drawing in the Uffizi shows a further distinction within the dream scene itself—to be made still more distinct in the tapestry—between Joseph and the two celestial bodies. The Joseph of the drawing, however dainty, is lithe, fresh, springy, moving swiftly (so the legs suggest), the outline

varied. In contrast, the figure of Apollo is abstract in contour, more evenly outlined and lighted—in effect, a more purely *maniera* figure.[181] Once more we are given a lesson in the variety of Bronzino's draughtsmanship. But the marks of his own hand are clear: above all the containment, the purity and reserve of line, of shading, and of volume. Compared to Colle, of course, it is another world.

In some respects, although to a very different expressive purpose, the handling of the Uffizi's drawing is akin to that of finished drawings by Pontormo for the frescoes at San Lorenzo dating between 1546 and 1550/51, roughly the same time.[182] Also, it has enough ties to draughtsmanship of the past so that comparison again with some drawings of Leonardo would not be wholly far-fetched.[183] But the effect Bronzino wanted to achieve with the means he commanded is instead neo-classic, in accord with a growing taste in Florence and Rome at mid-century to which Bronzino was one of the contributors.

The second drawing in the Uffizi connected with the tapestry of *Joseph Recounting his Dream of the Sun, Moon, and Stars* is a well known one in black chalk representing the eleven stars, shown as *putti*.[184] Since it gives most of the remainder of the composition to the left of the sun and the moon, it is natural to ask if it belonged to the same sheet as the previous drawing. This is difficult to determine on physical grounds. Unlike the drawing with the sun and moon, the one with the stars is mounted on a supporting sheet, hindering examination of the paper against the light; and, while they appear to be alike in scale, the two Uffizi drawings cannot be matched at the edges where they would have met, since a narrow zone of the composition is missing between them.[185] On the other hand, the drawing of the stars represents a stage of the design prior to the final one and comparable to the stage represented by the fragment in the Ashmolean. In contrast to the tapestry, it shows a molding at the bottom, and the lowest *putti* have their feet on either side of it. This molding is also seen at upper left on the Ashmolean's sheet (*Fig. 33*). It would have been represented in the tapestry just above the doorway that the tapestry was made to fit. At the same time the composition of the *putti* is exactly as we see it in the final design, just as is the composition of the figures in the Ashmolean's drawing, except for minor differences noted earlier.

But next to the drawing of the sun and moon (*Fig. 34*) the drawing of the stars shows differences from it that raise doubts: less care with

details like toes, less perfect finish in faces, a slight scratchiness and less strength in contours, by comparison a slightly trivial effect. The differences from the drawing in the Ashmolean are similar and would probably appear more pronounced in such a side-by-side comparison. Is the drawing of the stars possibly another study by Bronzino for the tapestry, perhaps also a fragment of one showing the whole composition? Heikamp classified it as from Bronzino's workshop.[186] Can it be denied to Bronzino altogether? The handling of some details—the hands of the *putti*, for instance—appears fresh; volumes like the shadowed torsos at the top of the sheet and in the middle are drawn convincingly; and the treatment throughout looks true to Bronzino's forms. Yet there seems a chance that the Uffizi's drawing of the stars could be a very faithful copy from a missing drawing of Bronzino once part of the Ashmolean sheet—just enough chance to exclude it for the present from certification as one of the drawings we should rely on first for knowledge of Bronzino's hand.[187]

In the collection at Christ Church, Oxford, James Byam Shaw has identified a much damaged drawing in black chalk (*Fig. 37*) as a study by Bronzino for his signed tapestry of *Joseph Fleeing Potiphar's Wife* (*Fig. 36*),[188] delivered like the tapestry of *Joseph Recounting his Dream of the Sun, Moon, and Stars* (*Fig. 35*) between 15 July and 3 August 1549.[189] The two tapestries are notably different in mode, even though they must both have been begun about the same date and in both cases seem to have been designed with compositions of Raphael's *logge* in mind. *Joseph Fleeing Potiphar's Wife* is not only richer in ornament, but much more imbued with the conventions of *maniera*. Among tapestries, it somewhat parallels in the first respect Salviati's one contribution to the Joseph series and in the second the same artist's design for a tapestry of *September*.[190] But the new heaviness and hardness of the figures and their exaggerated movement could very well have been prompted by the presence of Raffaellino dal Colle, whose probable influence in just these respects we shall shortly consider in Bronzino's *Resurrection* at SS. Annunziata (*Fig. 39*) and in the drawing for it (*Fig. 38*).

The drawing for *Joseph Fleeing Potiphar's Wife* (*Fig. 37*) shows almost as great a difference in mode from the Ashmolean Museum's drawing for *Joseph Recounting his Dream* (*Fig. 33*) as that between the two tapestries. It recalls instead the mode Bronzino used for figures

39

in the foreground of the *modello* for *Joseph in Prison and Pharoah's Banquet* (*Fig. 16*), despite its difference in medium and the change in the types of face and figure. This change in types seems likely to be chiefly a reflection of the presence of Raffaellino, as the Giulio Romano-like conception of Potiphar's wife suggests.[191] But the drawing does not yet show the heavy volumes and forceful chiaroscuro of the final version of the figures in the tapestry, which Raffaellino could himself have had a hand in achieving when helping with the cartoon. Instead, the drawing at Christ Church is like a delicate diagram of the final figure composition, stylized, precise, extremely refined, and with a minimum of shading, omitting the ornament that the walls, pavement, and bed were to provide. Neither complete *modello* nor representative of quite the ultimate effect of the design, it must come, nevertheless, from late in the preparations leading to the tapestry cartoon. Much in evidence are the figural conventions of *maniera*; and the way Bronzino used them in arranging his figures and describing their relation to each other is an instance of his capacity to realize, with the vocabulary of *maniera*, an eccentric expressiveness that still seems fresh and original.

More than is true of any other drawing we have seen, the technique reminds of Pontormo's in drawings for San Lorenzo of roughly the same period, however different the forms. When it comes to the problem of distinguishing the hands of Bronzino and Pontormo around 1550, the drawing at Christ Church will surely need to be consulted.

There should be mentioned finally a drawing in black chalk, wash, and white heightening showing the composition of the signed tapestry of Bronzino at the Quirinal Palace representing *Jacob Arriving in Egypt*, a drawing that Geisenheimer called attention to in the print room at Berlin and gave to Allori.[192] Now in the Bode Museum, it has recently been published as Bronzino's by Heikamp.[193] Yet it does not seem to me that Bronzino can be responsible for it. To judge only from a photograph, there appear to be two hands. The one that executed almost all of the drawing is stilted and empty compared to Bronzino's and looks rather like Raffaellino dal Colle's. This should not be surprising, for the tapestry was delivered to the ducal *guardaroba* in 1553, evidently one of the very last tapestries of the series to arrive from the weavers.[194] Also, while no doubt basically Bronzino's in design, the tapestry shows elements that recall paintings by Raffaellino and suggest that he had still more effect on the final result than in

tapestries seen so far.[195] Another hand, working with more subtlety and richness, appears to have intervened in figures at the upper left of the drawing. Drawings of Bronzino known to me do not offer convincing evidence that this hand is his, and the young Allori—as old as sixteen or seventeen when the drawing could have been made—does seem a candidate. These doubts about the Berlin sheet argue against its inclusion in the restricted group of drawings here.[196]

* *
*

The *cartonetto* at the Uffizi in brush, wash, and white heightening over black chalk (*Fig. 38*) representing the composition of Bronzino's signed and dated *Resurrection* at SS. Annunziata (*Fig. 39*) again appears to show two hands, but in this case there is reason to believe that Bronzino's is one of them.[197] The altarpiece was commissioned in April 1549 and finished in 1552, when it was signed and dated.[198] Differences in detail from the painting indicate the drawing is preliminary to it but close to the final cartoon. While mostly confined to garments and accessories, the differences include a figure (an angel?) visible in outline in the photograph just to the right of Christ's legs that was not worked up in the drawing (where it is all but invisible) or used in the painting; the shouting head at far right, replaced in the painting by a different head and an arm; two heads at far left, one eliminated in the picture, the other changed; and the hiding of the leg of the soldier fleeing to the left as well as the second foot of the angel next to him, both shown in the finished work.

It is a puzzling drawing. Comparison with the *modello* for *Joseph Receiving Benjamin* (*Fig. 31*) and with the tapestry drawing at Christ Church (*Fig. 37*) gives assurances that Bronzino's hand should be largely responsible for the main lines and forms. They were laid in with strength and grace. But the finish is impersonal and dry, robbing the forms of their purity and spoiling the light. This led me to suggest that an assistant went over the drawing, and Anna Forlani Tempesti has agreed that this is probable.[199] Also, something in the realization of the white heightening, for example in the hair, something in the

presence and in the shaping of the raised and open hands can make one think of the drawing of the *Resurrection* by Raffaellino dal Colle in the Louvre (*Fig. 27*). There is no reason to suppose that as Bronzino's assistant for the tapestries Raffaellino could not have helped with the *Resurrection*, commissioned less than a year after his arrival. Indeed, there is a certain kinship between Bronzino's painted *Resurrection* in SS. Annunziata (*Fig. 39*) and Raffaellino's Resurrections in Borgo San Sepolcro (*Figs. 28* and *29*) that suggests his help with this commission.

Modern observers see Bronzino's painting of the *Resurrection* as a prime instance of cold academic spirit in Florentine art at mid-century. What is surprising, however, is the contrast it makes in this respect to Bronzino's tapestries of the late 1540's, to the *Joseph Seizing Simeon* (*Fig. 26*), for instance, which we have found reason to believe was designed less than a year earlier than the commission for the *Resurrection*. It is not likely nowadays that the *Simeon* would be charged with being a cold, contrived display of poses and composition, of forced expressions and finished details, without feeling for the humanity represented or the theme, as the *Resurrection* can be charged. Even though practically the same figure with muscled back and raised hands appears in both, the effect of the two works is very different.

In a typical product of Raffaellino dal Colle from the years immediately following the death of Raphael "the exaggerated movements, the sweeping gestures and draperies, the ponderous bodies, and hard plasticity of the forms do not, to say the least, seem particularly appropriate to the theme, or meant to direct the mind towards the meaning of the Gospel words"—to use Wilde's lines concerning Raffaellino.[200] His *Resurrection* at the Cathedral in Borgo (*Fig. 28*), old fashioned though its vocabulary of more than twenty years before may be, anticipates Bronzino's *Resurrection* at SS. Annunziata in spirit, in the kind of action and expression, as well as in the lighting, the idea of the night scene, and the smooth, cold handling.[201] Notable in Bronzino's picture is the great dependence in gesture on raised, open hands with splayed fingers, oddly like badges of Colle's influence. And it does appear likely to have been his influence that tipped the balance in Bronzino's *Resurrection* toward "academic mannerism." If so, this is not Florentine academicism so much as an outside contribution from the old Raphael School.

42

It is strange if Bronzino let his art be affected by Raffaellino's presence in this way, even though, having worked in the Raphael School, perhaps originally under Raphael himself, Raffaellino may have seemed to represent its authority, however moderate his talent. Critics have seen evidence in Bronzino's *Resurrection* of intrusions from other sources, too: a new awareness of recent Roman developments as represented by Daniele da Volterra,[202] a new nearness to Vasari's idiom.[203] A trip to Rome might have led to the first; Colle's very recent experience assisting Vasari could have promoted the second. But Vasari's work in Florence had long been familiar to Bronzino. Could it be that in embarking on the *Resurrection* Bronzino somewhat lost confidence in himself? True, sharp changes of mode were nothing new in his work. In 1551, however, Borghini wrote to Giovio that rumor had it Bronzino began retouching and changing his pictures as soon as Vasari's altarpiece of 1550 was unveiled in Florence.[204] The very existence of the rumor could be symptomatic. Bronzino had seen new currents gain strength in Florence and Rome. Salviati's latest altarpiece, the *Deposition* in Sta. Croce,[205] was before his eyes as well as Vasari's. As for Vasari, he had clearly arrived. In only a few years he would take Bronzino's place as the chief court painter in Florence. There might well have been uncertainty now on Bronzino's part, opening him to the latest trends and to more influence from Raffaellino than one would have expected.

The circumstances suggest that the Uffizi *cartonetto* for the *Resurrection* could have been worked on by Raffaellino dal Colle. The academic impersonality that weighs heavily upon it might then be due to his having taken part in finishing this drawing as well as to the effect of his presence on the conception of the work as a whole.

<p style="text-align:center">* *
*</p>

A drawing of the figure reclining at lower left in Bronzino's *Resurrection* was found by Sydney Freedberg several years ago in the Isabella Stewart Gardner Museum in Boston and has been published as Bronzino's in the catalogue of the museum's drawings.[206] It shows

the figure nude and beardless, as in a study from life. But it is not put forward among the drawings in this essay because Bronzino's hand does not seem to me to be apparent in it. The impression I have is of an admirable copy after a Bronzino drawing, scratchy and loose in some of its fabric by comparison with Bronzino's draughtsmanship, without the sustained containment, the continuity of his form. It bears comparison, however, with a fine drawing in the Louvre related to Allori's painting of the *Pearl Fishery*.[207]

The drawing at Windsor showing a figure to be seen in Bronzino's *Christ in Limbo* in the Museum of Sta. Croce, signed and dated 1552, should be regarded in rather the same way, in my judgment.[208] Although the painting shows a hardness and exaggeration new in Bronzino's work, it is difficult to see how this change could account for the lack of correspondence between the drawing at Windsor and others for which there is external evidence of his authorship. The contours, though stressed, seem weak, lacking the indeflectible life, elasticity, and tautness of Bronzino's. Moreover, what might seem at first a normal *pentimento* at the right biceps appears instead to be due to faltering, a mistake. The contour at the raised knee does not put it effectively in space. The shading, more even and pale than in reproduction, also seems weak—in the rock as well as in the figure, where it fails to achieve the life or the reflection of lights to be expected. The little lines at the figure's temple are irrelevant in a way that is not easy to square with Bronzino. Thus the drawing at Windsor, too, has the air of being a copy after a drawing by him.[209]

There is a drawing, however, that can represent Bronzino's draughtsmanship with respect to the human figure in his late years (*Fig. 40*). The fact that it is among drawings at the Louvre assigned to Alessandro Tiarini is warning of how far afield Bronzino's drawings can be expected to have been dispersed on occasion. It is a study in black chalk for the *Martyrdom of Saint Lawrence* in the Church of San Lorenzo at Florence, commissioned in 1565 and finished in 1569. It represents the figure in the fresco's lower left hand corner, without the drapery and beard it has in the finished work.[210] There are *pentimenti*, and the handling is consistent in kind and quality with Bronzino's hand. Indeed, it might almost be an excerpt from the drawing in the Ashmolean Museum (*Fig. 33*) except that now, in keeping with the figure in the fresco, ungracefulness in the human form

has been exaggerated toward the grotesque. The Greek ideal reflected in the *Red Sea* nude (*Fig. 5*) is very far away. But this does not mean that the contours have lost their tautness and capacity to evoke volume or that there is less intensity in the patches of light and less evidence of sensitivity to luminousness in the shadows.

At the Uffizi under the name of Allori there is another chalk drawing for a figure in the *Martyrdom of Saint Lawrence*, showing the executioner who kneels with bellows at the left end of the grating where Saint Lawrence lies. Although it is similar to the study at the Louvre, by comparison it appears crude.[211] By comparison, its contours lack consistency, purity, and strength while the modeling looks untidy and does not do for structure, light, and shadow what it could. The drawing in the Louvre makes it doubtful that the Uffizi's drawing could be Bronzino's rather than an assistant's or pupil's. It reminds us again that exacting distinctions are desirable if Bronzino is to be seen clearly as a draughtsman, at least in the present stage of our knowledge about his drawings.[212]

* *

*

The drawings considered here are a miniscule representation of what must have been a very large body of work. Remarkably varied, they still cannot convey Bronzino's whole range. When less well documented drawings that can qualify as his in their company are grouped around them, the picture becomes fuller. Since such drawings are beyond the scope of this essay, so also is an attempt to characterize Bronzino's draughtsmanship comprehensively.[213] But the drawings here do tell us much. They are likely to dispel any surviving vestiges of the old belief that his draughtmanship was inept and limited. They point to high standards of craft rooted in Florentine traditions. When Paolo Pino compared Bronzino and Titian in his *Dialogue on Painting* of 1548,[214] evidently considering these two painters the most suitable representatives of Florence and Venice, it is unlikely he had reservations as to the worthiness of Bronzino's draughtsmanship to exemplify Florence. Perhaps in drawing Bronzino seemed to qualify particularly by virtue

45

of the value he gave to line—to the circumscribing contour line, more or less uniform, continuous, and distinct from shading—and to the sculpturesque volume he could achieve within it. But, as we have seen, he was imbued with Florentine tradition in other ways, and receptive also to what he saw beyond it. The drawings testify to Bronzino's artistic culture, to a wide frame of reference within which he chose the directions and emphases of his own art.

To leaf through the accompanying illustrations, including the less familiar tapestries, is to see a somewhat different Bronzino from the one we think of normally. They show, moreover, an artist who continually turns away from the expected. The conventions of *maniera* are much in evidence, but rather than promoting routine, as they can, they support continually new effects. From the classic point of view, these are largely unaccustomed and strange. We may be sure they held fascination, beauty, and no small power of expression for many in the mid-cinquecento who saw them first.

Footnotes

1. Smyth [1949], 195–196.

2. Berenson [1903], II, 31, also I, 327; McComb [1928], 147–153; Berenson [1938], II, 62–64, also I, 321. There is not much change in the latest edition, Berenson [1961].

3. An exception to this view was Hermann Voss, who introduced drawings by Bronzino not in accord with the standard picture, including those in Figs. 9 and 14.

4. Smyth [1955], 35–90. Published only in microfilm, this has had a limited circulation. Much in the present essay was proposed there. Of the remaining drawings in Berenson's and McComb's lists almost all were classified as copies or school or discarded entirely.

5. Contributions concerning Bronzino as a draughtsman have been made recently by Anna Forlani Tempesti (Forlani [1962], 174–178; Forlani [1963], 23–30), Janet Cox-Rearick (Cox-Rearick, *Bronzino* [1964]; see also Cox-Rearick, *Pontormo* [1964]), Keith Andrews (Andrews [1964]), and Detlev Heikamp (Heikamp [1968] and Heikamp [1969]). Andrews' strong statement on the lack of information about Bronzino's drawings helped suggest the idea of the present essay, devoted to very well documented examples.

6. Bronzino worked for Duke Cosimo before 1539 on the decorations of the Villa of Castello, but as Pontormo's associate.

7. Emiliani [1960], pls. 61, 62.

Signed by Bronzino and showing the coat of arms of the Panciatichi on the banner at upper left, the *Holy Family* must be, as always assumed, one of the two Madonnas that Vasari says Bronzino did for Bartolommeo Panciatichi. Vasari appears to date both in the 1530's, since he refers to them, along with various other works, between his account of Bronzino's activity at Pesaro in 1530–1532 (see later in the text) and the beginning of his work for Duke Cosimo and Eleonora of Toledo at the time of their marriage in 1539 (Vasari-Milanesi, VII, 595). The painting has regularly been dated from the 1530's except by Schweitzer and Emiliani. Schweitzer placed it about 1547–1548 because he thought it was influenced by a version of the Cnidian Aphrodite in Rome as well as by antique sculptures collected at the Villa Madama and hence must presuppose Bronzino's stay in Rome in 1546–1548 (Schweitzer [1918], 49–50, 53–56, 59; E. Paribeni, "Reflessi di sculture antiche," *Archeologia classica*, XIII [1961], 103, pls. XLV and XLVI points to a different Praxitelean model). Emiliani agreed, citing particularly the evidence the picture gives of interest in Michelangelo and in Roman, or Raphaelesque, classicism as reasons for assuming it was painted after the Roman sojourn of 1546–1548 (Emiliani [1960], opp. pl. 61).

As it happens, Bronzino did not stay in Rome from 1546 to 1548. The two-year stay has been assumed because of the portrait he painted of the Roman Stefano Colonna, which is signed and dated 1546 (for example, McComb [1928], 18–19, 22, 80; Emiliani [1960], 76–77 and opp. pl. 60), and because of Bronzino's letter of 30 April 1548 to Duke Cosimo, referring to his return from Rome two days before (Gaye [1839], II, 368–369). The evidence instead indicates that he made a relatively short visit in 1548. Several letters written in March, April, and July 1547 by Paolo Giovio in Rome to Vasari in Florence send greetings to Bronzino and show he was not in Rome at that time (K. Frey, *Der literarische Nachlaß Giorgio Vasaris*, Munich [1923], 195–199; and also 168–169 for a letter of late August 1546 from Don Miniato Pitti in Florence to Vasari in Rome sending Bronzino's greetings). In fact, the wording of Bronzino's letter of 30 April 1548 indicates he had made only a rather short visit. (He tells of having written Raffaellino dal Colle just before leaving for Rome, proposing that Raffaellino come to Florence and help with Bronzino's tapestry designs on Bronzino's return because he was swamped with work, and he refers also to the bad weather ever since he left Florence. He could not have written Raffaellino a very long period before he would need him, nor is he likely to have been referring to bad weather over many months—much less years.) Meanwhile, that Bronzino painted Stefano Colonna in 1546 does not mean he must have been in Rome in that year, because Colonna was in Duke Cosimo's service and could well have been in Tuscany, where he died in 1548. His funeral was in Florence, and he was buried there in San Lorenzo (*Diario Fiorentino di Agostino Lappi*, Florence: Odoardo Corazzini [1900], 107).

While Bronzino's visit to Rome in 1548 was not extended, there is no reason not to assume he had been to Rome on other occasions during his career. Uffizi,

Santarelli Collection, Cartella 3, 195, which I attribute to Bronzino (Smyth [1955], 64–65), suggests this. It is a copy of Michelangelo's *Haman* on the Sistine ceiling and appears to date from the 1530's. It seems quite unnecessary to place the Panciatichi *Holy Family* late in the 1540's in disagreement with Vasari's indication in order to make it fit a particular visit to Rome, which was not a long one. Moreover, the style of the picture fits in well shortly after Bronzino's work in Pesaro, where he assimilated Roman ideals through Raffaellino dal Colle (Smyth [1949], 206), Genga, and in all likelihood Sebastiano del Piombo (Smyth [1963], 22, 72, note 153). His preparation for the Panciatichi *Holy Family* is attested by the allegorical figures in the Sala Grande of the Villa Imperiale at Pesaro claimed for him in Smyth [1955], 177–185 and Smyth [1963], 22, figs. 22, 23. The *Holy Family* also implies an influence from Parmigianino's work of around 1530, the *Madonna of the Rose* and perhaps also the *Madonna with Saint Zachary*, something that seems more likely soon after they were painted than much later.

8. Florence, Uffizi, 6639F. In black chalk, 190×265 mm. By Pontormo in Berenson [1903], II, 148, no. 2131. By Bronzino for the Christ Child in the Panciatichi *Holy Family* in Clapp [1914], 199; McComb [1928], 150; Berenson [1938], II, 63, no. 601c, III, fig. 999; Smyth [1949], 195; Smyth [1955], 38–39, fig. 112; Emiliani [1960], opp. pl. 61; Berenson [1961], II, 115, no. 601c, III, fig. 984; Cox-Rearick, *Pontormo* [1964], 380, A113.

9. The other was Uffizi 6704F (*Fig. 5*).
 Two other drawings in Berenson's list, Uffizi 570F (Berenson [1938], II, 62, no. 597; Forlani [1963], fig. 9) and Uffizi 6357F (*Fig. 34*; Berenson [1938], II, 62, no. 600), show parts of the composition of a tapestry designed by Bronzino (*Fig. 35*), as pointed out by Geisenheimer [1909], 143, note c. But this relation had evidently escaped the notice of Berenson and others interested in Bronzino's drawings until relatively recently. (McComb listed only one of these, Uffizi 6357F, apparently without knowing the connection with the tapestry; McComb [1928], 148–149.)

10. Smyth [1949], 195, part of a description showing little spirit of praise.

11. There is another drawing that has been associated with the Panciatichi *Holy Family*: Munich, Staatliche Graphische Sammlung, No. 2249, first connected with Bronzino and this picture by H. Schulze, *Die Werke Angelo Bronzinos*, Strassburg [1911], 8 and xiii, followed by Schweitzer [1918], 46, unmentioned in the lists of Berenson and McComb (though its existence is cited in McComb [1928], 60), and recently reaffirmed as Bronzino's by Keith Andrews [1964], 159, pl. 28a. The attribution to Bronzino has since been doubted by Anna Forlani Tempesti [1967], 85, note 14. In my view it is by Bronzino (Smyth [1955], 54a–56), but discussion of it is postponed here because it does not have an undeniable connection with Bronzino's picture. The composition, though close and related in all probability, is nevertheless not close enough to guarantee the connection.

12. Emiliani [1960], pl. 18.

13. Chatsworth, Collection of the Duke of Devonshire, 714. In black chalk, squared in the same medium, 264 × 187 mm. By Pontormo in S. A. Strong, *Reproductions of Drawings by Old Masters in the Collection of the Duke of Devonshire at Chatsworth*, London [1902], 7 and pl. 16; Berenson [1903], I, 323 and II, 137, no. 1957; Clapp [1914], 81; and Berenson [1938], I, 318, note 1; II, 273, no. 1957; III, fig. 984. By Bronzino in A. G. B. Russell, *Vasari Society for the Reproduction of Drawings by Old Masters*, 2nd series, part VI [1925], no. 9, pl. 9; A. E. Popham, *Italian Drawings Exhibited at the Royal Academy Burlington House, London, 1930*, London [1931], 34, fig. 198; L. Becherucci, *Manieristi toscani*, Bergamo [1944], 44; J. Gere, "Some Drawings at the Chatsworth Exhibition," *Burlington Magazine*, XCI [1949], 169–170, fig. 29; Smyth [1949], 195 and notes 82, 83; Smyth [1955], 60–61, fig. 111; Emiliani [1960], opp. pl. 18; *Old Master Drawings from Chatsworth*, catalogue of an exhibition circulated by the Smithsonian Institution [1962–1963], 17, pl. 8; P. Pouncey, "Bernard Berenson: *I disegni dei pittori fiorentini*," *Master Drawings*, II [1964], 284; Cox-Rearick, *Pontormo* [1964], I, 82, 298, 362, no. A16.

As long since noted, the drawing varies from the *Man with the Lute* in several respects: the type and expression of the face, the absence of the lute, the collar and cap, the presence on the left hand of a ring missing in the painting, and the fact that the hands are not visualized in quite the forceful manner of the portrait. Gere's explanation seems correct that Bronzino probably used one of his *garzoni di bottega* as a model for the dress and hands. Originally I had felt the drawing might be earlier than the picture, possibly about 1530. Janet Cox-Rearick rightly disagreed, dating both about 1534. Perhaps the date should be between these, not long after Bronzino's return from Pesaro, which probably took place in the spring or summer of 1532 (see footnote 32 below), because the drawing and the painting appear to reflect aspects of what he learned there (see Appendix I) and because, among the Bronzino drawings I am acquainted with, the one in the Louvre (Emiliani [1960], pl. 10) for the Leningrad *Apollo and Marsyas*, painted at Pesaro (see footnote 21 below), seems the closest in mode.

14. See also Emiliani [1960], pl. 21 (although the color is misleading, as pointed out in Shearman [1963], 416).

15. And with the drawing of the half-length female figure in the British Museum (Berenson [1938], III, fig. 609), whose pose Mr. Berenson thought "may have given the cue to the portraiture of Pontormo ... and Bronzino" (*ibid.*, I, 197).

16. Shearman [1963], 415. For the Naples Rosso see P. Barocchi, *Il Rosso Fiorentino*, Rome [1950], pl. 37.

17. Cox-Rearick, *Pontormo* [1964], pl. 219.

18. In Cox-Rearick, *Pontormo* [1964], I, 298, 362, it is proposed that in the Chatsworth drawing Bronzino was strongly influenced by Pontormo as represented in the well known portrait drawing, Uffizi 6698F (*ibid.*, II, fig. 325), given there to Pon-

tormo, as always in the past. Longhi, Sinibaldi, Berti, Forlani Tempesti, Forster, and Andrews have been quite right, I think, in attributing it to Bronzino (for the bibliography, *ibid.*, I, 297 and Forlani [1962], 177, no. 37; see also K. W. Forster, "Probleme um Pontormos Porträtmalerei," *Pantheon*, XXII [1964], 384; Andrews [1966], 581; and Forlani Tempesti [1967], 79), although Berti has since changed his mind (Berti, *Precisioni* [1966], 53). I credit Bronzino also with the *Prudence* for Careggi, Hamburg, Kunsthalle 21173 recto (Cox-Rearick, *Pontormo* [1964], II, fig. 305), always given to Pontormo and to be discussed in a later paper, and this was the principal link of Uffizi 6698F to Pontormo in Mrs. Cox-Rearick's argument.

19. Smyth [1949], 203–204 and note 140, also 184–195. For the strongest statement of the opposite view, see Berenson [1938], I, 316, 318. Recently Berti (*Precisioni* [1966], 53) has pointed again to dependence on Pontormo in Bronzino's portraits of 1530–1535. See, however, Appendix I.

In this connection it is worth mentioning the *Portrait of a Lady* in Frankfurt (Clapp [1916], fig. 127; L. Berti, *Pontormo*, Florence [1964], pl. CLVI). The proposal was made and argued in Smyth [1955], 109–117, that this picture was painted by Bronzino instead of Pontormo. It was cited as Bronzino's in Cox-Rearick, *Pontormo* [1964], I, 391, though without comment. John Shearman has arrived independently at the same conclusion (Shearman [1963], 416 and [1965], 123, note 1). I am still very much of this opinion. Berti, however (*Precisioni* [1966], 53, 57, note 32), has recently cautioned against an attribution to Bronzino. This is not the place to consider the question, but it is clear that to take Uffizi 6698F and the Frankfort portrait away from Pontormo and give them to Bronzino much weakens the argument that the distinctive character of Bronzino's portraits of the 1530's is derived solely from Pontormo.

20. Compare, for example, the face of Judas in the *Discovery and Proof of the True Cross* (K. Clark, *Piero della Francesca*, 2nd ed., London and New York [1969], pl. 66). But it is possible to see here also a reminiscence of faces by Michelangelo and his circle: compare those of the half-length female figures at Windsor (Berenson [1938], III, fig. 788), in Uffizi 603E (*ibid.*, fig. 783), and in the British Museum (*ibid.*, fig. 609).

21. Discussion of some of them will follow in a separate paper. Below in this note is a list of drawings that have been attributed to Bronzino for the years before 1539/40 and have credentials other than their style—some more, some less strong—while at the same time qualifying stylistically in my view for acceptance as Bronzino's. (Not included are drawings to be claimed for him initially in a subsequent discussion.)

The following, having connections with Bronzino before Pesaro, were catalogued as Bronzino's in Smyth [1955], 35–90 and given as his in Cox-Rearick, *Bronzino* [1964]:

Uffizi 6658F recto and verso. The recto had been thought to be by Pontormo, Pichi, or Lappoli. The drawing on the verso (Cox-Rearick, *Bronzino* [1964], pl. 2),

unknown and therefore unattributed until detached from its mount on the occasion when I studied it, is inscribed "bronzino" in an old hand. There is a good possibility that the suggestion as offered in Smyth [1955], 53–54 is right, that it could be a study for Bronzino's *Saint Lawrence* at the Certosa in Galuzzo. But it cannot be certain, as implied in Cox-Rearick, *Bronzino* [1964], 365, because the pose differs considerably. (The recto will be reproduced in connection with subsequent discussion of it.)

Uffizi 13847F. Attributed by Berenson to Bronzino, it could be—as suggested in Smyth [1955], 62, and affirmed in Cox-Rearick, *Bronzino* [1964], 366–369—a study for one of the *putti* in the *Madonna Enthroned* in the Uffizi (Cox-Rearick, *Bronzino* [1964], pl. 3 and fig. 2). I proposed Bronzino without reservation as the author of this painting (Smyth [1955], 91–92), discussing it as one of his earliest works. In the catalogue of the Pontormo exhibition, Berti also suggested Bronzino as the possible author (L. Berti in *Mostra del Pontormo e del primo manierismo fiorentino*, 2nd edition, Florence [1956], 26–27). Mrs. Cox-Rearick accepted these proposals (tentatively in *Pontormo* [1964], 231–232, unconditionally in *Bronzino* [1964], 366 and 378, note 7). Andrews has given his assent to the attribution (K. Andrews "Pontormo Drawings," *The Burlington Magazine*, CVIII [1966], 581). Forster believes it is probably by Bronzino (K. W. Forster, *Pontormo*, Munich [1966], 33). Hence the picture now seems rather solidly in Bronzino's oeuvre, but the connection of the drawing with it is not a foregone conclusion.

Uffizi 6552F recto and verso. Formerly attributed to Pontormo. The connection of the recto with the *Holy Family* in the National Gallery, Washington, is clear, and the attribution of the painting and both sides of the drawing to Bronzino seems to have been generally accepted since proposed in Smyth [1949], 196–198, figs. 10–12. But since Pontormo appears to have done one drawing for the picture and since there is a good chance he had a hand in painting the Saint John, the attribution of Uffizi 6552F must rest in large part on its style.

Uffizi 6527F. This drawing, always attributed to Pontormo and labeled on the verso "de Jacopo," was identified in Smyth [1955], 54–54a, as a study for the legs of the dead Christ in Bronzino's *Pietà* from Sta. Trinita, at the Uffizi (Emiliani [1960], pl. 66), which in the opinion of most observers is the painting Vasari recorded in Sta. Trinita as done by Bronzino before he left for Pesaro in 1530 (as argued in Smyth [1949], 202f.). The connection of drawing and painting was accepted in Cox-Rearick, *Pontormo* [1964], 371, A66 and *idem, Bronzino* [1964], 380, note 43. However, neither the specific connection nor the early date of the painting have since been undenied. All students of Bronzino concur in considering the painting Bronzino's, but Emiliani [1960], opp. pl. 66, proposed a date in the late 1540's, after Bronzino's supposed two-year sojourn in Rome (see, however, note 7 above). In reviewing Emiliani, Shearman [1963], 416, favored the earlier date, and Emiliani has reverted to it (Emiliani [1966], 1). The supplement to Janet Cox-Rearick's catalogue of Pontormo drawings, however, suggests again a later date and proposes that Uffizi 6527F is in any case not a study by Bronzino

for the *Pietà* but one by Pontormo for a *Nailing to the Cross* projected, though never executed, for the Certosa and witnessed in various drawings (Cox-Rearick, "The Drawings of Pontormo: Addenda," *Master Drawings*, VIII [1970], 370–371, pl. 9a). Uffizi 6527F does not belong in the present restricted discussion, but in the end, I think, is likely to be accepted as Bronzino's.

The following three drawings having connections with Bronzino before Pesaro were assigned to him by Janet Cox-Rearick:

Besançon, Musée des Beaux-Arts D.1511. Pointed out by Popham and undeniably a study for Bronzino's *Saint Mark* of Sta. Felicita, the drawing was considered Pontormo's by all, including myself (Smyth [1949], 190). Mrs. Cox-Rearick's rejection of Pontormo's authorship (*Pontormo* [1964], I, 360, A9) and attribution to Bronzino (Cox-Rearick, *Bronzino* [1964], 369, pl. 1) are surely right. But the four evangelists at Sta. Felicita were done under Pontormo's direction, and he as well as Bronzino worked on them. Hence the reasons for attributing the drawing to one or the other depend on its style, and because these are first of all reasons against giving it to Pontormo, it falls to Bronzino initially by the process of elimination.

Uffizi 6674F. There has been agreement as to its connection with the tondi of the evangelists at Sta. Felicita, but not as to precisely which one. I retained the attribution to Pontormo in Smyth [1949], 190. Mrs. Cox-Rearick excluded the drawing from Pontormo's oeuvre with good reason, and the alternative attribution to Bronzino is indicated (Cox-Rearick, *Pontormo* [1964], I, 382, A125; *idem*, *Bronzino* [1964], 369–370) as well as instructive concerning Bronzino's range as early as the middle 1520's.

Dresden, Kupferstichkabinett C 85. This drawing, labeled "A. Bronzino," is his on the basis of its stylistic relation to the Christ Child of the Washington *Holy Family*, as Mrs. Cox-Rearick, who discovered the drawing, pointed out, and it should date from about the same time even though not a study for it (Cox-Rearick, *Bronzino* [1964], 376–377, pl. 9). The Washington picture is Bronzino's for reasons of style only, and Pontormo probably had a hand in it.

(The head at the left of Uffizi 6729F, a drawing related to the Washington *Holy Family* but retained as Pontormo's in Smyth [1949], 199, fig. 15, has been given to Bronzino in Cox-Rearick, *Bronzino* [1964], 373, pl. 7. But this attribution presents difficulties, as witnessed by the objection of Forlani Tempesti [1967], note 14. The drawing in the British Museum, Payne Knight Collection Pp. 2, 102, long known to represent the *Saint Matthew* of the tondo in Sta. Felicita and formerly given to Pontormo, has been given to Bronzino by Keith Andrews [1964], 157–158, pl. 22. Ever since finally seeing it, shortly after referring to it in Smyth [1949], 189, note 38, I have had the same opinion as that expressed in Cox-Rearick, *Bronzino* [1964], 379, note 33, that it is by neither Pontormo nor Bronzino, but is a copy.)

The following drawings attributed to Bronzino (though in two cases there is not agreement) have obvious circumstantial connections with his work from Pesaro on in the 1530's, in addition to their style, and are in my opinion his:

Louvre 5923 (Emiliani [1960], pl. 10), the study for the figure of Marsyas in the *Apollo and Marsyas* at Leningrad (Voss [1920], I, figs. 67–68), perceptively proposed by Voss as the harpsichord cover Bronzino is reported by Vasari and Borghini to have painted at Pesaro, but for which Correggio's name is given as author in Sanudo's engraving of it from 1562. Though the painting and drawing were claimed for Correggio by A. E. Popham as recently as 1957 (and, because I knew his view, the argument for Bronzino's authorship in Smyth [1955], 68–69, was tentative), I do not doubt they are by Bronzino and will return to them.

Munich, Graphische Sammlung 2249. See footnote 11 above.

Munich, Graphische Sammlung 2147. Since Vasari says Bronzino painted a *Portrait of Dante* for Bartolommeo Bettini not long after returning from Pesaro, this drawing (attributed to Bronzino in Berenson [1938], II, 63, no. 604E, and Berenson [1961], II, 116, no. 604E; III, fig. 97) could well be a study for the lost picture, as suggested in Smyth [1955], 63 and Cox-Rearick, *Bronzino* [1964], 381, note 64, but there cannot be certainty of this connection.

(The drawing of the *Madonna and Child with the Infant Saint John and Saint Anne* in Frankfort, Staedel Institut 5601, is related to the Faudel-Phillips *Madonna* in the National Gallery, London, as pointed out by Voss [1920], 212, note 1. See also P. Pouncey, "Bernard Berenson: *I disegni dei pittori fiorentini*," *Master Drawings*, II [1964], 284 and Andrews [1964], 159, pl. 28b. Squared though this drawing is, I have not been able to see Bronzino's hand here, nor has Anna Forlani Tempesti [1967], 85, note 14.)

22. For illustrations see Emiliani [1960], pl. 36; A. Emiliani, "Il Bronzino e la Cappella di Eleonora da Toledo in Palazzo Vecchio," *Acropoli* [1960/61], Edizioni Aeropoli, Milan, 121f.; Emiliani [1966], pl. v; Levey [1967], pl. v.
The corresponding figure in the fresco is slightly coarse in execution compared to the others of the same wall, and possibly it was redone somewhat later than the rest of the fresco. But the drawing's style accords well with that of the unexceptionable figures in the fresco, such as the nude in the center resting his elbow on the rock (Emiliani [1960], pl. 37). Hence drawing and fresco should be the same date.

23. As reported in Emiliani [1960] opp. pls. 34–35 and *idem, op. cit.* [1960/61], 136. Emiliani's credit to me belongs to others. The new evidence, consisting of writing in crayon pencil in a sixteenth century hand on the right-hand marble strip around the chapel door (and giving, besides, the date of the start of work on the fresco of the *Brazen Serpent* as 5 June 1542; Emiliani [1960], pl. 41), was found during the cleaning of the frescoes. At the request of Edward Sanchez (who learned of it in 1957 from Giovanni Poggi and very kindly told me) the writing was cleaned.

Sanchez transcribed it and then confirmed that in the years concerned the dates and days mentioned coincide. Sanchez also found writing on the left side of the door, dating completion of the *Miraculous Spring of Moses* (*ibid.*, pl. 45), but the date is illegible. In addition Sanchez has discovered documents recording frequent payments to Bronzino by order of Duke Cosimo from April 1542 to December 1544, at least partly for work in the Palazzo Vecchio and hence probably for the work in the chapel.

The new evidence was gratifying, for it coincides with Vasari's account (Vasari-Milanesi, VII, 596) placing the start of the work shortly after the marriage in 1539 of Duke Cosimo to Eleonora of Toledo. My only claim is to have argued before knowing it, on the basis of Vasari and the style of the frescoes themselves, for dating the beginning of the chapel decoration about 1540, with the ceiling first, and the completion of the decoration probably in the first half of the 1540's except for a few small parts (Smyth [1955], 216–218). In my opinion the *Miraculous Spring* and the *Miracle of the Manna* (Emiliani [1960], pl. 45) followed in that order immediately upon the *Brazen Serpent*, the *Manna* leading toward the mode seen in the *Vindication of Innocence* (Fig. 22a), the tapestry delivered in April 1546 (see Appendix II).

The date that modern writers (beginning with H. Schulze, *Die Werke Angelo Bronzinos*, Strassburg [1911], xi) had given for the commission was 1545 (for which there was no source, only the fact that in that year the altarpiece, the *Deposition* in Besançon, was complete and in the chapel but ordered sent to France as a gift from the duke). Most of the work was thought to date much later: because it was considered to presuppose Bronzino's Roman sojourn of 1546–1548 (see, however, footnote 7 above), because of the mistaken assumption that the first payment was made 26 September 1553 (McComb [1928], 33, note 1, and 56), which was in fact only for blue used in the new *Deposition* substituted for the first, and because of a letter from Bronzino to the duke of 15 April 1564 saying he would finish shortly what was lacking in the chapel (Gaye [1839], III, 134). Bronzino's letter sounds as if there were not much to finish, and only a few parts can be dated in the 1560's on style: the panels of the *Annunciation* flanking the *Deposition*, which were substituted for the earlier Saints Cosmos and John the Baptist (Vasari-Milanesi, VII, 597; F. Zeri, "Agnolo Bronzino: il 'San Giovanni Battista' dalla Cappella di Palazzo Vecchio," *Paragone*, III, no. 27 [1952], 57–59) and framed in 1564 (A. Lensi, *Palazzo Vecchio*, Milan-Rome [1929], 134 and 270, note 17), the *putti* with the chalice over the door at left, and three of the four virtues at the corners of the ceiling (the fourth, Justice, coincides better with the rest of the decoration). The Trinity in the center of the ceiling was painted over the coat of arms which united the bearings of the duke and duchess, but it is difficult to be sure just when Bronzino made this change—my guess is in the mid-1540's or early 1550's.

24. Florence, Uffizi, 6704F. Black chalk on orange-yellow prepared paper, 420 × 155 mm. By Pontormo in Berenson [1903], II, 152, no. 2187. By Bronzino for the fresco of the *Red Sea* in Clapp [1914], 248; McComb [1928], 150; Berenson [1938], I, 321, note 3 and II, 63, no. 601D; Smyth [1949], 195; Marcucci [1954], 58, no. 97; Smyth [1955], 41–42, fig. 117; Emiliani [1960], repro. p. 26; Berenson

[1961], II, 115 and III, fig. 981; Forlani [1962], xxvi and 177, pl. 38; Forlani [1963], 25, no. 15; Cox-Rearick, *Pontormo* [1964], 384, A134.

25. Smyth [1949], 195.

26. Cf. Berenson [1938], III, figs. 586 and 631. But there is probably truth also in Hirst's suggestion that in such a drawing as this, which isolates the individual figure as a single unit and stresses its plasticity, Bronzino, like other artists of Florence and Rome in the 1540's, is feeling the influence of later drawings of Michelangelo "where figures and drapery are minutely delineated but where there is little or no indication of setting" (M. Hirst, "Daniele da Volterra and the Orsini Chapel—I: The Chronology and the Altarpiece," *Burlington Magazine*, CIX [1967], 506, note 33).

27. Cf. *ibid.*, fig. 102. It is in keeping with Bronzino's training under a late fifteenth century artist that his work shows roots in quattrocento art on various occasions, as noted frequently in this essay.

28. Cf. K. Kusenberg, *Le Rosso*, Paris [1931], pl. XI; E. A. Carroll, "Some Drawings by Rosso Fiorentino," *Burlington Magazine*, CIII [1961], fig. 7 opp. p. 449; *idem*, "Drawings by Rosso Fiorentino in the British Museum," *ibid.*, CVIII [1966], fig. 8 opp. p. 173.

29. Cf. Cox-Rearick, *Pontormo* [1964], fig. 100.

30. R. Kekulé, "Über die Bronzestatue des sogenannten Idolino," *49 Program zum Winkelmannsfeste der Archaeologischen Gesellschaft zu Berlin*, Berlin [1889], 3–21, doc. on p. 15; W. Amelung, *Führer durch die Antiken in Florenz*, Munich [1897], 272–275, no. 268; Patzak [1908], 19.

31. Vasari-Milanesi, VII, 594.
 2 August 1530 is given in Clapp [1916], 204 and McComb [1928], 57 as the date Bronzino left Florence for Pesaro. This date probably goes back to a misprint, 2 August for 12 August, the day the peace was presumably made, to be found in C. Justi, "Die Bildnisse des Kardinals Hippolyt von Medici in Florenz," *Zeitschrift für bildende Kunst*, N.F., VIII [1897], 38.

32. Vasari was in a position to know details of Bronzino's stay at Pesaro because he worked as his assistant for a short time in Florence not long afterwards; see the entry for 20 March 1533 in Alessandro del Vita, *Il libro delle ricordanze di Giorgio Vasari*, Arezzo [1938], 20. He indicates that the *Portrait of Prince Guidobaldo della Rovere (Fig. 2)* was the last work Bronzino executed in Pesaro (Vasari-Milanesi, VI, 276). According to the inscription on the portrait it was painted during Guidobaldo's eighteenth year (McComb [1928], 57). Since his seventeenth birthday was on 2 April 1531 (Clapp [1916], 204) Bronzino would then have painted the picture after this, and he would have left for home at the latest not much after Guidobaldo's eighteenth birthday, 2 April 1532. Vasari (Vasari-Milanesi, VII, 595) also says that

55

Bronzino left Pesaro before he had done all that he might have on the decorations of the villa, in response to repeated requests from Pontormo that he return to Florence and help with Pontormo's second commission at Poggio a Caiano (Vasari-Milanesi, VI, 276). The date of this commission is now considered to be 1532 (Cox-Rearick, *Pontormo* [1964], I, 285). In one place Vasari says that after the siege of Florence Pope Clement VII ordered Ottaviano de' Medici to have the room at Poggio a Caiano finished and that Pontormo got the whole commission because Franciabigio and Andrea del Sarto were both dead (Vasari-Milanesi, VI, 275). Since the former died in 1525 and the latter in September 1530, this tells only that the commission dates after September 1530, but not how long after. Elsewhere Vasari says Pontormo got the commission from Duke Alessandro de' Medici in 1532 (*idem*, V, 196). If 1532 is correct (and if Vasari did not have Florentine dating in mind, postponing the beginning of 1532 to March), then Bronzino left Pesaro in late winter or spring of 1532 at the earliest.

33. For the various opinions and literature, see A. Rumpf, "Der Idolino," *La critica d'arte*, IV, parte prima: arte antica [1939], 17–27; L. Alscher, *Griechische Plastik*, III, *Nachklassik und Vorhellenismus*, Berlin [1956], 16 and 180, note 14; L. V. Borrelli in *Enciclopedia dell' arte antica*, IV [1961], 87; D. Arnold, *Die Polykleitnachfolge*, Berlin [1969], 135–136 and 267.

For colored photographs, see P. E. Arias, *Policleto*, Milan [1964], pls. XIX–XXII.

34. Kenneth Clark, *The Nude, a Study in Ideal Form*, New York [1956], 41.

35. Kekulé, *op. cit.*, 1 and 15–16, note 4.

36. Patzak [1908], 21, 30 and fig. 55; Gronau [1936], 17–18. For the sunken court, C. H. Smyth, "The Sunken Courts of the Villa Giulia and the Villa Imperiale," *Essays in Memory of Karl Lehmann* (*Marsyas*, Supplement I), Locust Valley, New York [1964], 304f., fig. 5.

37. Schweitzer [1918] called attention to Bronzino's interest in specific Greek models, n connection with the Panciatichi *Holy Family* (see note 7 above).

38. As suggested in Smyth [1963], 14f.

39. When found, the statue was broken, but at most, so far as I can discover, only in the arms and probably only in the case of the right arm—despite the sound of the sentence in the diary of G. B. Belluzzi (son-in-law of Girolamo Genga, architect in charge at the Imperiale) telling that "we put together the Bacchus [the name first given the *Idolino*] which was all broken [*tutto rotto*]" (Gronau [1936], 13). There seems little chance, moreover, that the curving left hand of the *Idolino* is an addition of the sixteenth century, as suggested by Arnold (*op. cit.*, 136). There are very careful descriptions of the statue's condition by Kekulé (*op. cit.*, 6–7) and L. A. Milani (quoted by Kekulé, *ibid.*, 18, note 16). Milani saw signs that both arms had been

soldered to the torso and considered the arms restorations dating from antiquity (*ibid.* and L. A. Milani, *Il R. Museo Archeologico di Firenze*, Florence [1912], 173). He thought that the whole left arm gave the effect of being shorter than the right. Of the left hand he observed that it showed "some rough folds or wrinkles at the thumb and in the interior" which were "strong and deep" and did not harmonize with the youthfulness of the figure and that the same was true of the right hand. The right hand, he went on to say, was "rigid, hard, and modeled rather imperfectly" and not in accord with the modeling and treatment of the feet, which he found "true and realistic." Kekulé agreed that the right arm had been broken off high up, observing that, so far as he could see, the correct pose of the arm had not suffered when it was reattached. He reported the thumb and fingers of the right hand somewhat injured, perhaps when the statue fell. As for the left arm, he stated flatly that it had never been broken. "What one might consider traces of a modern joining in the upper arm is only a place that has been denuded of patina in the modern cleaning. The left hand is undamaged and, on this account, of much more beautiful drawing than the right." Professor Hans Jucker at Bern (to whom I am most grateful for observations in answer to my questions) comments that without X-rays it will not be easy to go farther. He thinks it noteworthy that neither Kekulé nor Milani note any sign of alteration in the left hand and also that if it were modern this would not have escaped Milani.

40. For the *maniera* convention of angularity, see Smyth [1963], 11. The tradition behind it in Florence goes back to the quattrocento.

41. Forlani [1962], 177.

42. Cf., for example, the red chalk drawings of Michelangelo for the Libyan Sibyl (Berenson [1938], III, fig. 631) and Perino for the *Vertumnus and Pomona* of Caraglio's print (Davidson [1963], part II, pl. 18).

43. As seen in a figure such as the male nude leaning on the rock in the *Red Sea* (Emiliani [1960], pl. 37), to which Emiliani applied Longhi's observation about Bronzino's mix of "idealismo plastico superbamente glaciale" and realism (*ibid.*).

44. Assuming that the ceiling was painted first, as would be normal, we can date it in 1540 and the first part of 1541, before the *Red Sea* was started on 6 September 1541. For illustrations see Emiliani [1960], pl. 33; *idem* [1966], pl. IV; Levey [1967], pl. IV.

45. Paris, Louvre, Inv. 6356. Black chalk on grey prepared paper, 387 × 226 mm. The drawing was in Tome 2, p. 102 of Baldinucci's collection, where it was given to Lomazzo.

46. It has been observed that toward mid-century the old practice of studying figures from the model was being abandoned. It is testimony to Bronzino's continuation of Florentine tradition that he held to it.

47. Cf. A. E. Popham, *The Drawings of Leonardo da Vinci*, New York [1945], pls. 213 and 222 in silverpoint, pl. 238 in red chalk, the last on prepared paper.

There seems a kinship of spirit, too, with drawings from the areas of Lorenzo di Credi (cf. Berenson [1938], III, fig. 141 or even 139) and Granacci (*ibid.*, fig. 382). It is worth noting in this connection that Credi's influence has been discerned in certain works of Bronzino's teacher Raffaellino del Garbo (Carpaneto [1970], 15).

48. Bronzino copied a *Madonna* by Leonardo, which the Duchess Eleonora of Tuscany sent as a gift to Spain (Gaye [1839], III, 94). And in the Washington *Holy Family*, which Bronzino painted as a young man while still with Pontormo, he took over a Leonardesque composition and adapted it to Pontormo's manner (Smyth [1949], 200–201). Michael Levey has pointed recently to the awareness of Leonardo that the Faudel-Phillips *Madonna* indicates (M. Levey, "Sacred and Profane Significance in Two Paintings by Bronzino," *Studies in Renaissance and Baroque Art Presented to Anthony Blunt on his 60th Birthday*, London and New York [1967], 30).

49. Vasari-Milanesi, VI, 246; Cox-Rearick, *Pontormo* [1964], 17 and 21.

50. See the excellent reproduction in color in M. Meiss, *The Great Age of Fresco, Discoveries, Recoveries, and Survivals*, New York [1970], 212; also Emiliani [1960], pl. 45; Emiliani, in *Acropoli* [1960/61], 129 (illus.).

51. Louvre, Inv. 17 (from volume II, p. 5 of the Baldinucci Collection). In black chalk, stumped, heightened with white, cut out and mounted on another sheet measuring 288 × 218 mm. As by Bronzino in H. Voss, *Zeichnungen der italienischen Spätrenaissance*, Munich [1928], 13 (with reproduction); *Portraits et figures de femmes*, Musée de l'Orangerie, Paris [1935], 17; Smyth [1955], 42–43, fig. 119 (identified as for the *Miraculous Spring of Moses*); R. Bacou, *Choix de dessins de maitres florentins et siennois, première moitié du XVI^e siècle*, mimeographed catalogue, Louvre, Paris [14 September 1955], no. 78 (independently identified as for the fresco); R. Bacou and J. Bean, *Dessins florentins de la collection de Filippo Baldinucci*, Louvre, Paris [1958], no. 13; *idem, Disegni fiorentini del museo del Louvre dalla collezione di Filippo Baldinucci*, Gabinetto Nazionale delle Stampe, Rome [1959], no. 16 and pl. 16; Emiliani [1960], opp. pl. 36; R. Bacou, *Great Drawings of the Louvre Museum, The Italian Drawings*, New York [1968], no. 45 (repro.).

52. I am grateful to Marjorie Licht for the measurement of the head in the fresco taken on a vertical from a level even with the point of the chin to the level of the top of the forehead, as 16.25 cm. My calculation of the same distance in the drawing, using a photograph, is 16.77 cm., a difference of .52 cm., less than one-quarter of an inch, which I assume to be due to the difficulty of measuring the distance in exactly the same way and/or changes during painting.

53. Cf. Popham, *Drawings of Leonardo*, pl. 178.

54. Meiss, *The Great Age of Fresco*, 213.

55. *Ibid.*, 213.

56. Uffizi, 10320F. Giovannoni [1970], 20, no. 3, fig. 3. (The recto is inadvertently connected here with the *Miracle of the Manna*, while the connection of the verso with the *Manna* is omitted.)

57. Smyth [1955], 73–74. Also connected with the same fresco, lower in quality, and still farther from Bronzino is Uffizi 10322F, under the name of Allori, showing the male nude drinking from the stream in a variant rendering (*ibid.*, 74).

58. *Loc. cit.*

59. Frankfort, Staedel Institut, 4344. Pen, brush, black ink, grey and brownish wash, and white heightening over black chalk on blue paper, 262 × 343 mm. By Bronzino for the ceiling of the Chapel of Eleonora da Toledo in Voss [1920], I, 217, note 2. Reproduced and labeled as Bronzino's (with discussion of the scheme, though not of the attribution) by F. Würtenberger, "Die manieristische Deckenmalerei in Mittelitalien," *Römisches Jahrbuch für Kunstgeschichte*, IV [1940], 75 and fig. 32. Cited in Smyth [1949], 195, note 80. Catalogued and discussed in Smyth [1955], 39–41, figs. 114–116. Mentioned in Emiliani [1960], opp. pl. 36; Smyth [1963], 64, note 115; and Shearman [1963], 45–46, fig. 35. For illustration of the ceiling see Emiliani [1960], pls. 33–34; *idem* [1966], pl. IV; Levey [1967], pl. IV.

60. John Shearman [1965], I, 152, has pointed out that on at least one occasion a *modello* occupied an early place in the sequence of studies for a work by Andrea del Sarto rather than coming at the end. While he thought this probably exceptional (there was no other case where a *modello* of Sarto survives with enough other drawings to permit conclusions), he suggested that Sarto did sometimes make a practice of drawing *modelli* early to serve "the function of elaborated compositional drafts which were followed by the definitive studies." This must be the case with Bronzino's Frankfort *modello*.

61. Emiliani [1960], pls. 30–32.

62. Bronzino's letter to Duke Cosimo (Gaye [1839], II, 368–369) is the source for the knowledge that Raffaellino worked at the Imperiale at the same time as Bronzino. See also Vasari-Ricci, IV, 234 and Vasari-Milanesi, V, 99; VI, 318.

63. The figures in the Sala Grande claimed for Bronzino in Smyth [1963], 22, figs. 22 and 23; also Smyth [1955], 177–185.

64. As suggested by Giulio's early will designating Raffaellino heir to the implements of his shop (Hartt [1958], I, 38).

65. Vasari-Milanesi, VI, 213. Raffaellino's name does not appear in records of the Palazzo del Tè, which begin in the summer of 1527 (Hartt [1958], 91–92 and 314), but Vasari knew him so well (see later in the present text) that there is reason to believe him. Possibly Raffaellino was there earlier and active at the Stalle del Tè.

66. Vasari-Milanesi, V, 164–165.

67. Through Raffaellino Bronzino could have known Rosso's compositions for the Madonna delle Lagrime, which Vasari indicates Raffaellino was designated to execute in fresco (*ibid.*). Uffizi 15559F, a copy of one of them, is surely attributable to Bronzino, as was realized by Emiliani and myself independently (Emiliani [1960], repro. on p. 27 but without comment).

68. See footnote 155 below.

69. The Perino of the British Museum's *Deposition* and study for San Marcello (Davidson [1963], Part I, pls. 2 and 3).

70. See Millard Meiss, *Giovanni Bellini's St. Francis*, Princeton [1964], 21 f., for the role of light in scenes of the Stigmatization and particularly in Bellini's picture, where the painter "wishing to dwell on the religious exaltation of St. Francis took the bold step" of eliminating the seraph and the crucifix (p. 31). Meiss goes on to say (*ibid.*): "Later Renaissance and baroque paintings tended increasingly to give to light a metaphysical function, and the seraph was often replaced by the tiny head of an angel." Bronzino's *Stigmatization* in the vault of the chapel is the only example of the scene where the seraph and crucifix were omitted completely and "the supernatural essence [was referred to] by radiance alone" that Meiss cited as a sure instance from the sixteenth century, his next reference being to a seventeenth century *Stigmatization* by Orazio Gentileschi.

71. See P. Pouncey and J. A. Gere, *Italian Drawings . . . in the British Museum: Raphael and his Circle*, London [1962], II, pl. 59 and I, 50 f.

72. F. Valcanover, *Tutta la pittura di Tiziano*, Milan [1960], I, pls. 94 and 96.

73. Active in the Marches at various times since 1506, Lotto left two of his most notable works there in 1531 and 1532. The *Crucifixion* of Monte Sangiusto is dated in the first of these years, the altarpiece of Saint Lucy at Iesi in the second. It is not in fact documented that he himself was present, but it is normally assumed he came and went from about 1530 (and he is documented at Iesi simply for the purpose of executing a painting in 1535). (See P. Zampetti, *Lorenzo Lotto nelle Marche*, Urbino [1953], 24, 26 f., 68). It is besides not inconceivable that Lotto might have stopped to visit court artists at Pesaro on trips back and forth from Venice.) See also Appendix I.

74. A. Banti, *Lorenzo Lotto*, Florence [1953], pl. 139. Lotto's picture is dated 1526, four years before Bronzino came to the Marches.

Meiss (*Bellini*, 21f.) noted that the pictorial field Bronzino designed for his scenes on the ceiling was restricted, implying this may have motivated the omission of the seraph and crucifix. If so, Lotto's precedent could still have alerted him to the possibility of omitting them and giving special stress to light.

75. Proposed in Smyth [1955], 149–158; accepted by Amalia Mezzetti [1965], 32–33, 108) and looked upon favorably by Felton Gibbons ([1968], 79 and 84).

76. P. Pouncey, "Un disegno attribuito a Dosso Dossi," *L'arte antica e moderna*, no. 12, [1960], 385 and pl. 140a.

Felton Gibbons [1968], 266, fig. 227, considers it more likely by Girolamo da Carpi in the Dossi workshop. In any case it must exemplify a kind of drawing to be expected from the Dossi.

77. See Appendix I.

78. The article by Guido Battelli ("Una Deposizione del Bronzino ispirata dal Correggio," *Crispoli*, III [1935], 415f.) appears to have escaped notice; Battelli suggests that Correggio's *Deposition*, painted about 1524 for the Del Bono chapel (A. E. Popham, *Correggio's Drawings*, London [1957], 59 and pl. Lb), was the direct source for Bronzino's *Pietà* from Sta. Trinita (Emiliani [1960], pl. 66), regarded by most observers as a work of the late 1520's (see note 21 above). Although there are other sources for the *Pietà* as well, Correggio's picture does seem a possible one. If so, it is instructive to see how much of its style Bronzino rejected. But there is an earlier work of Bronzino's where I think he accepted more of Correggio's style—or rather tried to—namely, the *Saint Benedict Tempted in the Wilderness* (Emiliani [1960], pls. 1–3). My explanation of the peculiarities of this curious fresco seems to me correct as far as it goes, but insufficient (Smyth [1949], 192–193). The oddity of the picture, in both form and emotion and for both Bronzino and Florence in the mid-1520's, would be more understandable if we knew Bronzino had seen Correggio's second painting in the Del Bono chapel, the *Martyrdom of Saints Placidus, Flavia, Eutychius, and Victorinus* (compare particularly Emiliani [1960], pl. 3 and Popham, *op. cit.*, pl. XLVII, but comparisons in other respects will come to mind as well). And once having gone so far as to suppose Bronzino may have gone over the mountains to Parma about 1525 to look at Correggio's new cupola and other decorations in S. Giovanni Evangelista (about which a young Florentine artist should have been very curious), we have an explanation for a quality of emotion and for certain faces and expressions in other products of Bronzino's hand from the mid-1520's (especially the Washington *Holy Family*'s Saint Elizabeth and Christ Child [Emiliani (1960), pl. 6]) that I find increasingly puzzling if interpreted simply as deficient imitations of Pontormo. The old explanation makes less sense the more one learns of Bronzino's capacity on other occasions for imitating Pontormo well and the more one considers the speed with which he was able to go from his work of the mid-1520's

61

to the *Pygmalion and Galatea* of 1529/30 (*ibid.*, pls. 8, 9) and the *Portrait of Guidobaldo* of 1531/32 (*Fig. 2*). But if Bronzino, while still close to the education he had had from Garbo and trying to free himself from its limitations with the help of the extraordinary Pontormo, suddenly felt the impact of the extraordinary Correggio and, shaken, tried to incorporate a little of Correggio as well as Pontormo, then what he produced in the mid-1520's—and the particular variety within it—seems more comprehensible. In 1530/32 some of his work at Pesaro appears to show sympathy for Correggio (Smyth [1955], 165), not least the Leningrad *Apollo and Marsyas*, so often attributed to Correggio himself (Popham, *op. cit.*, fig. 8).

79. Possibly the faces in the *Stigmatization* will remind of those in the *Study for a Creation of Eve*, Uffizi 465Fr (Cox-Rearick, *Pontormo* [1964], fig. 114). But this is one of those drawings that needs to be discussed in relation to the problem of distinguishing Bronzino from Pontormo. For there is an argument to be made that it is one of the notable Bronzinos still in the Pontormo lists, and I shall return to it. (Keith Andrews viewed the attribution of this drawing to Pontormo with suspicion, it has been gratifying to find; Andrews [1966], 582.)

An exceptional drawing for Poggio a Caiano in pen and wash may also come to mind, Uffizi 454F (*ibid.*, fig. 123). This still appears to fit better at the time of Pontormo's second campaign at Poggio a Caiano, as Berenson thought, when it could be the reflection of Bronzino's new enthusiasm for a more Roman idiom, which was part of what he came back with from the Marches on his return to help Pontormo in the second campaign. Indeed, it is a candidate for consideration as a work by Bronzino. (Again, Andrews has doubted the attribution to Pontormo as well as a date at the time of the first campaign; Andrews [1966], 582.)

80. On the deliberateness of *maniera*, Smyth [1963], esp. 18 and 26.

81. Davidson [1963], part I, pl. 5a.

82. Vasari-Milanesi, V, 603f.; Davidson [1963], part II, 19f.

83. Gibbons [1968], pl. 45. Also the *Apollo* in the Borghese (*ibid.*, pl. 47) or the *Holy Family* in the Capitoline Gallery (*ibid.*, pl. 55).

84. See also A. Mezzetti [1965], pl. 86 (Gibbons [1968], 265, no. 189) for a *modello* attributed to one of the Dossi somewhat similar as regards the quirkiness of the figure.

85. It is worth noting, too, that when listing the few works comparable to the Dossi's ceiling in the Camera delle Cariatidi at the Imperiale (Mezzetti [1965], pl. 40; Gibbons [1968], pls. 183 and 187) Mezzetti mentions Bronzino's ceiling in the Chapel of Eleonora because of the aerial architecture and luminosity (Mezzetti [1965], 33–34). One might add the *putti*-caryatids in both. By my chronology for the work of the Dossi and Bronzino at the Imperiale (note 75 above), Bronzino

knew their ceiling. He would doubtless have been mindful of it then in developing his own remarkable scheme. (For antecedents of the Dossi's scheme, see Gibbons [1968], 82–83).

86. Appendix I.

87. Cox-Rearick, *Pontormo* [1964], figs. 185 and 186.

88. Cf. Berenson [1938], III, fig. 191. Garbo had a Botticelli-like mode among others (Carpaneto [1970], 13 and fig. 13).

89. R. Van Marle, *The Development of the Italian Schools of Painting*, The Hague [1931], XII, figs. 286 and 283; Carpaneto [1970], figs. 17 and 20. (There is possibly something German reflected in Bronzino's *Saint Jerome* as well, as Janos Scholz once suggested to me.)

90. K. B. Neilson, *Filippino Lippi, A Critical Study*, Cambridge, Mass. [1938], fig. 100 or Smyth [1949], fig. 20b.

91. Smyth [1949], figs. 5 and 8.

92. Hartt [1958], II, figs. 358, 359.

93. Oxford, Christ Church, nos. 0170 and 1142, first called to my attention by Philip Pouncey, who noticed that they were connected with Bronzino's fresco and were by one hand. James Byam Shaw observed that they were originally one drawing. (Gernsheim Photo Archive, nos. 41312 and 41858 respectively.)

94. For example, in no. 0170, the figures one above another at left next to the nude, which are not present in the fresco.

Vasari reported that an engraving of the *Red Sea* had been published in Antwerp (Vasari-Milanesi, VII, 597). Not listed in Hollstein's list of Cock's prints, the engraving is inscribed with Hieronymous Cock's name. I hope to reproduce it in a subsequent discussion.

95. Cock's earliest dated prints are from 1550.

96. Smyth (1955), 74. Pouncey had thought the two drawings might be Allori's. The fact that they show differences from Bronzino's composition in the fresco, and *pentimenti* as well, was initially very puzzling because I was not aware of the connection with Cock's engraving. Nevertheless, I could not see Bronzino's hand. Byam Shaw has also considered them Allori's, concluding that they were made by Allori early in his career as a free adaptation or reminiscence of the fresco (in a draft of the forthcoming catalogue of drawings at Christ Church). Recently in trying to solve the puzzle, upon learning from Mrs. Cox-Rearick and Mr. Byam Shaw that

she entertained the possibility of Bronzino's authorship and had written about it, I thought to consult the engraving. We shall be concerned with a drawing farther on (*Fig. 25*) that indicates Bronzino allowed a trusted assistant on occasion to share in developing his designs. There is no reason to suppose this could not have been true on the occasion of the preparation of a revised, updated version of the old composition for publication.

97. Uffizi 13846F, showing a figure from the chapel, the Virgin of the *Annunciation* flanking the altarpiece, will be mentioned later since the *Annunciation* is datable in the sixties (see note 212 below). For such a large commission more drawings in all probability survive, though I have not found more that are at once undeniably connected with it and acceptable as originals.

98. See, however, the accounts of what has been known about them in McComb [1928], 21–25 and Emiliani [1960], 73–76.

99. Vasari-Milanesi, VI, 283–284; VII, 599.

100. Viale Ferraro [1961], 18–22. H. Göbel, *Wandteppiche*, Part II, *Die romanischen Länder*, Leipzig [1928], I, 371f., 405f.

101. Uffizi 570F (Forlani [1963], 27, no. 17, fig. 9) and 6357F (our *Fig. 34*). Geisenheimer [1909], 143, note 1c.

102. Heikamp [1969], 63, note 9.

103. *Ibid.*, 35.

104. Florence, Uffizi 15721F. Pen, brown ink, brown wash, heightened with white over black chalk on yellow-brown paper, squared in black chalk, 580 × 425 mm. By A. Allori after the cartoon for the tapestry of *Joseph in Prison* in Geisenheimer [1909], 143, note 1a; by Allori after the tapestry in McComb [1928], 166. By Bronzino for the tapestry in Smyth [1955], 43–46, figs. 120, 121 and in Heikamp [1969], 35, 63, fig. 1. From the workshop of Bronzino in Giovannoni [1970], 19, no. 1.

105. Geisenheimer [1909], 143, note 1.

106. As Heikamp [1969], 35, observed, the figure has a cap on his head and hat in his hand, both missing in the tapestry, where the figure holds a *cartellino* not present in the drawing.

107. Compare, for example, Emiliani [1960], pls. 80 or 83.

108. Compare *ibid.* pls. 40, 61, 79, 91.

109. For random examples see Joseph Meder, *Die Handzeichnung, ihre Technik und Entwicklung*, Vienna [1919], figs. 150, 60, 148; or Berenson [1938], III, figs. 82–85.

110. A. E. Popham and P. Pouncey, *Italian Drawings . . . in the British Museum: The XIV and XV Centuries*, London [1950], pl. CXXI.

111. Cf. G. Marlier, *La renaissance flamande, Pierre Coeck d'Alost*, Brussels [1966], figs. 212 and 249; L. Baldass, "Bernaert van Orleys Ruhe auf der Flucht nach Ägypten," *Jahrbuch für Kunstwissenschaft* [1926], fig. 5 opp. p. 134.

112. Cf. M. J. Friedlaender, "Bernaert van Orley," *Jahrbuch der preussischen Kunstsammlungen*, XXX [1909], pl. opp. p. 92. For passages less similar in technique but elaborate in detail and stylization, see *ibid.*, 156 f., figs. 41–45, and Marlier, *op. cit.*, fig. 255.

113. See J. Bean, *100 European Drawings in the Metropolitan Museum of Art*, New York [n.d.], no. 8.

114. Cf. Perino's drawing of *Saint Peter and Saint John Healing the Lame Man* in the Metropolitan Museum (*The Mannerist Figure*, exhib. cat., The Fogg Museum, Cambridge, Mass. [1962], no. 22).

115. The drawing attributed to Perino by Konrad Oberhuber, "Observations on Perino del Vaga," *Master Drawings*, IV [1966], 179–180, fig. 5.

116. Cf. P. Barocchi, *Vasari Pittore*, Florence [1964], pl. 26.

117. Cf. Voss [1920], I, figs. 79–82.

118. Compare the Salviati drawing, Uffizi 1077S, for the Sala di Udienza in the Palazzo Vecchio, datable about 1543–45 (Gernsheim photo no. 40436).

119. London, British Museum, Pp. 2/95. Pen, brown ink and brown wash over leadpoint, heightened with white on blue paper, 346 × 226 mm. (at top), 239 mm. (at bottom). Inscribed below at left *41*. Geisenheimer pointed out to the museum the connection with the borders of the Joseph series. Classified as Bronzino there. Called to my attention originally by Philip Pouncey. By Bronzino in Smyth [1955], 48, fig. 123 a; Heikamp [1968], 22, fig. 1, and Heikamp [1969], 35, 63, note 15.

120. Geisenheimer [1909], 143, note 1; Heikamp [1969], 35.

121. Geisenheimer [1909], 143, note 1.

122. We can be sure all the seven Joseph tapestries delivered before 15 July 1549 had borders when they were inventoried on that date (Appendix III) because of the following. One of the seven was made to fit over a doorway, the *Joseph Selling Grain*

65

to his Brothers (*Fig. 24*), and thus one side of it (except at the top) consists only of a frieze. The measures of all its parts were recorded in the inventory, and these included explicitly the frieze on that side (Rigoni [1884], 73; Geisenheimer [1909], 143, though he missed this, *ibid.*, note 1). Hence we can only assume that the whole frieze was present. The inventory measurements of the height and width of the other three tapestries of wide size agree approximately, as do the measurements of height for the three narrow ones. Consequently, even if we did not know the kind of measurement we are dealing with in this inventory, we could assume the tapestries all had friezes at this time. (As it turns out, the measurements prove to be in Roman *braccia*; see Appendix II, where the Roman measure emerges as practically exact for Bronzino's three *portiere* in the 1549 inventory and a possible reason for the use of Roman *braccia* is given. In most cases they are very close to modern measurements of the Joseph tapestries *with* their borders. Those for the *Joseph in Prison* [*Fig. 15*] are closest, off by only 2 cm. in height and 6 cm. in width.) The first existing record of payment for border cartoons dates from 13 July 1549, only two days before the inventory. Obviously, however, the work of designing and weaving the borders of the tapestries listed in the inventory had started long before.

Granted this, there is no reason to suppose the borders were not woven with the tapestries originally, especially in view of their integration with the main field by virtue of the way figures and decorative elements in the borders impinge on the main field.

Geisenheimer's idea that the borders were added later arose from the circumstance that the measurements of the inventory of 1549 are in Roman *braccia* while those in the inventory of 1553 (see Appendix II) are in Florentine *braccia* (though only roughly approximate). Unless this is understood, it looks, from a comparison of the inventories, as if the tapestries had been enlarged between these dates. But since the apparent enlargement is about twice as great in length as in width, it should have been plain that the supposed difference could not have been due to the addition of borders, which are the same width all the way around. (In several cases I owe my knowledge of present-day official measurements of Joseph tapestries to information from Edward Sanchez.)

123. Emiliani [1960], pls. 43 and 44.

124. *Ibid.*, pl. 21.

125. *Ibid.*, pl. 9.

126. *Ibid.*, pl. 19.

127. Is there also some reflection again of Perino, as represented by his drawing at Windsor for Castel Sant' Angelo (A. E. Popham and J. Wilde, *The Italian Drawings of the XV and XVI Centuries . . . at Windsor Castle*, London [1949], pl. 73)?

128. Cf. the example, a complex frieze, in Forlani [1962], pl. 103.

129. The reference is given in Appendix II.

130. See the comparisons between this *Primavera* and Brussels tapestries in H. Göbel, *Wandteppiche*, part II, vol. I, 381–382 and part I, vol. II, pls. 158 and 159: "Der Behang erinnert lebhaft an die um die Mitte des 16. Jahrhunderts in den Brüsseler Ateliers häufig auf die Gezeuge gelegten reinen Gärtenteppiche die allerdings allegorische Figuren vollkommen ausschalteten." Also Heikamp [1969], 36.

131. The verso of Uffizi 6695F, formerly attributed to Pontormo, shows a peacock in red chalk which I have labeled Bronzino's on the grounds of its style and the style of the sketch of a nude male in black chalk on the recto (Smyth [1955], 62–63). The peacock has recently been linked with this tapestry of *Primavera* by Heikamp, a connection in which he found support for attributing the tapestry to Bronzino (Heikamp [1968], 25, 30 and fig. 6; *idem* [1969], 36, 63, note 17). Very likely he is correct about the relationship, and his acceptance of the drawing's attribution is welcome. But the peacocks of drawing and tapestry are not so precisely alike as to make the connection indisputable, and the style of the nude points to an earlier date for the recto. Thus the drawing does not qualify for the present discussion.

132. Appendix II. Formerly thought from 1553.

133. Panofsky [1939], 85–86.

134. Appendix II. Formerly thought from 1549. Panofsky (*ibid.*) noted the slight difference in mode.

135. Appendix III.

136. Milan, Biblioteca Ambrosiana, Codex Resta, fol. 61. Ink and brown wash over black chalk heightened with white on grey-green paper, 318×218 mm. (visible, that is; the border covers a fraction). Attributed to Vasari by Resta and in G. Fubini, *Cento tavole del Codice Resta*, Fontes Ambrosiani in lucem editi cura et studio Biblioteca Ambrosianae, XIX, Milan, [1955], pl. 61. As by Bronzino in Heikamp [1968], 25, fig. 3 and Heikamp [1969], 34, 63, note 4.

137. The bent leg of Innocence, for instance, related to that of the figure at Pharoah's feast (*Fig. 16*) but more exaggerated.

138. Panofsky [1939], 84.

139. For the influence of antique relief, see Smyth [1963], 14–17, 23, 25–27.
There are two drawings of the *Vindication of Innocence* at the British Museum. (1) Inv. no. 1943–11–13–3 in pen and brown ink, brown wash, heightened with white on blue paper. On the ground that it seemed somewhat pat and empty, it was classified as a faithful copy of a drawing by Bronzino in Smyth [1955], 76. The

British Museum labels it as after Bronzino. The emergence of the Resta drawing confirms this. (2) Inv. no. 1895-9-15-559 in lead point and black chalk on blue paper. Because it is full of adjustments in the position of major elements in the design, it might seem that Bronzino should be responsible. But the drawing was sketched first in a weak way and then adjusted and reinforced in a manner too calligraphic in its final effect for Bronzino and not at all in keeping with the effect achieved in the tapestry or Resta drawing. It must be a pupil's or assistant's.

140. True even of *Joseph Recounting his Dream of the Sun, Moon, and Stars*, where it is not a question of two episodes but of illustrating the dream Joseph is telling (*Fig. 35*).

141. Florence, Uffizi, 15168F. Pen and brown wash over leadpoint or black chalk and squared, 604 × 240 mm. By Allori in Geisenheimer [1909], 142, note 1. By an assistant of Bronzino, possibly Raffaellino dal Colle but perhaps someone of a younger generation in Smyth [1955], 75, figs. 139–141. A copy from Bronzino's cartoon in Emiliani [1960], 74. From the workshop of Bronzino in Heikamp [1969], 63, note 9. (Iris Cheney and Robert Rosenblum once argued against Bronzino's responsibility for this drawing in a discussion that contributed to my first conclusions about it.)

(Another drawing, Uffizi 10316F, also shows *Joseph Seizing Simeon*. It is in reverse and practically a final version of the composition. All commenting on it have agreed it is not by Bronzino: Geisenheimer [1909], 142; Smyth [1955], 76; Emiliani [1960], 74; Heikamp [1969], 63, note 9; and Giovannoni [1970], 19, note 2, who reaffirms the Uffizi classification as A. Allori, regarding it as a copy of Bronzino's cartoon and among Allori's earliest works.)

142. Gaye [1839], II, 368–369; Patzak [1908], 17.

143. Venturi [1933], figs. 343 and 344.

144. For bibliography and accounts of Raffaellino dal Colle, see *ibid.*, 607–620 and W. Bombe in Thieme-Becker, 215–218. Also F. Hartt, "Raphael and Giulio Romano, with Notes on the Raphael School," *Art Bulletin*, XXVI [1944], 67f.; *idem*, "The Chronology of the Sala di Costantina," *Gazette des Beaux-Arts*, Ser. 6, XXXVI [1949], 304; *idem*, [1958]; S. J. Freedberg, *Painting of the High Renaissance in Florence and Rome*, Cambridge, Mass. [1961], 369–370; plus other references in this and the following notes.

For the documentary evidence concerning the authorship and date of the *Resurrection* in the Cathedral at Borgo San Sepolcro, see note 154 below.

The *Assumption* in the gallery at Città di Castello is from the church of San Francesco (from the altar of the Albizzini family) according to G. Magherini-Graziani, *L'arte a Città di Castello*, Città di Castello [1897], 187. A document of 1588 given by Giustiniani degli Azzi Vitelleschi, *Gli archivi della storia d'Italia*, series II, vol. IV (vol. IX of the collection), Rocca S. Cassiano [1915], 221, shows that about 1560 Raffaellino dal Colle painted a large panel in the church of "San Francesco di

Castello." In the early seventeenth century an *Assumption* was the only painting by Raffaellino listed in the church of San Francesco by Angelo Conti, *Fiori vaghi delle vite de' santi e beati della Città di Castello*, Città di Castello [1627], 164. (Conti is said by Mancini, antiquarian of Città di Castello, to have been a contemporary of Raffaellino as well as a citizen of the town: G. Mancini, "Intorno alla patria, alle opere ... di Raffaellino del Colle, discepolo di Raffaello di Urbino e di Giulio Romano ...," *Giornale arcadico di scienze lettere ed arti*, LXX, January-March [1837], 276. The only copy of Conti's book I have found [with the help of the late Werner Cohn] is in Città di Castello.) The *Assumption* remains the one work by Raffaellino listed in the church by L. Lanzi, *Storia pittorica dell' Italia*, Bassano [1795–1796], I, 160 and G. Mancini, *Istruzione storico-pittorico per visitare le chiese e palazzi di Città di Castello, colle memorie di alcuni artefici del disegno che in ditta città fiorirono*, Perugia [1832], I, 141; II, 76. All the evidence points, therefore, to the *Assumption* of the gallery as the picture painted by Raffaellino about 1560.

The source for Raffaellino's authorship of the *Deposition* in the gallery at Città di Castello is Angelo Conti. In his book of 1627 (*op. cit.*, 164) "la Sconficcatione di Christo dalla Croce" is one of three paintings by Raffaellino that he lists in the "Chiesa e Convento de' Servi della Madonna." The *Deposition* in the gallery is always reported to be from this church. Vasari (Vasari-Milanesi, VI, 214) mentions that Raffaellino did "alcun' altre opere per i frati de' Servi a Città di Castello" in what sounds from the context like the mid- to later 1520's. But the style of the *Deposition* indicates it is likely to have been painted after Colle's stay in Florence with Bronzino. The other two pictures listed by Conti were an Annunciation and a "Presentation of the Madonna in the Temple", both of which subjects are also represented in the gallery at Città di Castello by pictures reported to come from the same church. (Venturi [1933], figs. 342 and 346.) These both present problems of quality and style, as suggested by Lanzi's exclusion of them from Raffaellino's work. One of them, the Presentation, I think may be a work of collaboration with Giovanni Paolo dal Borgo and perhaps dates after 1546, whereas the *Annunciation*, puzzling features of which may be due to an assistant, could fit in the mid-1520's.

145. Conti [1875], 48.

146. See Freedberg, *Painting of the High Renaissance in Florence and Rome*, 369–370.
The primary source for Raffaellino's work in Rome is Vasari (Vasari-Ricci, IV, 330 and Vasari-Milanesi, V, 533–534). Vasari connects him with the Sala di Costantino; and beginning with Gaspare Celio, *Memorie di nomi degli artefici delle pitture, che sono in alcune chiese, facciate, e palazzi di Roma*, Naples [1638], 115–116, Raffaellino is said specifically to have painted the *Donation of Constantine* in the the Sala di Costantino. (Not normally cited concerning Raffaellino, Celio wrote in 1620 [little more than fifty years after Raffaellino's death] according to S. Bonino's introduction to the book. Celio's statement is followed by Scanelli and Titi.) Celio (126–127, 110f.) also made Raffaellino one of Raphael's assistants in the Sala di Psyche at the Farnesina (naming no specific part) and in the *logge* at the Vatican, where he lists the *Deluge* and *Golden Calf* as his (again followed by Scanelli and Titi). (J. Hess, "Raphael

and Giulio Romano," *Gazette des Beaux-Arts*, ser. 6, XXXII [1947], 78, believed Celio's mention of him at the Farnesina simply a free interpretation of Vasari's words in Vasari-Milanesi, V, 533, where there is no reference to the Farnesina.)The stiff sweeps of drapery, the types, and the short-limbed figures in the *Deluge* do recall Raffaellino, and the *Mercury Guiding Psyche to Olympus* in the Farnesina does as well, I think.

147. Vasari-Milanesi, V, 163–165.

148. *Idem*, VI, 228–229.

149. *Ibid.*, 214.

150. Vasari-Milanesi, VIII, 252–253.
 Nineteenth century writers on Raffaellino were puzzled that Vasari did not devote a Life to him as he did to Gherardi (for example, Lanzi, *op. cit.*, I, 160).

151. Paris, Louvre, Inv. 3468. Black chalk, pen and brown ink, brown wash, heightened with white and squared in black chalk, 370 × 280 mm. This drawing has not been connected with Raffaellino dal Colle before to my knowledge.

152. The figure of Christ also appears in the *Noli me tangere* in Madrid which has been associated usually with Giulio Romano but which, as Wilde observed, seems nearer Raffaellino (J. Wilde, "Cartonetti by Michelangelo," *Burlington Magazine*, CI [1959], 373 and fig. 3).

153. What appears to be the earliest mention of the *Resurrection* of San Rocco places it "alla Confraternità del Santiss Crocifisso" (Pietro Farulli, *Annali e memorie dell' antica e nobile città di S. Sepolcro*, Foligno [preface dated 1713], 77). This is the company that built the Church of San Rocco after 1554, when the church called "del Crocifisso" was destroyed (see L. Coleschi, *Storia della città di San Sepolcro*, Città di Castello [1886], 171–172). Other old references to the *Resurrection* in San Rocco are: Lanzi, *op. cit.*, I, 160; Giacomo Mancini, *Istruzione storico-pittorico . . .*, *op. cit.*, 275; *idem*, *Intorno alla patria . . .*, *op. cit.*, 289; Coleschi, *op. cit.*, 172; and O. H. Giglioli, *Borgo San Sepolcro*, Florence [1921], 34.

154. Mancini and Giglioli (see the previous note) thought the San Rocco picture was the *Resurrection* referred to by Vasari as having been painted by Raffaellino in the later 1520's for the Chapel of Saints Gilio and Arcanio (Vasari-Milanesi, VI, 213–214). Milanesi considered the *Resurrection* Vasari mentioned as lost, on what grounds he did not say (*ibid.*, 214, note 1). Almost certainly, however, Vasari was referring to the *Resurrection* in the Cathedral because the chapel of the two saints preceded the Cathedral at the site and remained connected with it (see Coleschi, *op. cit.*, 165 for the chapel) and because Vasari's statement that the picture imitated Giulio and Raphael applies much more to the Cathedral than to the San Rocco

version. The painting was recorded in the Cathedral as early as 1713 (Farulli, *op. cit.*, 77). (It is possible that Farulli's statement of Raffaellino's authorship depends, not only on local tradition, but on an early manuscript chronicle of Borgo San Sepolcro he cites on p. 76 as "il Bercordati," by which is meant "L'anonimo della historia Burgi sancti Sepulcri, Cod. 25 Pluteo LXVI della Biblioteca Medicea Laurenziana," cited in Coleschi, *op. cit.*, 5, not consulted by me.)

The order of events in Vasari's account (Vasari-Milanesi, VI, 213–214) dates the Cathedral picture at the time Gherardi entered Raffaellino's shop before Rosso's arrival in Borgo San Sepolcro following the sack of Rome—and hence between 1524 when the Sala di Costantino, on which Colle is said by Vasari and Celio to have worked, was probably finished (Hess, *op. cit.*, 88 and Hartt [1958], 45, note 1) and the early months of 1528 when, even if he worked in the meantime at Mantua, Raffaellino was certainly back in Borgo. For on 1 July 1528 Rosso was commissioned to paint the *Christ in Glory* for Città di Castello (Vasari-Milanesi, V, 163 and 164, note 1) but, according to Vasari, had already arrived before this and got the commission for his *Deposition* at Borgo thanks to Raffaellino. (Vasari was in a position to know since he himself visited Borgo to see Rosso in 1528 and met Gherardi [*idem*, VI, 216].)

155. There is another drawing at the Louvre (no. 3611) with some claim to be considered Raffaellino's on evidence other than style. It reproduces the composition of Giulio Romano's altarpiece at Sta. Maria dell' Anima and bears the inscription in a fairly old hand: "operà famosa di Giulio Romo. si può tener per originale, ma è dal Colle suo discepolo. similisso. e bello quanto l'originale." On the mount is written in a more modern hand: "Raffaelle dal Colle. da Giulio Romano. en 1567." Since Raffaellino died in 1567 (Venturi [1933], 610) this might repeat an inscription made at the time of his death.

As it happens, Raffaellino was the owner of the cartoon by Giulio for the painting in Sta. Maria dell' Anima, as recorded by Beato Alberti: "A dì 10 di giunio 1571 Carbino e Alesandro miei comperàro uno cartone da Michelagnilo di Rafaelle dal Colle pittore: ditto cartone è di Gulio Romano di la taula che feci in la capella di S. Maria di l'anime; mi pare, li dettero sc. $6^1/_2$, coe sc. $6^1/_2$." (G. degli Azzi Vitelleschi, *op. cit.*, 206.)

Any of Raffaellino's pupils could have copied the cartoon. Louvre 3611 is weaker than the drawing of the *Resurrection*. I first thought it a pupil's work, mistaken as Raffaellino's by someone after his death, but I think now it could be by him.

Thanks to Celio's fairly early connection of Raffaellino's name with the *Donation of Constantine* (footnote 146 above), the preparatory study for the fresco at the Ashmolean Museum (K. T. Parker, *Catalogue of the Collection of Drawings in the Ashmolean Museum*, II, *Italian Schools*, Oxford [1956], 119, no. 248, pl. LXIII) has a circumstantial link to him. Gere saw two hands in it (J. A. Gere, "Drawings in the Ashmolean Museum," *Burlington Magazine*, XCIX [1957], 161). It seems worth considering whether the weaker one may be that of Giovanni da Lione, whom Vasari mentioned together with Raffaellino as helping in the Sala di Costantino. There are some reasons for believing him Giovanni Paolo dal Borgo, I believe, and

71

it is worth comparing the weaker hand of the Ashmolean drawing, as represented by the unreworked figure at right, with the drawing by Giovanni Paolo in the Louvre (J. Bean in *Master Drawings*, VII [1969], 56, pl. 33) especially with respect to the face, with its small high mouth, and the large hand. As to whether the stronger draughtsman who went over the drawing could be Raffaellino instead of Giulio, it seems conceivable, but it is hard to say more.

156. Emiliani [1960], pl. 41.

157. Appendix III.

158. Since records of delivery are missing for most Joseph tapestries arriving between the summer of 1549 and the inventory of 1553, to determine their chronology is largely a matter of style. The *Benjamin Received by Joseph* is one of those showing most kinship with early tapestries like *Joseph Seizing Simeon* (*Fig. 26*), in contrast, for example, to the *Jacob Arriving in Egypt* delivered in 1553 (see p. 40 below).

159. Florence, Uffizi, 10311F. Brush, black ink, brown to grey wash, and white heightening over leadpoint on darkish buff paper, 670 × 270 mm. The right side has apparently been cropped slightly, eliminating a narrow strip containing the upper framing element and a small portion of the figures at the edge. A copy by A. Allori after the cartoon for the tapestry of *Joseph Receiving Benjamin* in Geisenheimer [1909], 147, note 2; by A. Allori after the tapestry in McComb [1928], 167. By Bronzino for the tapestry in Smyth [1955], 49–51, figs. 125, 126. From the workshop of Bronzino in Heikamp [1969], 63, note 9.

160. In the faces of the three brothers at the right of the drawing, the drapery of Benjamin, the line of the platform, and in several respects to be mentioned in the text.

161. Emiliani [1960], pls. 30–32.

162. The face at the very edge of the drawing at right recalls Colle's presence.

163. See Sarto's *modello* for Poggio a Caiano, as Shearman showed it to be (Shearman [1965], I, 151–152, pl. 75c; II, 370), and the one for an *Adoration* (*ibid.*, I, pl. 93).

164. *Ibid.*, I, 153.

165. To judge from his tempera study on linen (Berenson [1938], III, figs. 201, 202).

166. Shearman [1965], I, pls. 52a, 53b, and especially 54.

167. To mention the aspects of Sarto's style in the *Baptism* that Shearman brings out (*ibid.*, 68).

72

168. Compare a detail (*ibid.*, pl. 53b) with a drawing of the *Last Supper* in brush, ink, and wash in the Morgan Library (J. Bean and F. Stampfle, *Drawings from New York Collections, the Italian Renaissance*, The Metropolitan Museum of Art and Pierpont Morgan Library, New York [1965], 20, no. 5).

169. Claimed for him in Smyth [1963], 22, 72–73, figs. 22 and 23; see also G. Marchini, *La Villa Imperiale di Pesaro*, Associazione fra le Casse di Risparmio Italiane [1970], pl. XVI.

170. Compare, for instance, L. Baldass, "Tapisserieentwürfe des niederländischen Romanismus," *Jahrbuch der kunsthistorischen Sammlungen in Wien*, N.F. II [1928], 250, fig. 302; O. Benesch, *Die Zeichnungen der niederländischen Schulen des XV. und XVI. Jahrhunderts ... in der Graphischen Sammlung Albertina*, II, Vienna [1928], nos. 44–46, pls. 13–14.

171. Compare Lotto's *Saint Martin and the Beggar* in brush, wash, and white heightening (Bean and Stampfle, *op. cit.*, pl. 45; P. Pouncey, *Lotto disegnatore*, Vicenza [1965], pl. 11; or E. Schilling, "A Signed Drawing by Lotto," *Gazette des Beaux-Arts*, series 6, XLI [1953], 277–279, figs. 1–2) thought to be from about 1530, when Bronzino would have encountered Lotto's work and conceivably Lotto himself in the Marches (footnote 73 above).

172. Compare particularly Conte in San Giovanni Decollato (Voss [1920], figs. 40–41).

173. Oxford, Ashmolean Museum (no accession number). In black chalk, with traces of very light squaring in black, 434 × 331 mm. (not including the addition of the separate piece of paper at top, which was not originally part of the drawing). The bump, or tab, on the top edge of the drawing itself, containing the hand of one figure, is 24.5 mm. high at its highest point by 72 mm. across at its bottom edge (see footnote 180 below). Inscribed in ink in an old hand on the verso: "del Bronzino." Purchased from P. and D. Colnaghi, Ltd. 1961. Published as Bronzino in *Ashmolean Museum. Report of the Visitors*, Oxford [1961], 58, pl. 14; Andrews [1964], 160, pl. 29; and Heikamp [1969], 34, 63, note 10, fig. 2.

In designing the composition Bronzino appears to have had in mind Raphael's composition of the same subject in the *logge*, which he could have known directly and in prints (and possibly could have been encouraged to draw upon by Colle).

174. Rigoni [1884], 74; Geisenheimer [1909], 143.

175. Vasari-Milanesi, IV, 11.

176. *Ibid.*, 13. Vasari's passage on the new speed of execution was one of the few additions he made to the introduction of Part III of the *Lives* for the new edition of 1568.

177. It has been satisfying to see Michael Levey's parallel estimate of Bronzino's position as a painter, "the last great painter of the Florentine Renaissance ... a worthy representative to close that long tradition: with its sculptural and linear interests, its concern with design and form, its elevated emphasis on the intellectual aspect of art. Not merely was he heir to the High Renaissance of Leonardo and Michelangelo, but he was highly conscious of that heritage. During most of his life Michelangelo was alive, physically absent from Florence and yet ever-present, and when Bronzino wrote to him it was with the timidity of one addressing a legend rather than a man. It was right that Bronzino should serve as one of the two representatives of painting at Michelangelo's funeral; at Bronzino's own death Vasari regretted that there were not some elaborate official obsequies, and certainly it was a whole tradition that expired with Bronzino. Born well within Botticelli's lifetime, he died when the Carracci were growing into manhood. In the year following his death Caravaggio was born. Painters, of course, went on painting in Florence, but the centre of artistic activity for all Italy was shifting to Rome, itself preparing for the triumphant position it would hold throughout the seventeenth century." (Levey [1967], 6).

178. See above, note 9 and p. 21.

179. It would be desirable, however, to see the two sheets together before taking it for granted that they were originally one. See the following note.

180. Florence, Uffizi, 6357F. In black chalk, with what appear to be traces of very light squaring in black, seen at upper left, 190 × 313 mm. The loss at the bottom of the sheet is 23 mm. at its highest point and 89 mm. across at its widest. By Bronzino in Berenson [1903], II, 31, no. 600; Geisenheimer [1909], 143, note 1c (where the relation to the tapestry is indicated); C. Gamba, *I disegni della R. Galleria degli Uffizi*, Florence [1912–1921], series V, I, 10; McComb [1928], 148; Berenson [1938], II, 62, no. 600, III, fig. 1001; Marcucci [1954], 58–59, no. 99; Smyth [1955], 46–47; Berenson [1961], II, 115, no. 600; Forlani [1963], 26, no. 16. From the workshop of Bronzino in Heikamp [1969], 63, note 9. Gamba, McComb and Berenson saw the subject as an "Allegory of the Zodiac," not noting the connection with the tapestry, and although the connection was pointed out in Marcucci [1954] and Forlani [1963], the title remained. (See also note 9 above.)

Whereas the loss at the bottom of the Uffizi sheet is 22.5 mm. high when measured vertically to the top of the curve on the left, the bump, or tab, on the top edge of the Ashmolean Museum's drawing (*Fig. 33*) is 24 mm. high when measured vertically to the top of the corresponding curve—1.5 mm. too high. But the curve of the tab appears to fit the curving left side of the loss and to occur at the right place, to judge by comparison with the composition as executed in the tapestry (*Fig. 35*). Hence if the two drawings were originally one, the indication is that a horizontal strip 1.5 mm. wide between the figure of the moon and the heads of the brothers has been lost in trimming. There is also a discrepancy between the width of the tab and the width of the area of the loss into which it would fit (the tab of the Ashmolean's

drawing measures 72 mm. across at the bottom; the area of loss from the Uffizi's sheet measures 89 mm. across at the same place). This could perfectly well be due to trimming.

Besides the testimony of the tab and the loss, there is that of the circle of the moon. The moon is shared by both sheets, and in both its rim is wider on the left than on the right. The distance between the outer edges of the rim is 111 mm. at the bottom edge of the Uffizi sheet and 106 mm. at the top edge of the Ashmolean sheet. (The distance between the inner lines of the rim is 105 mm. in the first case, 101 mm. in the second.) This small discrepancy would appear to be accounted for if the horizontal strip of 1.5 mm. is assumed to be missing between the two parts of the moon because of trimming.

Trimming could also account for the difference of 18 mm. in the width of the two sheets (that in Florence being 313 mm. wide, that in Oxford 331 mm.) To judge from the composition of the tapestry, both were trimmed at the right, but the Uffizi's sheet (where part of Apollo's hand is missing) more than the Ashmolean's. That the Ashmolean sheet is not trimmed on the left is indicated by the fact that it shows the complete composition there (the composition stops where it should, to allow for the doorway that the tapestry was to fit). But from the left of the Uffizi sheet a slight amount of the composition is missing in relation to the Ashmolean drawing.

Whether the paper is the same in both sheets is difficult, for me at least, to make sure, especially because the sheet in the Ashmolean is mounted on supporting paper and little can be told about it by looking at it against the light. Thus one cannot see if it has the same lines running through it horizontally with respect to the drawing's direction at about 40 mm. intervals, which the sheet in the Uffizi shows. I judge the sheets could have matched as to color, although that in the Uffizi is now slightly browned while the Ashmolean's has remained white.

If we are indeed dealing with parts of an originally complete *modello*, a section with the eleven *putti* that represent the stars would have been cut from the left of the Uffizi sheet. (The odd format of the composition, owing to the doorway, and the way the composition falls into three rather separate parts could have encouraged the dismemberment.) Uffizi 570F, showing the *putti*, does not however clearly qualify as the missing piece, as will be observed.

181. Judged, that is, according to the characterization of *maniera*'s tendencies in the delineation of figures given in Smyth [1963], 12.

182. Cox-Rearick, *Pontormo* [1964], II, figs. 345 and 350.

183. Cf. Berenson [1938], III, figs. 551 and 552.

184. Uffizi 570F; see Forlani [1963], 27, no. 17 and fig. 9. (See also note 9 above.)

185. As the loss of the head of the *putto* at the lower right is enough to show.
From the front of Uffizi 570F it seems impossible, using a magnifying glass, to find any pattern of lines in the paper like the horizontal ones 40 mm. apart in

Uffizi 6357F. (Marjorie Licht confirms this from a separate examination made at my request.) The paper of the two drawings is about the same color, 570F being a little whiter and yellowed more at the bottom, with 6357F a bit browner overall. Also, Uffizi 570F is like Uffizi 6357F and the drawing in the Ashmolean in showing some light vertical and horizontal lines that appear to be traces of squaring.

186. Heikamp [1969], 63, note 9. Doubts were also felt by Marjorie Licht when she examined the sheet at my request.

187. The drawing was accepted as Bronzino's in Smyth [1955], 47–48.

188. Oxford, Christ Church, 1840. In black chalk (and perhaps lead point), 608 × 380 mm. Torn and abraded throughout and in parts coarsely retouched, as James Byam Shaw has observed. I am most grateful to him for showing me this drawing and allowing me to publish it for the first time.

189. Rigoni [1884], 76.

190. Heikamp [1969], 42, fig. 11.

191. Damage to the nose of this figure has increased the Giulio-like appearance, as James Byam Shaw observed to me.

192. Geisenheimer [1909], 145, note 4. For a reproduction of the tapestry, see *ibid.*, 141 or Viale Ferraro [1961], 59.

193. Heikamp [1969], 35, 63, note 13, and fig. 3. The drawing is in the Kupferstich-kabinett und Sammlung der Zeichnungen, Staatliche Museen zu Berlin. It lacks an inventory number, and in the years following the second war it could not be located. I am grateful to the photographic division of the museum for a photograph.

194. On 21 August 1553 (only a month before the inventory of all twenty Joseph tapestries [see Appendix III]) three tapestries arrived from the weaver Rost specifically "for the *sala*" (Geisenheimer [1909], 145) and hence for the Joseph series (this is the way tapestries of the series are designated in the records on several occasions). Since Rost made nine of the series in all and had already delivered six, all identifiable, the three now delivered can be identified, one of them as the *Jacob Arriving in Egypt*, which Geisenheimer noted. (See also Emiliani [1960], 75. Heikamp [1969], 35 put the date of the tapestry at 1549, but to my knowledge there is no documentary basis for this.)

195. Compare Bronzino's tapestry with Raffaellino dal Colle's *Deposition* in Città di Castello (Venturi [1933], fig. 343) in respect to types of figure and drapery. The *Deposition* seems likely to date from after Colle's stay with Bronzino and to reflect it somewhat, but the painting of *Saint Margaret* in Vienna, attributed to Giulio Romano with Raffaellino in S. J. Freedberg, *Painting of the High Renaissance in Rome and Florence*, *op. cit.*, I, 370 and 606; II, fig. 454, offers testimony that figures

heavy of torso and limb in clinging drapery with pleat-like folds, such as could have influenced the prominent standing female of Bronzino's tapestry, go back to Raffaellino's early years.

196. It is tempting to include here instead a fine drawing that I have no doubt is by Bronzino for a tapestry, the drawing at Windsor representing *Narcissus*, attributed to Salviati in Popham and Wilde [1949], 327, no. 895, fig. 171 and to Bronzino in Smyth [1955], 65–67. It represents Narcissus with a tree nymph and evidently Echo, who mourn his death at the spring of Narcissus, following Ovid's *Metamorphoses*, III, 407. Heikamp has very recently published a document that now supports the attribution to Bronzino with some evidence other than style. It shows that a tapestry of the "Passion of Narcissus" was delivered to the ducal *guardaroba* on 1 August 1555 (Heikamp [1969], 70, doc. 4; also 69, document 2, concerning the materials for weaving it). The designer is not named, and the tapestry has not come to light; but Heikamp (*ibid.*, 36) has surmised that it was by Bronzino because a record exists that he was paid from the ducal accounts for three other tapestry cartoons in 1555 and 1556 on themes of Ovid (*ibid.*, 36 and 69, doc. 3). Moreover, two of the tapestries he was credited with in 1555 showed springs, those of Hippocrene and Parnassus (Conti [1875], 50), suggesting that the one dealing with the spring of Narcissus could have belonged with them to a series concerning springs. The special importance of the Windsor drawing lies in its being a type of compositional study not so far represented, a relatively summary drawing evidently done rather rapidly with much sureness, to lay in the main lines of the design. It is also important that a date in the middle of the 1550's is indicated, for which time dated evidence of Bronzino's draughtsmanship is most welcome. (Popham had suggested the date of 1548 for the drawing as a Salviati, and I had dated it as a Bronzino about 1545–1548 before knowing of Heikamp's documents.) But discussion of the *Narcissus* is postponed because, however persuasive the documentary evidence of the connection with Bronzino, it does not guarantee the connection.

197. Florence, Uffizi, 13843F. In black chalk, brush, grey, green, and brownish washes and white heightening on green prepared paper, 725 × 484 mm. Damaged, especially at the bottom, where crude handling indicates repairs. By Bronzino in Ferri [1890], 37 and H. Schulze, *Die Werke Angelo Bronzinos*, Strassburg [1911], viii; as a copy of the painting in McComb [1928], 151. By Bronzino in Smyth [1955], 51–52, fig. 127; Forlani [1962], 178 and pl. 39; Forlani [1963], 28–29, no. 19, fig. 13.

198. Emiliani [1960], opp. pl. 81. (The correct date of commission pointed out by Chiappelli is given; an incorrect date of 1548 was given by A. Venturi in *Storia dell' arte*.)

199. Forlani [1963], 28.

200. J. Wilde, "Cartonetti by Michelangelo," *Burlington Magazine*, CI [1959], 373.

201. One head in Bronzino's *Resurrection* particularly recalls Colle's, the one in deep shadow at the lower right corner.

77

202. Forlani [1962], 178.

203. P. Barocchi, *Il Vasari pittore*, Florence [1964], 21; *idem, Mostra di disegni del Vasari e della sua cerchia*, Gabinetto Disegni e Stampe degli Uffizi, Florence [1964], 17.

204. K. Frey, *Il carteggio di Giorgio Vasari*, I, Munich [1923], 314. Presumably the pictures in question were Bronzino's *Resurrection* for SS. Annunziata and *Deposition* for Sta. Croce, both finished in 1552.

205. A. Venturi, *Storia dell' arte italiana*, IX, part VI, Milan [1933], fig. 90.

206. R. van N. Hadley, ed., *Drawings. Isabella Stewart Gardner Museum*, Boston [1968], 22, pl. 10. Sydney Freedberg very kindly brought this drawing to my attention.

207. Voss [1920], II, fig. 124.

208. Popham and Wilde [1949], 201, no. 143, pl. 34. For the painting see Emiliani [1960], pl. 83.

209. The copyist may be the draughtsman responsible for Uffizi 6358F, which also has the look of a copy. The Windsor drawing was classified as a copy in Smyth [1955], 77–78. Comments on it by Robert Rosenblum helped me to reach this conclusion originally.

In connection with the *Christ in Limbo* at Sta. Croce it may be mentioned that Uffizi 13842F shows its composition, but it is very inferior and certainly a copy.

210. Louvre, Inv. 10900. In black chalk, squared in black chalk, 472 × 237 mm., including the tabs at top and left (468 × 235 mm. without these). The drawing was assigned to Tiarini in recent years.

For the fresco see Emiliani [1960], pl. 97 and text opposite.

211. The drawing, Uffizi 10220F, is classified under the name of Allori.

212. Two compositional studies, Louvre, Inv. 953 and Christ Church, Oxford, 1340, which accord with Bronzino well as to style, would be included at this point if it were not that the external reasons for connecting them with him, while convincing, might theoretically be deniable. Hence they do not quite meet the condition arbitrarily imposed in this essay in an effort to ensure the most reliable basis for considering Bronzino as a draughtsman. The evidence of their subject matter is very strong, however, that they are studies for Bronzino's temporary decorations, now lost, on the occasion of the marriage of Francesco de' Medici to Giovanna of Austria in 1565. In the case of the drawing in the Louvre this connection and the attribution to Bronzino were made in 1913 by Hermann Voss (references and reproductions are in Voss [1920] I, 216, fig. 71 and E. Pillsbury, "The Temporary Façade on the Palazzo Ricasoli: Borghini, Vasari and Bronzino," *Report and Studies in the History of Art 1969*, National Gallery of Art, Washington [1970], 79, 83, note 8 and fig. 5; I owe my acquaintance with this article to James Byam Shaw). The

drawing at Christ Church was identified as Bronzino's independently by James Byam Shaw and by Philip Pouncey (to the latter of whom I owe my knowledge of it for the catalogue entry in Smyth [1955], 58–59; it has recently been cited by Pillsbury, *op.cit.*, 83, note 9). These drawings give a fuller picture of Bronzino as a draughtsman in the 1560's than the Louvre study for the *Saint Lawrence* can do, and I want to discuss them in the future.

Uffizi 13846F (Forlani [1963], 29, no. 21, fig. 14), also in black chalk, shows a figure from a painting of Bronzino's datable in the first half of the 1560's, the Virgin Annunciate flanking the *Deposition* in the Chapel of Eleonora (see the end of note 23 above). The drawing does not qualify as Bronzino's own in my judgment, particularly if the study in the Louvre (*Fig. 40*) is kept in mind.

It could be that the drawing of a female head in Vienna at the Albertina, no. 164a (not in the published catalogue), in black chalk on yellow prepared paper, is a study for the woman at right in Bronzino's very late painting at Sta. Maria Novella in Florence, the *Raising of the Daughter of Jairus* (Emiliani [1960], pl. 98). Inscribed with the name of Raphael and formerly labeled Florentine mid-sixteenth century, it was first pointed out to me by John Shearman as Bronzino's. It has since been published as by Franciabigio in O. Benesch, *Meisterzeichnungen der Albertina*, Salzburg [1964], 326, no. 26, pl. 26. I have no doubt about Shearman's attribution to Bronzino. But if the connection with the painting suggested here is possible, it is by no means sure and the drawing could be earlier.

There are two drawings in the Louvre that one can probably assume record the way Bronzino completed Pontormo's *Deluge* at the Church of San Lorenzo after Pontormo's death, but in any event they do not hold up as Bronzino's own work when judged in relation to such drawings as we have considered. (1) Louvre, no. 1026, from the Baldinucci Collection and formerly classified as by Pontormo, has been given to Bronzino in Clapp [1914], 331; V. Mariani, "Due disegni del Bronzino al Louvre," *L'Arte*, XXIX [1926], 58–60 (with reproduction); McComb [1928], 153; and Berenson [1938], I, 321, II, 63. It was labeled a copy after Bronzino in Smyth [1955], 78–79, and considered probably so in Cox-Rearick, *Pontormo* [1964], I, 406. Reminiscent of Bronzino in such works as the *Brazen Serpent* (Emiliani [1960], pl. 41) and *Resurrection* (*Fig. 39*), it suggests that, while affected by the need to conform with Pontormo's late style in completing his work, Bronzino still kept considerable independence from it. (2) Louvre, no. 1027, also from the Baldinucci Collection, where it was under Bronzino's name, shows one figure from the previous drawing. It was given to Bronzino in Mariani, *op.cit.* (with reproduction); McComb [1928], 153; and Berenson [1938], I, 321, II, 63. It was labeled as a pupil's or assistant's work in Smyth [1955], 79, and as from the same hand as the previous drawing in Cox-Rearick, *Pontormo* [1964], I, 406.

213. There is such an attempt in Smyth [1955] 83–90, to which I still more or less subscribe as far as it goes.

214. P. Pino, *Dialogo di pittura*, Venice [1546] in the edition of R. and A. Pallucchini, Venice [1946], 129–131.

Appendix I

On Non-Florentine Sources of Bronzino's Portraiture

Bronzino's portraiture is looked upon as purely Florentine in origin. Certainly his experience of Pontormo, Michelangelo, and Rosso provided its foundation. The relationship to Pontormo has been stressed most. The Michelangelesque element was emphasized by Berenson ([1938], I, 197, 316–318), and recently Michael Levey has written of it perceptively (Levey [1967]). John Shearman has called attention to the precedent in Rosso (Shearman [1963], 415). But there is reason to believe Bronzino also looked attentively at painting outside Florence and that this had results of importance for the distinctiveness and greatness of his art as a portraitist.

That Bronzino was not looking exclusively to Pontormo in his portraits at the opening of the 1530's is exemplified by the *Portrait of Guidobaldo*, later to be duke of Urbino, which Bronzino painted in 1531/32 while attached for approximately a year and a half (see the text) to the court of Duke Francesco Maria and Duchess Eleonora of Urbino in Pesaro (*Fig. 2*).

There appears every reason to believe (as argued in Smyth [1955], 131–133) that Bronzino depended partly upon Titian for the spreading pose, the placing of the delicate hands, the subdued glow of the armor, and the exceptional importance of color—particularly upon two recent portraits by Titian of Guidobaldo's relatives: the portrait of his uncle Duke Federigo Gonzaga of Mantua, painted probably about 1525 (F. Valcanover, *Tutta la pittura di Tiziano*, Milan [1960], I, pl. 115), and the portrait of his great uncle Alfonso d'Este of Ferrara, painted about 1523 (*ibid.*, 81 and pl. 206B). In 1530 Titian painted a portrait of Federigo Gonzaga in armor, now lost (*ibid.*, 83) which could have been important for Bronzino's handling of Guidobaldo's armor. Eleonora, duchess of Urbino,

should have been familiar at first hand with these portraits of her brother and uncle, as her son Guidobaldo probably was as well. Replicas were made of the first two certainly, and the court of Urbino could have had copies. Moreover, Duke Francesco Maria, commander of the Venetian land forces and thereby most decidedly connected to Venice, very much wanted paintings by Titian at just this time. A letter written to him in July 1532 reports on three pictures that Titian had been commissioned to paint for him (Gronau [1936], 85, doc. II). The duke, duchess, and Guidobaldo were all portrayed by Titian a few years later (Valcanover, *op. cit.*, I, 68, 69, 86), and it was for Guidobaldo himself that Titian painted the *Venus of Urbino* (Gronau, *op. cit.*, 93, doc. XXXI). Under these circumstances it is perfectly conceivable that Bronzino went to see portraits by Titian, including those of the family relatives. For even if he was not specifically directed to paint a Titian-like portrait—and it seems probable enough that he was—he would have understood that his *Guidobaldo* was likely to be judged in relation to this greatest of Venetian painters and the very recent family portraits he had done. It is a case of the influence of patronage. Becherucci wisely noted in the *Guidobaldo* "una più immediata e calma realtà, che quasi richiama il ritratto veneto" (L. Becherucci, *Manieristi Toscani*, Bergamo [1944], 44); and Michael Levey has recently observed that it "shows some definite awareness of Titian" (Levey, [1967], 2). I think that Bronzino painted the portrait in a spirit of emulation and also of competition and that afterwards, when he returned to a more Florentine style, Titian's example still remained a lesson to him, not least for its combination of fidelity and ornamental breadth. (In this connection it is perhaps pertinent to note that Bronzino's portraiture and Titian's seem to have been associated in Vasari's mind. In characterizing Giulio Clovio's portraits he says they are as faithful as portraits by Titian and Bronzino [Vasari-Milanesi, VII, 568]. And Paolo Pino's *Dialogue on Painting* of 1548 favorably compares Titian and Bronzino, not with specific reference to portraits, but as prime representatives of Venetian and Florentine painting [Paolo Pino, *Dialogo di pittura*, Venice [1548] in the edition of R. and A. Pallucchini, Venice [1946], 129–131].)

Nor was Titian the only non-Florentine toward whose portraits Bronzino looked at the opening of the 1530's. The head of Guidobaldo

is not like Titian but reminiscent instead of Sebastiano del Piombo: in the effect of the dark hair, beard, mustache, and brows, the pattern they form, the way they enclose the lighted face and contrast with it, the almost schematic drawing of the eyes and mouth. It is worth comparing Sebastiano's portraits in Sarasota and formerly in the Lansdowne Collection (R. Pallucchini, *Sebastiano Viniziano*, Milan [1944], pls. 58 and 42) and especially the portrait Sebastiano painted about 1524 of his friend Francesco Arsille from Senigallia (*ibid.*, pl. 57), who was the duke of Urbino's physician and present at his court in 1531 at the very same time as Bronzino (witnessed by a letter of 16 June 1531 from Sebastiano to Michelangelo in G. Milanesi, *Les correspondants de Michelange*, I, *Sebastiano del Piombo*, Paris [1890], 52). Sebastiano's effect upon Bronzino was more pervasive than this isolated instance and came probably through personal contact as well as example, as I intend to explain in a study of Bronzino at the Villa Imperiale. (That they probably met in Pesaro is suggested in Smyth [1963], 72–73, note 153.)

Meanwhile, in the *Portrait of the Man with a Lute*, the painted version (Emiliani [1960], pl. 18), the Caravaggesque realism and chiaroscuro and the atmospheric effect about the hands suggest that on this occasion Bronzino had more in mind portraits by Dosso Dossi (cf. Gibbons [1968], pl. 61). Dosso was court painter to the duchess of Urbino's uncle Alfonso. There is reason to believe Bronzino succeeded him and Battista Dossi in the work of decorating the Villa Imperiale at Pesaro, helping to complete some of the decorations they left unfinished (Smyth [1955], 144–160 and footnote 75 above). Portraits by Dosso Bronzino might conceivably have seen at the court of Urbino— or on a visit to Ferrara, which, as mentioned elsewhere in this book, he could have made. At the same time, the *Man with a Lute* could reflect some knowledge of portraits of Parmigianino's Bolognese period, from 1527 to 1531, seen perhaps on an excursion or on the way home from Pesaro by the route the train from Pesaro to Florence follows today (cf. S. Freedberg, *Parmigianino, His Works in Painting*, Harvard University Press, Cambridge [1950], pls. 125 and 131).

More important to Bronzino, it seems to me, was Lotto, who was apparently active in the Marches during the time Bronzino was there (see footnote 73). Although Bronzino translated what he received into Florentine terms, I believe he absorbed much for his portraits

of the 1530's from portraits by Lotto, including encouragement for the use of books and sculpture as emblems, for the importance given hands and setting, for elegance and optical objectivity, even for color and for the handling of paint—at once precise and sensuous. (Compare, for example, the *Ugolino Martelli* with the *Portrait of a Youth in his Study* in the Accademia at Venice, commonly dated around 1527 [Anna Banti, *Lorenzo Lotto*, Florence [1953], pls. 152 and VI; R. Pallucchini, *Lorenzo Lotto*, Milan [1953], pls. XI–XII]. Nor is it only the similarity of the facial type that makes a striking comparison of the drawing of a head in the Uffizi, 1876F [Banti, *op. cit.*, pl. 20; P. Pouncey, *Lotto disegnatore*, Vicenza [1965], pl. 12] with the head of Bartolomeo Panciatichi [Emiliani [1960], pl. 22].) Bronzino could conceivably have met Lotto in the Marches, he could hardly have missed seeing his work there, and he could have gone to Venice and seen portraits there as well, as suggested elsewhere in this essay.

Bronzino could look back to the fifteenth century with understanding by virtue particularly of his artistic education under Raffaellino del Garbo (Smyth [1949], 205). At the court of Urbino he had a famous predecessor, a fifteenth century painter we can expect him to have admired, Piero della Francesca. In Bronzino's approximately one and a half year's attachment to the court (see the text and note 32)—involved in painting pictures, though employed originally only for the decorations of the summer residence—it is reasonable to expect that he shuttled back and forth from Pesaro to Urbino on occasion and had ample opportunity to become familiar with Piero's work as represented in both Urbino and Pesaro itself (Vasari-Milanesi, II, 491). Also, either on the way from Florence to the Marches or on the return, he would very likely have taken the route over the Apennines normal for the trip today, through Arezzo and Borgo San Sepolcro, where he would have seen Piero's masterpieces. At Pesaro Bronzino worked with Raffaellino dal Colle, who hailed from Piero's native Borgo San Sepolcro and, being a painter, should have had more than normal knowledge of Borgo's greatest artist and much pride in him. Indeed, Vasari's account of Piero suggests a general esteem for him still in the cinquecento. Moreover, Vasari testifies to a continued interest in Piero's treatises (*ibid.*, 488), and he makes special note of the fact that "the books of Pietro are for the most part in the library of the ... Duke of Urbino" (*ibid.*, 501).

Piero della Francesca "wrote three treatises to show how the visible world might be reduced to mathematical order by perspective or by the extension of solid geometry" (K. Clark, *Piero della Francesca*, 2nd ed., London and New York [1969], 70). In Vasari's words "... tutti i migliori giri tirati nei corpi regolari egli meglio che altro geometra intese" (Vasari-Milanesi, II, 498). "His contribution in respect to arithmetic and geometry was at least as important as his contribution to painting" so far as the fifteenth and sixteenth centuries were concerned (Clark, *op. cit.*, 70; see also G. Nicco Fasola, *Piero della Francesca, de Prospectiva Pingendi*, Florence [1942], 32–55). In Duke Francesco Maria's library in Bronzino's time would have been the *De Prospectiva Pingendi*, presented by Piero to the duke's grandfather Federigo Montefeltro, and the *De Quinque Corporibus Regolaribus* with Piero's dedicatory letter to Francesco Maria's father by adoption, the first Duke Guidobaldo. The *De Prospectiva Pingendi* is addressed to painters and, as Clark says, is on the subject of composition, for which, however, he "adopted a word which makes clear from the start how he envisaged it, *commensuratio*," (*op. cit.*, 71), that is to say, comparative, or relative, measurement. Of this book, illustrated by Piero himself, Clark has observed that the diagrams in which Piero reduces heads to essentials and "maps out every plane of the face" "have a kind of beauty which depends not only on *commensuratio*, but on the detached purity of Piero's line" (*ibid.*, 73, figs. 59–62). "... Piero's diagrams, even if we do not attempt to unriddle them, fill the mind with a sense of harmonious construction. Having seen how [not only heads but] pavements, wellheads, columns, arches and other space-controlling forms are submitted to the same lucid and rigorous system of measurement we can look at his paintings with a more developed consciousness of their beautiful consistency" (*ibid.*).

It is hard to imagine that a young Florentine painter of promise working for the court of Urbino would not have been urged by someone, above all the duke himself, to look at Piero's book addressed to painters—or that Bronzino being the literate man he was would not have sought it out, and the *De Quinque Corporibus Regolaribus* besides, getting help with the Latin if he needed it. That he did pay attention to the message of the books and their diagrams and to Piero's paintings is suggested particularly by one of his portraits, the Havemeyer *Portrait of a Young Man* in the Metropolitan Museum

(*Fig. 3*): by the pure contour and geometrically regular structure of the face, also by its lighting, its mood, even by the full, plastic treatment of the features—lips, eyes, nose; by the strict uprightness of the figure; and, by no means least, by the way the figure and the architecture of the background are composed in relation to each other to give a sense of measured construction within the rectangle of the picture frame. When the Havemeyer portrait was engraved at the beginning of the nineteenth century, it was labeled a portrait of a duke of Urbino by Sebastiano del Piombo (F. Zeri with the assistance of E. E. Gardner, *Italian Paintings, a Catalogue of the Collection of the Metropolitan Museum of Art, Florentine School*, New York [1971], 201). Although it is clearly not a portrait of Duke Francesco Maria or his son Guidobaldo, the label suggests that the picture may have come from Urbino or Pesaro and could have been painted there. The qualities that distinguish it from Pontormo's *Halberdier*, so similar in pose, can be understood as developing at the time of Bronzino's opportunity to study Piero's paintings, diagrams, and writing. The Chatsworth study (*Fig. 4*) appears as a reflection in drawing of the same experience, indicating its nearness in date. Although no other portrait by Bronzino again suggests Piero so strongly as the Havemeyer portrait, the best of them, like the Panciatichi portraits (Emiliani [1960], pls. 22–25), can be seen as retaining something of Piero's lesson in their very essence—ideal regularity in forms, especially faces, strict uprightness of figure plus disciplined rectilinear construction within the frame's rectangle, and eloquent stillness. There is reason to believe that Piero was a decisive influence. (It was from seeing a photograph of the Havemeyer portrait pinned with photographs of some of Piero's paintings on the studio wall of an American painter who admires this particular Bronzino portrait and paintings of Piero for the same reasons that I first thought about their common ground. But it was Barbara L. Smyth who pointed independently to the similarities in a way that suggested Bronzino could have been quite conscious of Piero when painting the Havemeyer portrait. How he would have been conscious of Piero then became evident.)

This does not exhaust the list of Bronzino's sources. I do not mean to suggest by it that he was the less creative. But I do want to convey the breadth of his interest in art past and present and his understanding of it—expressed in the very juxtaposition of the *Giudobaldo* and the

Havemeyer portrait (*Figs. 2* and *3*). The phenomenon of the difference in mode between them is the counterpart of the variety we find in Bronzino's drawings. The possible effect upon his portraits of the court of Urbino's tradition of the ideal Cortegiano has long been considered (McComb [1928], 6). We can see there was more to his experience there. Drawing from varied sources, Florentine and non-Florentine, Bronzino made a portraiture of his own, unforgettably distinctive and extraordinary in its own right. Michael Levey's admirable characterization and appreciation of it is very much to be recommended. Reading his essay, one realizes how long overdue such unstinting recognition of the greatness of Bronzino's portraiture has been (Levey [1967], 3–6).

Appendix II

Bronzino's Early *Portiere*: Documentation and Chronology

In the early years of the new tapestry manufactory at Florence there were two principal weavers, Janni Rost and Nicholas Karcher. The earliest known record of the delivery of a finished tapestry is in a letter of 8 December 1545 from Duke Cosimo's major-domo stating that a *portiera* woven by Rost and designed by Bronzino, subject unidentified, was ready for inspection, that the weaver Rost would come himself to show it to the duke, and that Bronzino's cartoon would be available for comparison, to see how well it had been imitated (Rigoni [1884], xi; Geisenheimer [1909], 138–139; Heikamp [1969], 63, note 3). The letter added, "the master himself is not very satisfied with it, promising to improve." We can determine with a good chance of accuracy that this first tapestry was the *portiera* representing *Primavera* illustrated here in Figure 21. (McComb [1928], 21, had thought the delivery of 8 December 1545 the first of the Joseph tapestries. The *Primavera* in Figure 21 has not been considered so early and has only recently been attributed to Bronzino, as will appear. As in C. Ripa, *Iconologia*, Venice [ed. 1669], 579, Primavera is represented by a young female figure with myrtle, but the animals accompanying her, instead of domestic ones, lend notes of exoticism [the turkey was only just introduced to Europe from the new world] and local reference [the tortoise belonged to Duke Cosimo's device]. In addition we can be sure that it was followed in about five months by two other *portiere* of Bronzino's design, the *Vindication of Innocence* (*Fig. 22a*) and a second *Primavera* (*Fig. 22b*).

There is a document attesting that on 26 April 1546 a *portiera* representing *Innocence* was delivered to the ducal *guardaroba* by Rost and that on 15 May 1546 a *portiera* was delivered showing *Primavera*, also by Rost (for the document giving these delivery dates see below).

87

The *Innocence* is certified as Bronzino's in an inventory of 15 July 1549, made for the purpose of listing all tapestries delivered to the *guardaroba* up to this date by Rost and Karcher and fortunately giving their measurements (Rigoni [1884], 73). It is clearly identifiable with the now familiar tapestry (*Fig. 22a*) that Panofsky dubbed the *Vindication of Innocence* (Panofsky [1939], xix and 84), long thought to date from 1549 (for the bibliography, see Heikamp [1969], 62, note 3); and there is confirmation in the fact that the measurements agree, as we shall have occasion to see.

The same inventory of 15 July 1549 lists two *portiere* entitled *Primavera*. One, immediately preceding the *Innocence* in the inventory, is recorded specifically as Bronzino's and as having the same height as the *Innocence* but a slightly narrower width ("al $3^1/_2$ La $2^1/_5$" as against "al $3^1/_2$ La $2^1/_2$" for the *Innocence*). The other, immediately following the *Innocence*, is recorded as having exactly the same dimensions as the *Innocence* ("al $3^1/_2$ La $2^1/_2$"), but this time Bronzino's name is not attached—the tapestry is referred to simply as "Portiera simile La primavera."

Since these are the only three *portiere* in the inventory of all the tapestries delivered by Rost up to 15 July 1549, we are justified in deducing that they were the same three *portiere* for which there exist the records of delivery from Rost on 8 December 1545, 26 April 1546, and 15 May 1546 and hence that Bronzino's *portiera* of 8 December 1545 was a *Primavera* just as was the *portiera* delivered on 15 May 1546.

Two tapestries of *Primavera* bearing Rost's mark do exist (*Figs. 21 and 22b*). One is the well known *Primavera* (*Fig. 22b*) long known as Bronzino's. It used to be called *Flora* until Panofsky identified it as *Primavera* (Panofsky [1939], 85 f.), and it was thought to date from 1553 (see again Heikamp [1969], 62, note 3 for bibliography). This *Primavera* does indeed have the same dimensions as the *Innocence*: 2.35 m. by 1.68 m. as compared to 2.42 m. by 1.69 m. for the *Innocence*. (I have had to rely on official files at Florence for the measurements of height in the case of all three *portiere*, but not for the width, which is the crucial dimension for us here. I could not manage to measure their height, but did measure the width of each at the bottom edge and so give this measurement in each case, followed by the official measurement of width where it differs from mine. The official measurement of

the width of the *Innocence* is 1.72 m.) Hence the well known *Primavera* must be identical with the *Primavera* that has the same dimensions as the *Innocence* in the inventory of 1549. Although the designer was not given there, no one would dispute Bronzino's authorship. It is surely his on the basis of style.

The second tapestry of *Primavera* (*Fig. 21*) is less well known. It has been attributed to Salviati and to "author unknown," but Heikamp has recently claimed it for Bronzino, dating it 1549. (Heikamp [1969], 35–36, 63, note 16 with bibliography; also Heikamp [1968], 25, fig. 4. He supported this claim by the connection he saw between the tapestry and a drawing of a peacock attributed to Bronzino in Smyth [1955], 62–63 on the basis of style, Uffizi, no. 6695F verso [Heikamp [1968], 25, 30 and fig. 6]. The connection with the tapestry may well be correct, but as mentioned in footnote 131 above, it is not close enough to be regarded as undeniable). This second *Primavera* is the same height as the other two *portiere* but narrower. (Heikamp [1969], 63, note 16, incorrectly recorded its width as the same as that of the *Innocence*.) It measures 1.47 m. wide instead of 1.68 m. for the other *Primavera* and 1.69 m. for the *Innocence*. (The official measurement of its width is 1.50 m. As for the height, the files yielded two different figures, 2.33 m. and 2.40 m., but I was unable to find out which one is closer. A difference of 7 cm., or about $2^3/_4$ inches, may be understandable in the case of measurements of woven material nearly $2^1/_2$ meters long. There is less room for inaccuracy in the shorter distance of the width.) Thus the second *Primavera* is 21 cm., or about $8^1/_4$ inches, narrower than the other *Primavera*. This difference is the same as the difference in width between the two *Primaveras* in the 1549 inventory.

The measurements in the 1549 inventory turn out to be in Roman *braccia*, one of which equals 0.670265 m. The $3^1/_2$ *braccia* given for the height of all three tapestries in the inventory comes, in Roman *braccia*, to 2.35 m., exactly the official measurement for the height of the well known *Primavera* and very close to the official measurements of the other two *portiere* in question. The width of $2^1/_2$ *braccia* given by the inventory both for the width of the *Innocence* and the wider *Primavera* equals, in Roman *braccia*, 1.68 m., exactly the width of the wider *Primavera* (*Fig. 22b*) and within 1 cm. of the width of the *Vindication of Innocence*. The width of $2^1/_5$ *braccia* given in the inventory for the

narrow *Primavera* equals, in Roman *braccia*, 1.47 m., exactly the measurement of the narrow *Primavera* (*Fig. 21*). In the inventory the difference in width between the two Primaveras is thus 21 cm., precisely the difference we find between the two tapestries themselves. (Why the measurements are in Roman instead of Florentine *braccia* can only be surmised. Perhaps it was because one of the weavers, Karcher, had been weaving the designs of Giulio Romano, as it seems, just before coming to Florence. In an inventory of 5 and 6 November 1553 (C. Conti, *La prima reggia di Cosimo I de' Medici nel palazzo già della signoria di Firenze*, Florence [1893], 159) the measure reverted to Florentine *braccia* [see footnote 122].)

It is clear then that the inventory of 15 July 1549 documents the attribution of the narrow, less well known *Primavera* to Bronzino. This in itself is welcome. Since one *Primavera* was delivered 15 May 1546 and the other, by the deduction above, was delivered 8 December 1545, it remains to determine which was the earlier.

The indications are decidedly that the narrow *Primavera* is the early one (*Fig. 21*). For it is more likely that the two *portiere* that were delivered less than three weeks apart, in April and May 1546, were similar in the way the *Innocence* and famous *Primavera* are similar than different in the way the *Innocence* and the narrow *Primavera* differ. The famous *Primavera* (*Fig. 22b*) and the *Innocence* (*Fig. 22a*) are not only the same in size. They also have the same border (which in each case is integrally woven with the rest of the tapestry, not added later), and they are similar to each other in having complex compositions of figures close to the picture plane (although, as observed in Panofsky [1939], 85f., they differ some from each other in the way the compositions are carried out and must have been intended for two different sets of subjects, one a set of the four seasons, the other a series of allegorical subjects, neither of which was continued). In contrast, not only is the other *Primavera* (*Fig. 21*) narrower, but it has a very different border, which suggests a doorway, and the scene shown illusionistically through the doorway represents quite another kind of composition, stressing deep space rather than an all-over surface design of figures.

The only conclusion indicated by its striking difference from the other two *portiere* is that the narrow *Primavera* is the earlier one. In this case it is the first recorded product of the Medici tapestry enterprise

as well as the first recorded tapestry designed by Bronzino, the one "the master" regarded as unsuccessful. The dissatisfaction with it would account for the production of a second completely different *Primavera* so soon afterwards and before any other tapestry of a season was produced. It follows that the later *Primavera* was probably designed after 8 December 1545—but not later than the first weeks of 1546, since it was finished by mid-May. That after two Primaveras the other three seasons were never made could very well have been because Bronzino's responsibilities for the Joseph series were too demanding.

The dates of the three early *portiere* give us fixed points of reference for the early stages of Bronzino's work as a tapestry designer and also for comparison with his figure compositions in painting. Of particular interest, the two Primaveras exemplify two different approaches to tapestry design in evidence at the start of the new Florentine manufactory (see the discussion in the text). The stylistic progression indicated by the sequence in which we now have placed them coincides with, and helps confirm, the sequence that emerges as the most likely for the earliest Joseph tapestries, from the evidence given in Appendix III.

The text of the document dating the delivery of the *Innocence* and *Primavera* on 26 April and 15 May 1546, found by me some years ago and reproduced in Smyth [1955], 271, was referred to by Emiliani ([1960], 73 and opposite pl. 52), and its text has recently been included in Heikamp [1969], 69, Document I. There is an error, however, in Heikamp's transcription, making it appear that both tapestries were delivered on the same day, 25 (*sic*) April 1546. (In another place [*ibid.*, 34] Heikamp states the date of the delivery of both as 15 May 1546.) Although the error in transcription is not of much consequence, there exists more of the document than Heikamp gives. The omitted part records the delivery of four other tapestries that, along with Bronzino's two, appear to be the very earliest of the new Medici manufactory following the initial record of delivery from 8 December 1545. One of the four is a *Pietà* from Karcher "for an altar," which must be the *Pietà* by Salviati inventoried as Karcher's work on 15 July 1549 (Rigoni [1884], 75), since no other *Pietà* from Karcher is listed there. The full text of the document is as follows.

91

Archivio di Stato, Florence. Guardaroba vol. 12 (anno 1546), p. 5 recto:

<div align="center">

M.DXLVj

addj xxvj d'aprile

</div>

Noterassj in questa carta l'arazzerie verranno[?] in casa
da maestrj fiamminghi condottj da S.Ex^a ———————— P ——

V^o. Portiera di seta e d^o. [i.e., d'oro] in quale è intessuta Linnocentia
con piu animali e figure da m^ro. Janni
fiammingo ——————————————————— P_1 ——

<div align="center">

Addj xv di maggio

</div>

V^o Portiera di seta e d^o. [i.e., d'oro] in quale è intessuta la
prima vera con varij animali e fiorj dal deto
m^ro. Janni ————————————————— P_1 ——

V^o coperta da some di lana e seta intessuta
larme di s.ex^a con l'assendente in ogni canto
dal deto ———————————————————— P_1 ——

idem, p. 5 verso:

<div align="center">

M.D xlvj

Addj v di giugno

</div>

V^o coperta da some simile da m^ro. Janni deto —————— P_1 ——

<div align="center">

Addj 31 di Luglio

</div>

V^o Panno da altar di seta + oro dentrovj
v^a. Pietà da m^ro. Niccola tappezzierj ————— P_1 ——

<div align="center">

Addj xij di 7bre [i.e., Settembre]

</div>

V^o coperta di seta e lana da some
con larme delle biscie dal deto ——————— P_1 ——

Volume 12 of the *guardaroba* records runs from 26 March 1546 to 24 March 1547. I found no more entries in it listing deliveries after 12 September. The next record of a delivery to my knowledge is the one of 16 August 1547 (cited by Conti [1875], 48 and Geisenheimer [1909], 139 and note 5), which refers to Bronzino's *Joseph Selling Grain to his Brothers* (*Fig. 24*) in the series of tapestries illustrating the

story of Joseph (see Appendix III). This is in Volume 14, running from 28 March 1547 to 20 March 1548, and it is followed there by entries for deliveries on five other dates in September and October, up to 12 October 1547. Judging by the rate of arrivals shown in the entries from Volume 12 reproduced above and from those in Volume 14, I think we have to assume that there were deliveries between 12 September 1546, the last noted in Volume 12, and 16 August 1547, the first noted in Volume 14, and that the record, if kept, was kept elsewhere and has simply not turned up. That we do indeed have gaps in the delivery records is clear from the fact that of the seven Joseph tapestries in the *guardaroba* by 15 July 1549 there exist delivery records for only three (see Appendix III). There is a similar absence of delivery records from 12 October 1547 to 16 May 1548, when the arrival of the Joseph tapestry by Salviati appears in Volume 15, p. 21 (see Appendix III).

Appendix III

Notes on the Chronology of Bronzino's
Early *Joseph* Tapestries

The chronology of the Medici tapestries illustrating the story of Joseph presents problems. This appendix concerns only the chronology of the first four tapestries documented as designed by Bronzino, for two of which we have drawings considered above. (Left aside for the present are the problems of attribution and date surrounding the three tapestries connected partly by document and partly by Vasari to Pontormo, at work early in designing for the series, which sometimes, especially recently, have been attributed to Bronzino—incorrectly, there is good documentary reason to believe.)

It is worth bearing in mind from the outset the following pieces of information. From 20 October 1546 there is a contract showing that at least one tapestry of the Joseph series was being woven by then (to judge by the way the contract was first written, as given by Geisenheimer [1909], 139, there was probably another tapestry also on the looms at this time), that it was designed by Bronzino and almost finished, that it was Bronzino's first of the series (". . . del primo disegno fatto dal Bronzino"), and that it was to serve as the standard for the others (see the emended reading of the contract in Conti [1875], 97; also Rigoni [1884], xi). The series was finished in 1553. An inventory of 27 September 1553 lists twenty tapestries as having been delivered in all by then to the ducal *guardaroba*, nine from one of the two chief weavers, Janni Rost, eleven from the other, Nicholas Karcher, and gives their titles (though not the measurements or the designers' names). (For the inventory of 27 September 1553, see Rigoni [1884], 84–88. Emiliani [1960], 75, states that all twenty tapestries appear in an inventory of 5 November 1553 [Florence, State Archives, Guardaroba Medicea, 28, fol. 37 recto and fol. 38

94

recto] with their respective measurements. But this is true only in the most summary sense. The document was quoted earlier by C. Conti [*La prima reggia di Cosimo I de' Medici nel palazzo già della signoria di Firenze*, Florence [1893], 159, 162], and I am grateful to Dr. Gino Corti for again transcribing the passages. They simply state the number of Rost and Karcher tapestries of the Joseph series—twenty in all stored in two wardrobes [5 by Karcher in one, 6 by Karcher and 9 by Rost in the other]—without any titles or names of designers and with the measurements in roundest terms, twelve wide and eight narrow.) Twenty Joseph tapestries survive, ten in Florence, ten in Rome at the Palazzo Quirinale. They are of two sizes, twelve of them wide and eight narrow (about half the width of the wide ones). Of the twelve wide, two were made to fit over doorways and lack approximately the lower half to three-fourths of one side (*Figs. 24* and *35*).

By 15 July 1549 only seven Joseph tapestries had been delivered to the ducal *guardaroba*. An inventory was made on this date (already referred to in Appendix II) for the explicitly stated purpose of listing all tapestries delivered until then by each of the two weavers, Rost and Karcher, giving measurements and in the case of each Joseph tapestry the designer's name (Geisenheimer [1909], 142–143 and, for the full text, Rigoni [1884], 73–76). Of the seven Joseph tapestries, five were from Rost and two from Karcher, four were credited to Bronzino (three from Rost, one from Karcher), two to Pontormo (both from Rost), and one to Salviati (from Karcher). The four titles listed for Bronzino were: the "Selling of Joseph" (wide; Rost), the "Imprisonment of Joseph" (wide; Rost), the "Twelve Brothers of Joseph" (wide; Rost; described specifically as made for a door), and the "Seizure of Benjamin" (narrow; Karcher). In my view the one most likely to be the first, almost finished 20 October 1546, is the "Imprisonment of Joseph" of the 1549 inventory, identifiable without any doubt—as long realized (Geisenheimer [1909], 143)—with the wide tapestry in Figure 15, which is at the Quirinal. It is inscribed "Fatto in Firenze Bronzino" and shows in the background Joseph in prison interpreting the dreams of the Pharoah's butler and baker and, in the foreground, Pharoah at table three days later (no. 7 in the inventory of 27 September 1553). (Geisenheimer [1909], 142f. considered the *Joseph in Prison* to date between the later half of 1548 and July 1549, as does Heikamp [1969], 35.)

The date when the *Joseph in Prison* (*Fig. 15*) was delivered is not documented. In fact, documents recording delivery are known for only three of the seven Joseph tapestries that had arrived at the *guardaroba* by 15 July 1549. The first known record of the delivery of a Joseph tapestry documents a delivery from Rost on 16 August 1547 (Conti [1875], 48; Geisenheimer [1909], 139 and note 5). Although neither its designer nor title was mentioned, it was described as made for a doorway and so must have been Bronzino's "Twelve Brothers of Joseph" in the inventory of 15 July 1549, which is unquestionably identifiable, as pointed out in Geisenheimer [1909], 141–142, with *Joseph Selling Grain to his Brothers*, inscribed "Bronzino," in the Palazzo Vecchio (*Fig. 24*) (no. 9 in the inventory of 27 September 1553)—because (*ibid.*) the only other tapestry cut for a door is *Joseph's Dream of the Sun, Moon, and Stars* (*Fig. 35*; no. 2 in the 1553 inventory), the delivery of which took place between the inventory of 15 July 1549 and 3 August 1549 (Rigoni [1884], 74; Geisenheimer [1909], 143). Since it is the first tapestry for which we have the delivery date, Geisenheimer considered *Joseph Selling Grain* the earliest Joseph tapestry by Bronzino (*ibid.*, 142), and this seems always to have been accepted.

A month later on 15 September 1547 there was delivered a tapestry described as the "Taking of Joseph" ["la presura di Josef"] from Nicholas Karcher (*ibid.*, 141). There is a confusion in this entry. The tapestry to which the title should refer is the one listed as the "Selling of Joseph" in the inventory of 15 July 1549 (listed by the same title in the inventory of 27 September 1553, where it is no. 3) which is unquestionably the wide tapestry at the Quirinal (*Fig. 23*), signed "Bronzino Fiorentino," showing precisely the whole story of the taking of Joseph in a sequence of episodes: Joseph's brothers conspiring against him as he approaches (upper left), Joseph tied and placed in the well, the killing of the kid in order to soak Joseph's coat in its blood, the members of the caravan buying Joseph from the brothers, and Joseph being led off to Egypt. But, as the 1549 inventory rightly recorded, the Quirinal tapestry is by Rost, not Karcher (Rost's mark is at lower left). For this reason, beginning with Geisenheimer [1909], 142, the tapestry delivered 15 September 1547 has been thought—incorrectly, as I believe—to be the Karcher "Seizure of Benjamin" ["la cattura di Beniamino"], one of the four Bronzinos in the inventory

of 15 July 1549. To make matters more complicated, a "Seizure of Benjamin" is not represented among Karcher tapestries. Geisenheimer (*ibid.*) deduced that the tapestry recorded in 1549 as the "Seizure of Benjamin" must have been the Karcher tapestry that is called "Joseph's Retention of Simeon" ["La Retentione di Simeone da Josef"] in the 1553 inventory (where it is no. 10), which is identifiable, as Geisenheimer saw, with the Karcher tapestry at the Quirinal in my Figure 26, because this is the only Karcher tapestry showing a seizure. Given the two candidates—the *Taking and Selling of Joseph* by Rost (*Fig. 23*) and the *Joseph Seizing Simeon* by Karcher (*Fig. 26*)—it seems much more likely that the *guardaroba* recorder who entered the title as the "Taking of Joseph" on 15 September 1547 got the subject right and the weaver wrong than vice versa. For Karcher's *Joseph Seizing Simeon* (*Fig. 26*), where the action takes place in an architectural setting and Joseph himself, in his commanding role as Egypt's governor, issues orders for Simeon's arrest, is not easily mistaken for the taking of Joseph by his brothers in the pasture land of Dothan, while Rost's tapestry at the Quirinal (*Fig. 23*) does fit the title "Taking of Joseph" accurately, as we saw. Even so exacting a modern scholar as Clapp could make the error of recording the wrong weaver, cataloguing the narrow *Retention of Joseph's Cloak by Potiphar's Wife* as by Karcher, though it bears Rost's mark (F. M. Clapp, *Jacopo Carucci da Pontormo, His Life and Work*, New Haven [1916], 186). Meanwhile, whichever the identification, it is entirely unlikely that the Quirinal tapestry (*Fig. 15*) showing Joseph in prison interpreting the dreams of the Pharoah's butler and baker with Pharoah at table in the foreground would have been regarded at its delivery as the "Taking of Joseph."

On 16 May 1548 Salviati's *Pharoah's Dream of Seven Fat and Seven Lean Kine* was delivered from Karcher (Conti [1875], 48; Geisenheimer [1909], 142), the tapestry now in the Palazzo Vecchio (no. 8 in the 1553 inventory).

On 1 October 1548 record was made that six Joseph tapestries in all, not identified individually, had been delivered so far (Geisenheimer [1909], 142). As we have seen, delivery records survive for only three of these six. Geisenheimer (*ibid.*) thought the three for whose deliveries we have no record had arrived only recently. But there is evidence of a definite gap in the records of delivery between 12 Sep-

tember 1546 and 16 August 1547, as explained at the end of Appendix II. The Bronzino tapestry that was almost finished 20 October 1546 and was to serve as standard for the rest would have been delivered, it is logical to suppose, within this ten-month period—all the more so since the first tapestry for which there exists a delivery record was atypical because much abbreviated to go over a doorway (*Fig. 24*) and thus less qualified than a complete tapestry to serve as a standard for the series, as Bronzino's first tapestry was to do. Indeed, the best qualified would have been, not merely a complete tapestry, but a full-size one rather than half-size, since the majority of the series would be of full size.

The documentation and our reasoning so far indicate a tentative conclusion. If the surmises are correct that the "Taking of Joseph" delivered 15 September 1547 was the full-size tapestry showing the taking and selling of Joseph (*Fig. 23*), that the first Bronzino tapestry of the series, almost finished 20 October 1546, was delivered between 20 October 1546 and 16 August 1547, and that this tapestry was a complete and full-size example, then, by elimination, Bronzino's first Joseph tapestry must have been the *Joseph in Prison* (*Fig. 15*) (the only other candidate of the four Bronzinos delivered by 15 July 1549 being the half-size *Joseph Seizing Simeon* [*Fig. 26*]).

There are several indications that this conclusion is right. First, the *Joseph in Prison* is unique among Bronzino's Joseph tapestries in bearing the inscription "Made in Florence," "Fatto in Firenze." The only other tapestries by him that have this inscription are the two Primaveras (*Figs. 21* and *22b*), of which one appears to be the first tapestry delivered by the new Florentine manufactory and the other the third (see Appendix II). Hence if we classify the *Joseph in Prison* by its inscription, it separates itself from all the rest of Bronzino's Joseph tapestries and joins the very earliest productions.

I should add that two Joseph tapestries, but no more, have a substitute inscription: F F with the lily of Florence between, signifying "Factum Florentiae." These two are *Joseph Selling Grain to his Brothers* (*Fig. 24*) and the *Taking and Selling of Joseph* (*Fig. 23*), the two tapestries delivered just some months after the *Joseph in Prison*, according to the reasoning above. It appears that both inscriptions were used at first following Flemish practice, perhaps out of pride in the novelty of the new manufactory, and abandoned as the novelty

98

wore off. The occurrence of "Fatto in Firenze" on the two Primaveras, one delivered 8 December 1545, the other 15 May 1546, indicates it was the inscription used first. The occurrence of the second inscription on the tapestry delivered 16 August 1547 is evidence that it was used second. At the same time I should add that there are only two other tapestries of the series labeled "Made in Florence." These are the two half-size tapestries illustrating *Potiphar's Wife Holding Joseph's Cloak* (Clapp [1916], pl. 136) and the *Cup of Benjamin and the Retention of Benjamin* (*ibid.*, pl. 134) normally identified with the two tapestries credited to Pontormo in the inventory of 15 July 1549. I want to review the evidence for the attribution of the two tapestries to Pontormo elsewhere. Here it need only be noticed that their having been marked "Made in Florence" points to the start of the series as the time of their production, in accord incidentally with Vasari's account of Pontormo's part in the Joseph series, which had him designing for it only at the outset and then excluded afterwards because his designs were found unsatisfactory (Vasari-Milanesi, VI, 283–284). The two tapestries credited to Pontormo in the 1549 inventory are among the four out of seven for which no delivery records exist. Hence, if started at or near the same time as Bronzino's first Joseph tapestry—as the document of 20 October 1546 would allow at least one to have been—they could perfectly well have been delivered during the first gap in the records, especially as, on the evidence of the inventory, Pontormo's tapestries were indeed of half size and should have taken less time to weave than those of full size.

The *Joseph in Prison* (*Fig. 15*) is unique in a second respect. It is the only Rost tapestry of the nine woven by him in the Joseph series without Rost's mark. This exception accords with the assumption that it was the first tapestry of the series, where it would then date before it was standard for Rost to include his mark on the Joseph tapestries (Karcher never used his mark in this series).

Finally, the *Joseph in Prison* separates itself in style from Bronzino's other tapestries in the Joseph series and instead approaches his first *Primavera* (*Fig. 21*), delivered 8 December 1545 according to the evidence in Appendix II. It has more in common with the first *Primavera* in respect to the treatment of space and the arrangement of figures within it (discussed in the text) than it has with the other three Joseph tapestries by Bronzino in the July 1549 inventory (*Figs.*

99

23, 24, and 26) or any thereafter, for that matter. Indeed, it is nearly as different from the other three as the first *Primavera* (*Fig. 21*) is from the second (*Fig. 22b*) and from the *Innocence* (*Fig. 22a*) (see Appendix II). Hence stylistically it fits best at the beginning of the Joseph series.

Among the remaining three Joseph tapestries credited to Bronzino in the inventory of 15 July 1549, the *Taking and Selling of Joseph* (*Fig. 23*) separates itself clearly from the other two (*Figs. 24* and *26*) by its complexity of figures—lighted, complicated, stiffened, abstracted, and composed in obedience, in large part, to the conventions of *maniera*. It is more like the *Innocence* (*Fig. 22a*), delivered 26 April 1546, than any other Joseph tapestry. By contrast the *Joseph Selling Grain to his Brothers* (*Fig. 24*) is in still another mode, more readable and flowing. (For more on the styles of both, see the text.) My assumption is that, just as the *Innocence* and second *Primavera* (*Fig. 22b*) followed quickly upon the first *Primavera* (*Fig. 21*) as a deliberate change to a more Italian manner (see the text), so the *Taking and Selling of Joseph* followed in the same way directly upon the *Joseph in Prison* (*Fig. 15*), making the same deliberate contrast. In this case the *Taking and Selling of Joseph*, even though delivered a month later (by the reasoning above) than the *Joseph Selling Grain to his Brothers* (*Fig. 24*), was probably designed a little earlier than the *Joseph Selling Grain*. On practical grounds this is understandable. It would have required longer to weave the *Taking and Selling of Joseph* than the *Joseph Selling Grain*, because the latter was much abbreviated for the doorway.

The *Joseph Seizing Simeon* (*Fig. 26*), the last of the four tapestries in question, has more in common stylistically with *Joseph Selling Grain to his Brothers* (*Fig. 24*) than either has with the other two and also more in common with Salviati's tapestry, delivered 16 May 1548, than any of the others. On these grounds it should be the latest of the four credited to Bronzino on 15 July 1549. Last place in the sequence is also suggested by its situation with respect to inscriptions. Although carrying Bronzino's name (there remain visible only the letters — *ino*), it has no inscription to proclaim its Florentine manufacture. It is thus different from the other three credited to Bronzino in the 15 July 1549 inventory but, by the same token, is like the Salviati tapestry delivered in May 1548 and like every tapestry of the series that follows the July 1549 inventory. If, moreover, the reasoning above has been correct and if the two tapestries credited to Pontormo

in the 1549 inventory were delivered early, as the inscriptions on the two tapestries normally identified with them suggest, then the *Joseph Seizing Simeon* is the only one of the seven tapestries that would have been left to be delivered between 1 October 1548, when the number of Joseph tapestries on hand was six, and 15 July 1549, when the number was seven. Finally, the latest date is confirmed if the ascription of the drawing for it in the Uffizi (*Fig. 25*) to Raffaellino dal Colle is correct, as argued in the text. For the tapestry's design would have to have been in work after Raffaellino's arrival in Bronzino's studio 15 May 1548, which would place delivery of the finished tapestry itself after 1 October 1548.

The conclusion proposed here then is that the first four Joseph tapestries on Bronzino's design delivered to the ducal *guardaroba* by 15 July 1549, according to the inventory of that date, were designed in the following order and, on the basis of the delivery dates as presented above, probably at the following times: *Joseph in Prison* (*Fig. 15*) in the autumn of 1545, the *Taking and Selling of Joseph* (*Fig. 23*) within the first two-thirds of 1546, *Joseph Selling Grain to his Brothers* (*Fig. 24*) in the later part of 1546 or early 1547, and *Joseph Seizing Simeon* (*Fig. 26*) between about May and autumn 1548.

Bibliography of Frequently Cited Sources

K. Andrews, "A Note on Bronzino as a Draughtsman," *Master Drawings*, II [1964], 157–160.

K. Andrews, "Pontormo Drawings," *The Burlington Magazine*, CVIII [1966], 577—582.

B. Berenson, *The Drawings of the Florentine Painters*, New York [1903].

B. Berenson, *The Drawings of the Florentine Painters*, Chicago [1938].

B. Berenson, *I disegni dei pittori fiorentini*, Milan [1961].

L. Berti, "Precisioni sul Pontormo," *Bollettino d'arte*, LI [1966], 50–57.

M. G. Carpaneto, "Raffaellino del Garbo, I. Parte," *Antichità viva*, IX [1970], no. 4, 3–23.

F. M. Clapp, *Les dessins de Pontormo, catalogue raisonné precédé d'une étude critique*, Paris [1914].

F. M. Clapp, *Jacopo Carucci da Pontormo, His Life and Work*, New Haven [1916].

C. Conti, *Ricerche storiche sull' arte degli arazzi in Firenze*, Florence [1875].

J. Cox-Rearick, *The Drawings of Pontormo*, Cambridge, Mass. [1964].

J. Cox-Rearick, "Some Early Drawings by Bronzino," *Master Drawings*, II [1964], 363–382.

B. Davidson, "Early Drawings by Perino del Vaga, Part One," *Master Drawings*, I, no. 3 [1963], 3–16.

B. Davidson, "Early Drawing by Perino del Vaga, Part Two," *Master Drawings*, I, no. 4 [1963], 19–26.

A. Emiliani, *Il Bronzino*, Busto Arzizio [1960].

A. Emiliani, *Bronzino*, I maestri del colore, no. 143, Milan [1966].

P. N. Ferri, *Catalogo riassuntivo della raccolta di disegni antichi e moderni, posseduti dalla R. Galleria degli Uffizi di Firenze*, Rome [1890].

A. Forlani, *I disegni italiani del cinquecento, scuole fiorentina, senese, romana, umbro marchigiana e dell' Italia meridionale*, Venice [1962].

A. Forlani in *Mostra di disegni dei fondatori dell' Accademia delle Arti del Disegno*, prepared by P. Barocchi, A. Bianchini, A. Forlani, and Mazzino Fossi, Gabinetto Disegni e Stampe degli Uffizi, Florence [1963].

A. Forlani Tempesti, "Note al Pontormo disegnatore," *Paragone*, XVIII, no. 207/27 [1967], 80–86.

G. Gaye, *Carteggio inedito d'artisti dei secoli XIV. XV. XVI*, Florence [1839].

H. Geisenheimer, "Gli arazzi nella Sala del Dugento a Firenze," *Bollettino d'arte*, III [1909], 137–147.

102

F. Gibbons, *Dosso and Battista Dossi, Court Painters at Ferrara*, Princeton [1968].

S. L. Giovannoni in *Mostra di disegni di Alessandro Allori (Firenze 1535–1607)*, Gabinetto Disegni e Stampe degli Uffizi, Florence [1970].

G. Gronau, *Documenti artistici urbanati*, Florence [1936].

F. Hartt, *Giulio Romano*, New Haven [1958].

D. Heikamp, "La manufacture de tapisserie des Medici," *L'Oeil*, nos. 164–165 [August-September, 1968], 22–30.

D. Heikamp, "Die Arrazeria Medicea im 16. Jahrhundert, Neue Studien," *Münchener Jahrbuch der bildenden Kunst*, Series 3, XX [1969], 33–74.

M. Levey, *Bronzino 1503–1572*, The Masters, Vol. 82, London [1967].

A. McComb, *Agnolo Bronzino, His Life and Works*, Cambridge, Mass. [1928].

L. Marcucci in *Mostra di disegni dei primi manieristi italiani*, Gabinetto Disegni e Stampe degli Uffizi, Florence [1954].

A. Mezzetti, *Il Dosso e Battista Ferraresi*, Ferrara [1965].

E. Panofsky, *Studies in Iconology*, New York [1939].

B. Patzak, *Die Villa Imperiale in Pesaro*, Leipzig [1908].

A. E. Popham and J. Wilde, *The Italian Drawings of the XV and XVI Centuries in the Collection of His Majesty the King at Windsor Castle*, London [1949].

C. Rigoni, *Catalogo della R. Galleria degli Arazzi*, Florence [1884].

B. Schweitzer, "Zum Antikenstudium des Angelo Bronzino," *Mitteilungen des Deutschen Archeologischen Instituts, Römische Abteilung*, XXXIII [1918], 45–63.

J. Shearman, "Bronzino," *The Burlington Magazine*, CV [1963], 415–416.

J. Shearman, *Andrea del Sarto*, Oxford [1965].

C. H. Smyth, "The Earliest Works of Bronzino," *Art Bulletin*, XXXI [1949], 184–210.

C. H. Smyth, *Bronzino Studies*, Princeton [1955], doctoral dissertation (published only through University Microfilms, Inc., Ann Arbor, Michigan).

C. H. Smyth, *Mannerism and "Maniera,"* Locust Valley, New York [1963].

G. Vasari, *Le vite del Vasari nel edizione del 1550 a cura di Corrado Ricci*, Milan [n.d.].

G. Vasari, *Le vite de' piu eccellenti pittori, scultori ed architetti*, ed. G. Milanesi, Florence [1875-1885].

A. Venturi, *Storia dell' arte Italiana*, IX, part V, Milan [1933].

M. Viale Ferraro, *Arazzi italiani del cinquecento*, Milan [1961].

H. Voss, *Die Malerei der Spätrenaissance in Rom und Florenz*, Berlin [1920].

Photographic Sources

Alinari, Florence: Figs. 7, 21, 22b, 23, 28, 30, 36.
Ashmolean Museum, Oxford: Fig. 33.
Biblioteca Ambrosiana, Milan: Fig. 20.
British Museum, London: Figs. 18, 19.
Brogi, Florence: Figs. 6, 22a, 39.
Christ Church, Oxford: Fig. 37.
L. Ciacchi, Florence: Figs. 25, 34.
Fototeca Italiana, Florence: Figs. 1, 5.
Louvre, Paris: Figs. 9, 27.
Metropolitan Museum, New York: Fig. 3.
Palazzo Quirinale, Rome: Fig. 15.
Service de Documentation Photographique de la Réunion des Musées Nationaux, Paris: Figs. 8, 40.
Smithsonian Institution, Washington: Fig. 4.
Soprintendenza alle Gallerie, Florence: Figs. 2, 16, 17, 24, 29, 31, 32, 35, 38.
Staedel'sches Kunstinstitut, Frankfurt: Figs. 10, 11, 12, 13, 14.
Vasari, Rome: Fig. 26.

ILLUSTRATIONS

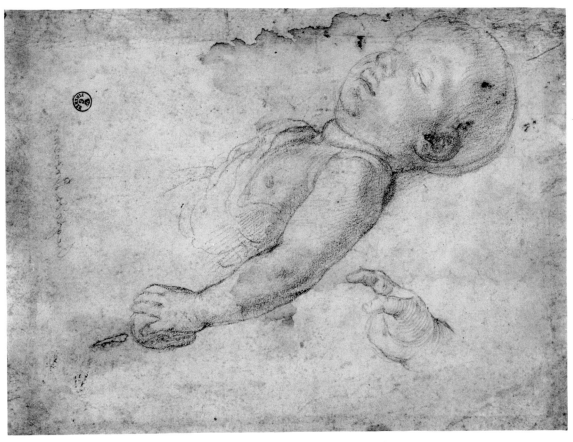

1. Study of the Christ Child for the Panciatichi *Holy Family*. (Uffizi, Florence.)

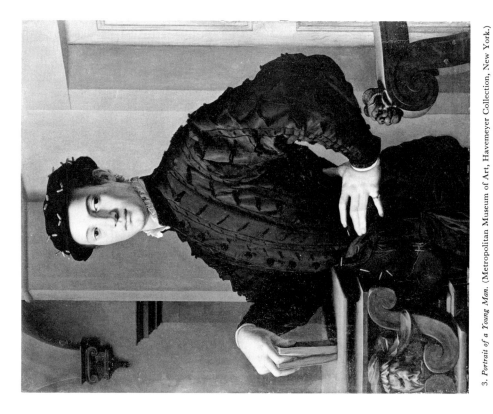

3. *Portrait of a Young Man.* (Metropolitan Museum of Art, Havemeyer Collection, New York.)

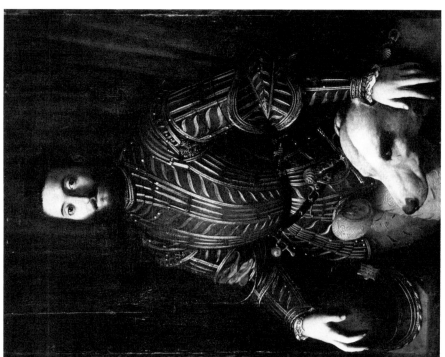

2. *Portrait of Guidobaldo II of Urbino.* (Palazzo Pitti, Florence.)

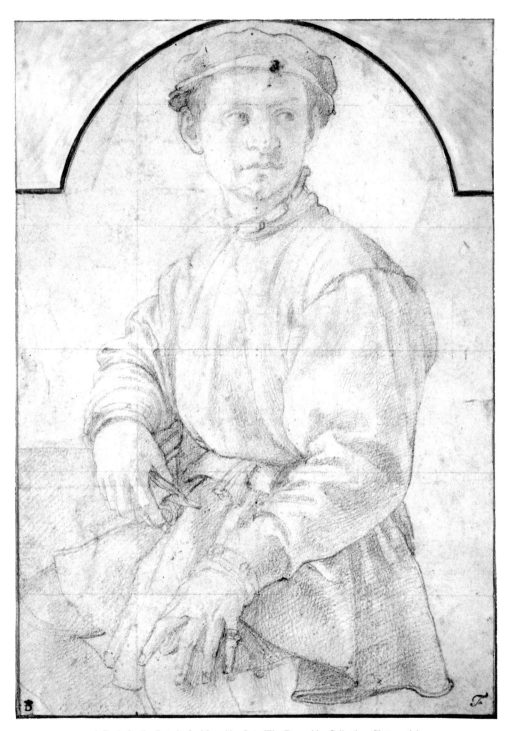

4. Study for the *Portrait of a Man with a Lute*. (The Devonshire Collection, Chatsworth.)

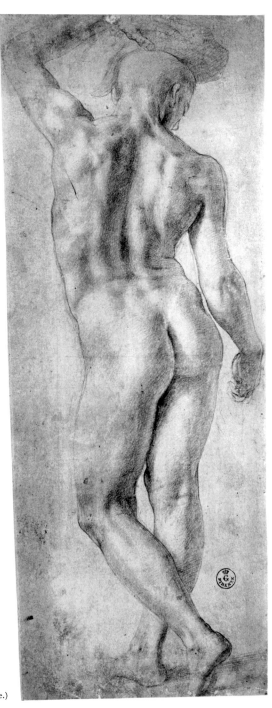

5. Study for a nude in the *Crossing of the Red Sea*. (Uffizi, Florence.)

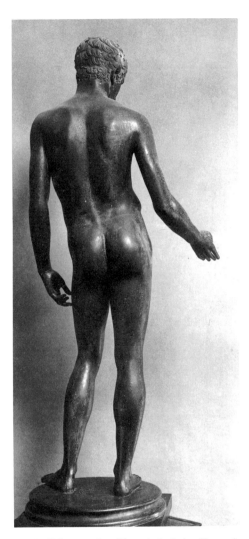

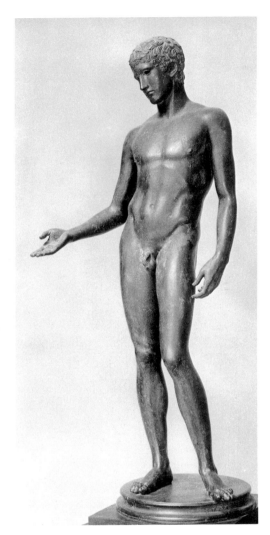

6. The *Idolino*, rear view. (Museo Archeologico, Florence.) 7. The *Idolino*. (Museo Archeologico, Florence.)

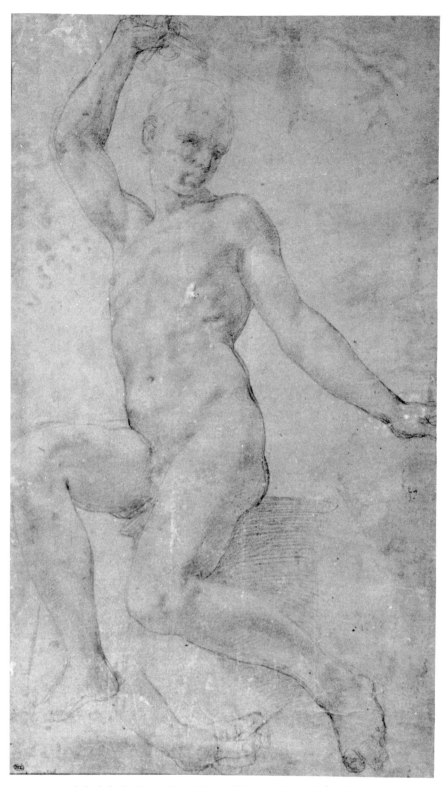

8. Study for the Figure of Saint Michael. (Cabinet des Dessins, Louvre, Paris.)

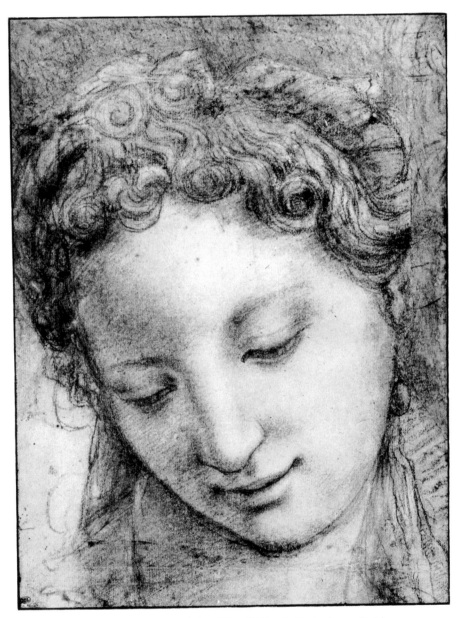

9. Study for the *Miraculous Spring of Moses*. (Cabinet des Dessins, Louvre, Paris.)

10. *The Stigmatization of Saint Francis.* Detail from the *modello* in figure 14. (Staedel Institut, Frankfurt-am-Main.)

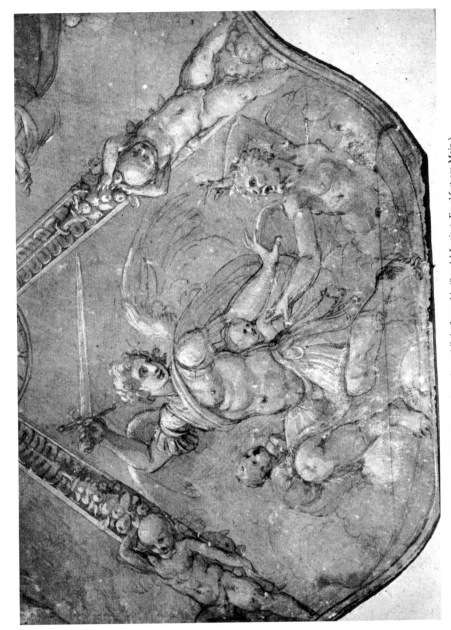

11. *Saint Michael*. Detail from the *modello* in figure 14. (Staedel Institut, Frankfurt-am-Main.)

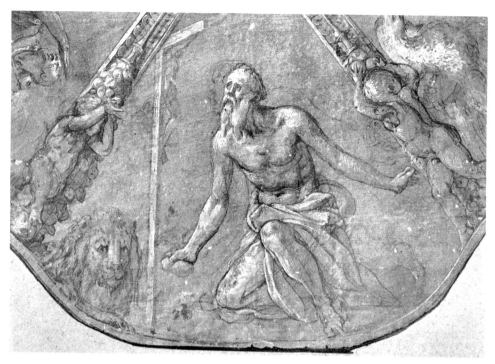

12. *Saint Jerome*. Detail from the *modello* in figure 14. (Staedel Institut, Frankfurt-am-Main.)

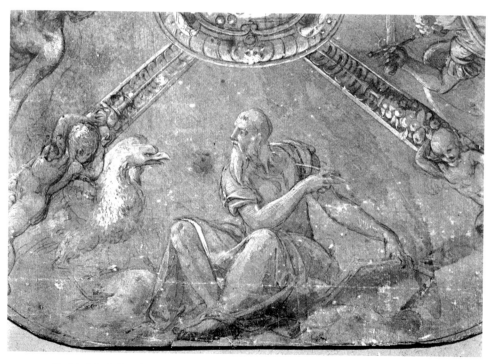

13. *Saint John the Evangelist*. Detail from the *modello* in figure 14. (Staedel Institut, Frankfurt-am-Main.)

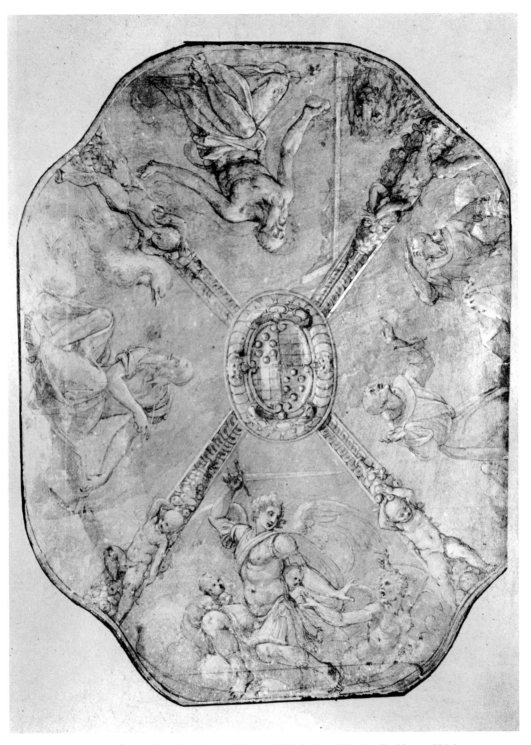

14. *Modello* for the ceiling of the Chapel of Eleonora di Toledo. (Staedel Institut, Frankfurt-am-Main.)

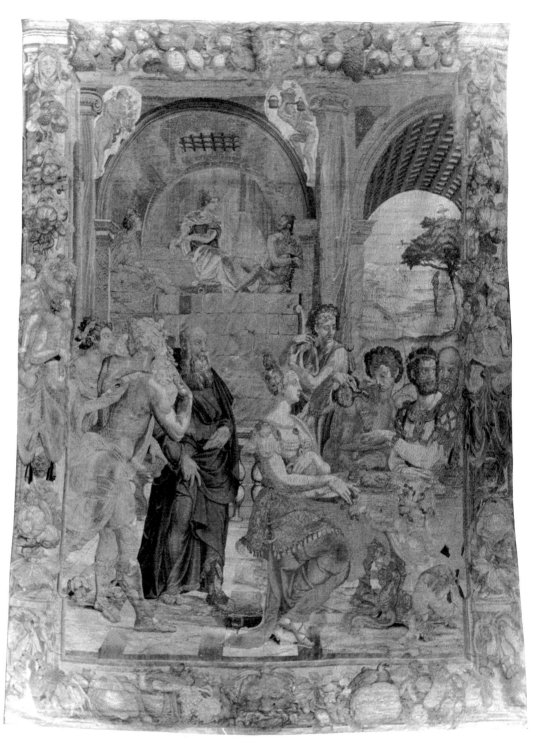

15. *Joseph in Prison and Pharoah's Banquet*, designed by Bronzino. Tapestry. (Palazzo del Quirinale, Rome.)

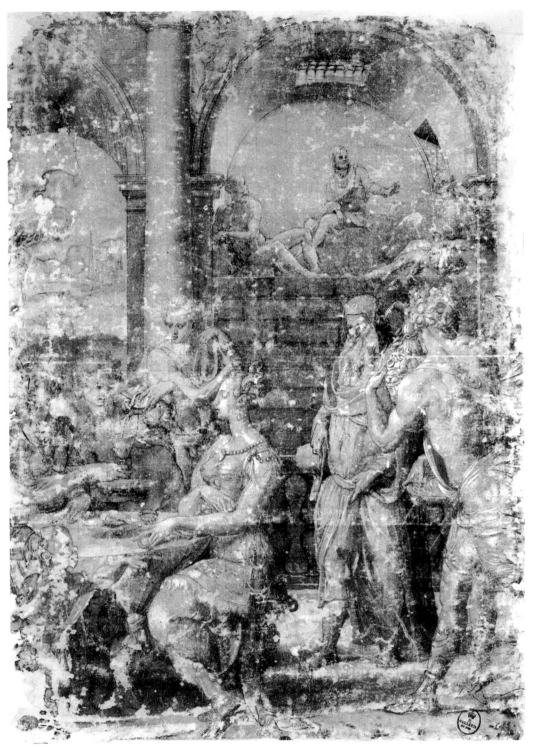

16. *Modello* for *Joseph in Prison and Pharoah's Banquet.* (Uffizi, Florence.)

17. *Joseph in Prison*. Detail from the *modello* in figure 16. (Uffizi, Florence.)

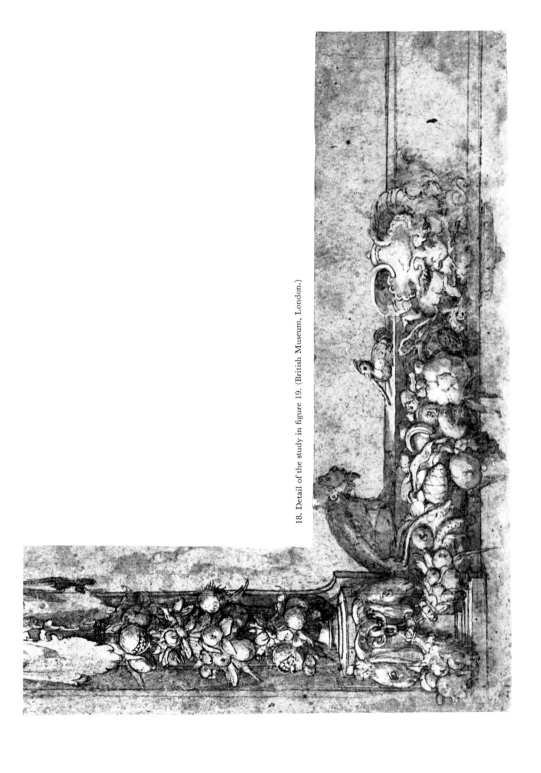

18. Detail of the study in figure 19. (British Museum, London.)

19. Study for the borders of the Joseph tapestries. (British Museum, London.)

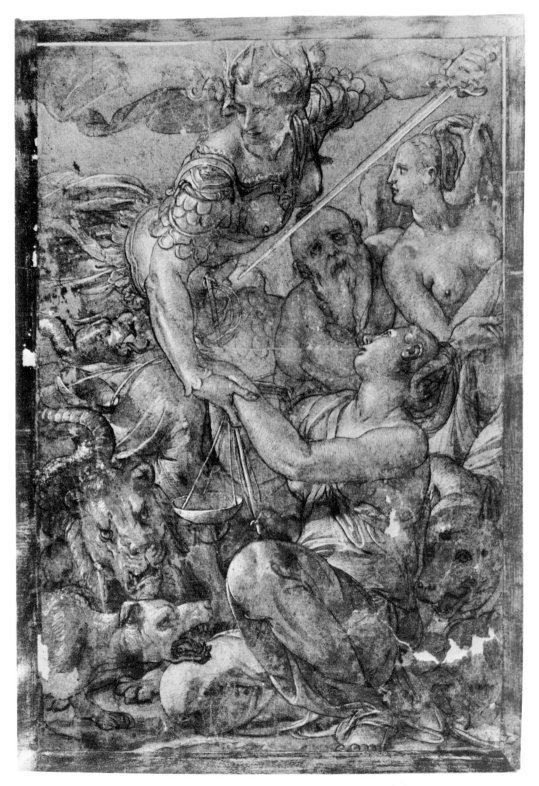

20. *Modello* for the *Vindication of Innocence*. (Biblioteca Ambrosiana, Milan.)

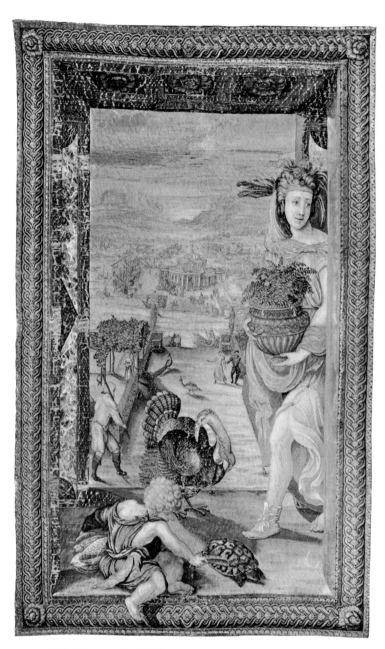

21. *La Primavera*, designed by Bronzino. Tapestry. (Palazzo Pitti, Florence.)

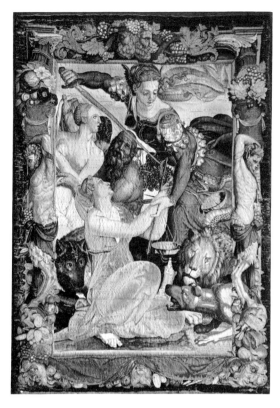

22 a. The *Vindication of Innocence*, designed by Bronzino.
Tapestry. (Palazzo Vecchio, Florence.)

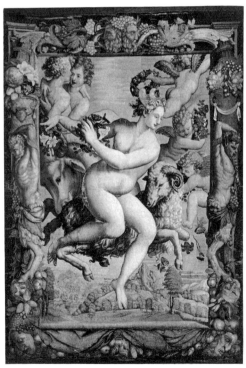

22 b. *La Primavera*, designed by Bronzino. Tapestry.
(Palazzo Vecchio, Florence.)

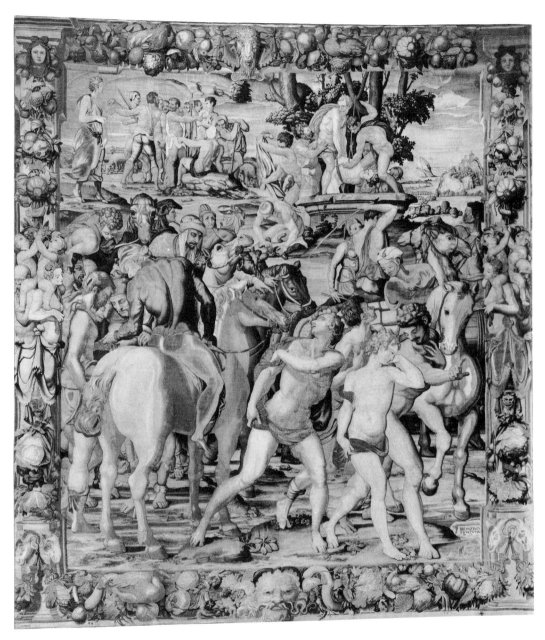

23. The *Taking and Selling of Joseph*, designed by Bronzino. Tapestry. (Palazzo del Quirinale, Rome.)

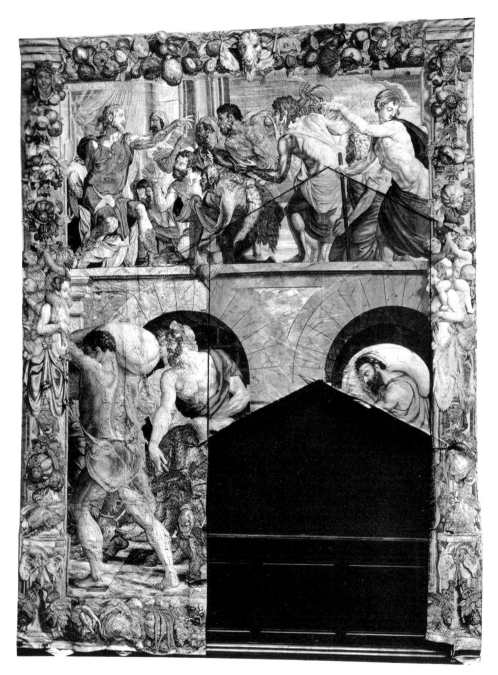

24. *Joseph Selling Grain to his Brothers*, designed by Bronzino. Tapestry. (Palazzo Vecchio, Florence.)

25. Study for the *Seizing of Simeon*, here attributed
to Raffaellino dal Colle. (Uffizi, Florence.)

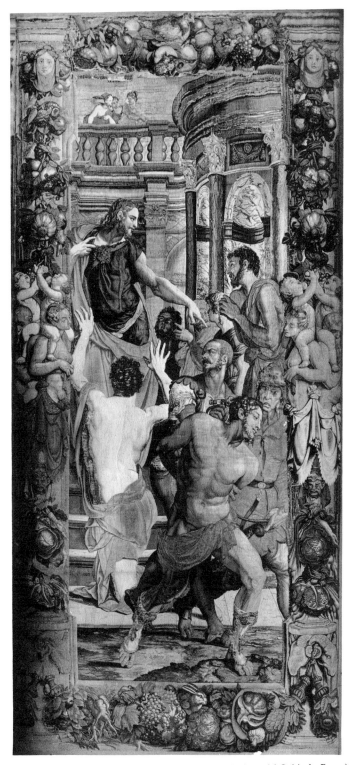

26. The *Seizing of Simeon*, designed by Bronzino. Tapestry. (Palazzo del Quirinale, Rome.)

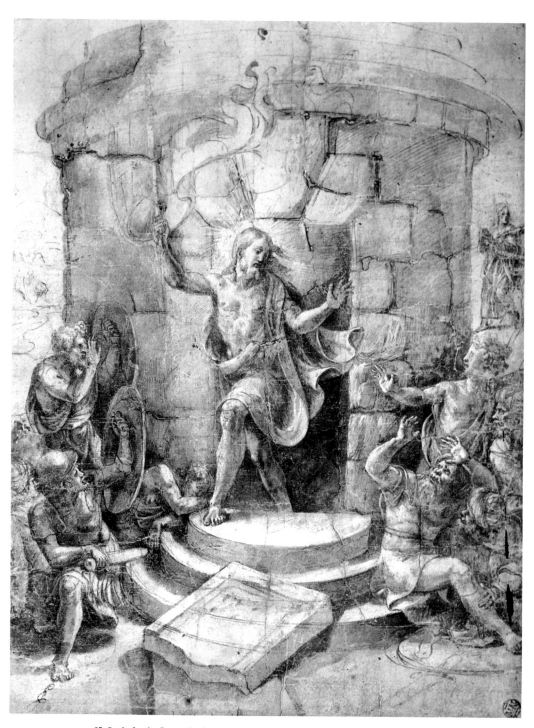

27. Study for the *Resurrection*, by Raffaellino dal Colle. (Cabinet des Dessins, Louvre, Paris.)

28. The *Resurrection*, by Raffaellino dal Colle.
(Cathedral, Borgo San Sepolcro.)

29. The *Resurrection*, by Raffaellino dal Colle assisted.
(The church of San Rocco, Borgo San Sepolcro.)

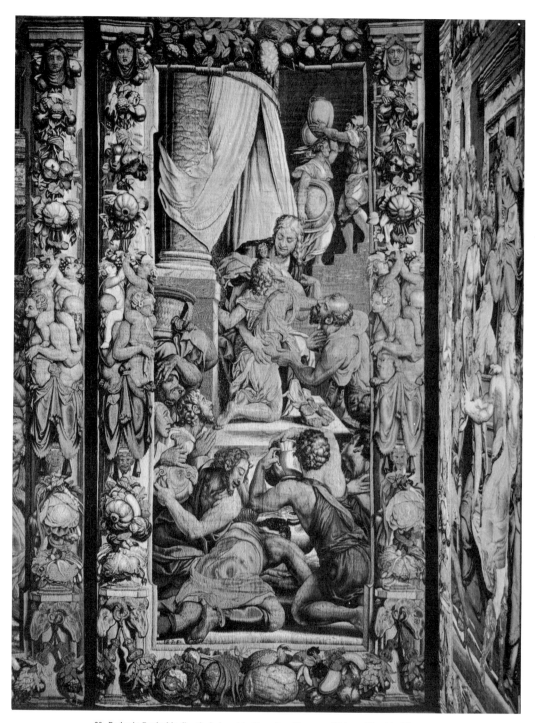

30. *Benjamin Received by Joseph*, designed by Bronzino. Tapestry. (Palazzo Vecchio, Florence.)

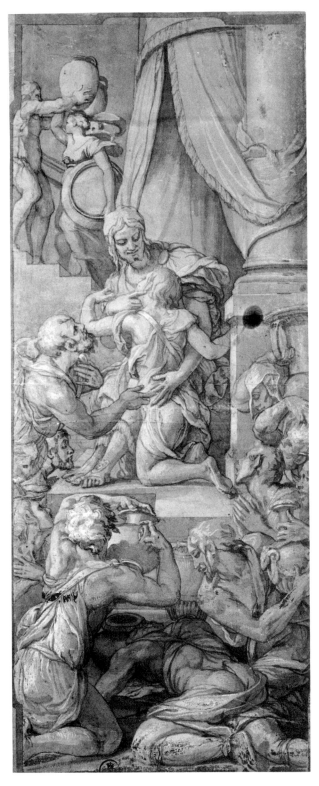

31. *Modello* for *Benjamin Received by Joseph.* (Uffizi, Florence.)

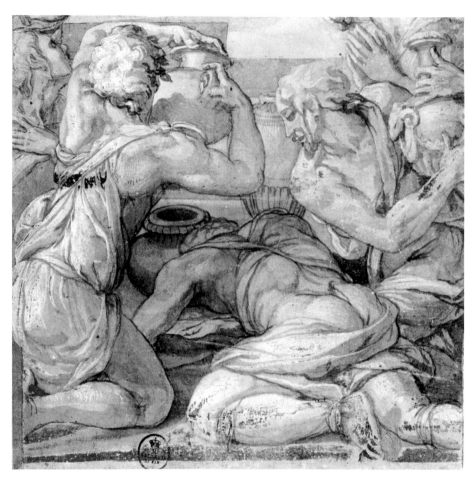

32. Detail from the *modello* in figure 31. (Uffizi, Florence.)

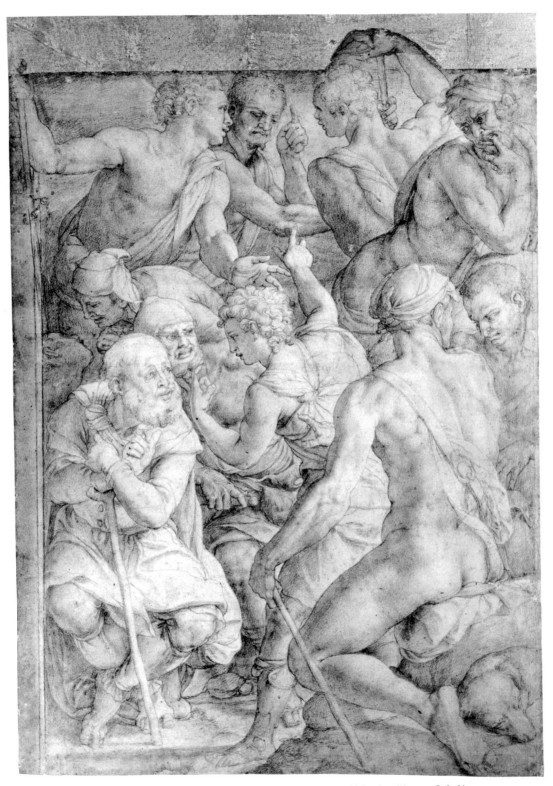

33. Study for *Joseph Recounting his Dream of the Sun, Moon and Stars.* (Ashmolean Museum, Oxford.)

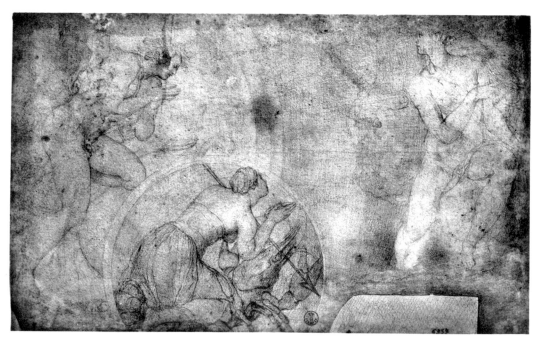

34. Study for *Joseph Recounting his Dream of the Sun, Moon and Stars* (Uffizi, Florence.)

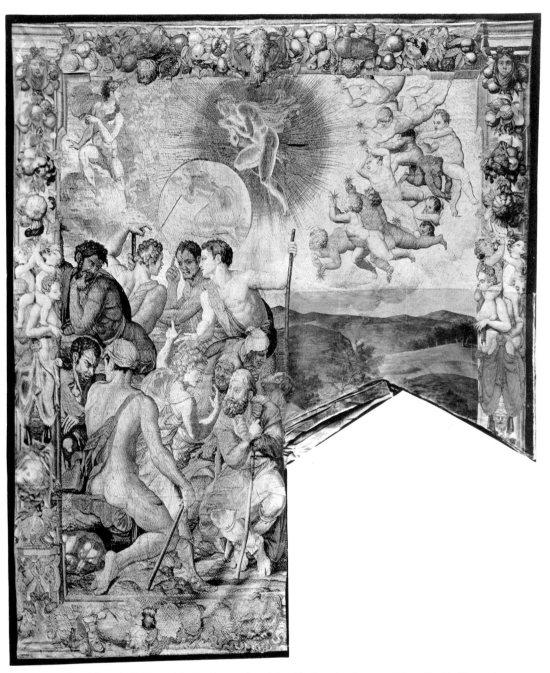

35. *Joseph Recounting his Dream of the Sun, Moon and Stars*, designed by Bronzino. Tapestry. (Palazzo Vecchio, Florence.)

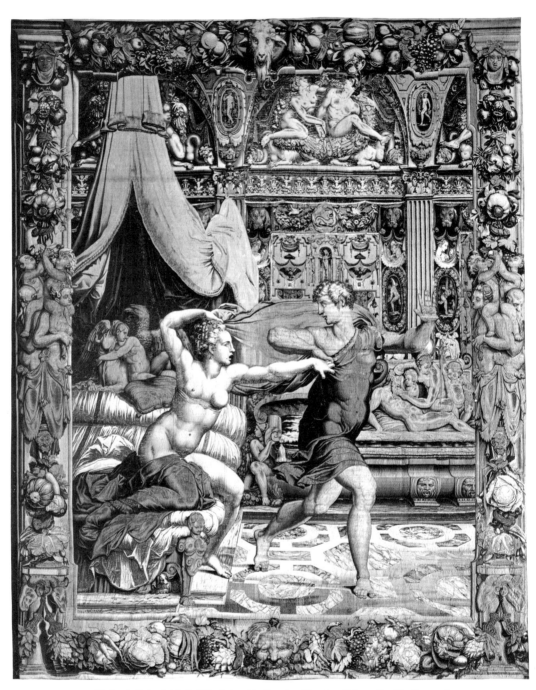

36. *Joseph Fleeing Potiphar's Wife*, designed by Bronzino. Tapestry. (Palazzo Vecchio, Florence.)

37. Study for *Joseph Fleeing Potiphar's Wife.* (Christ Church, Oxford.)

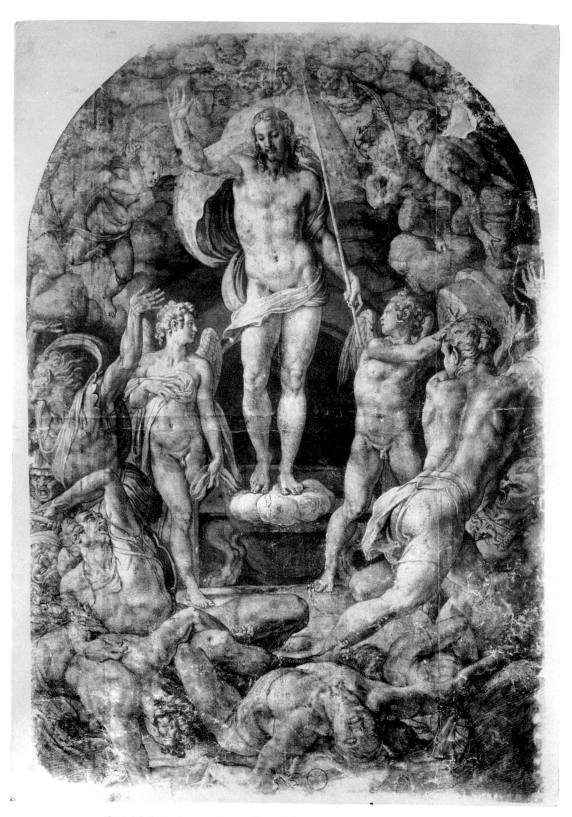

38. Modello for the *Resurrection*, by Bronzino assisted (Raffaellino dal Colle?). (Uffizi, Florence.)

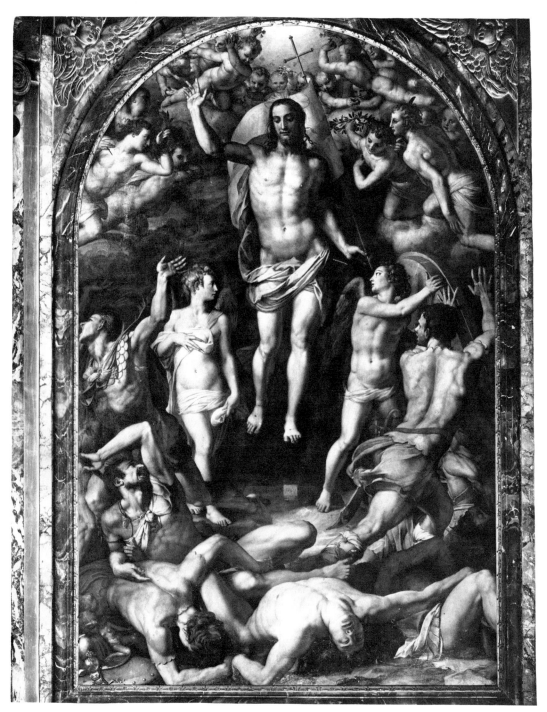

39. The *Resurrection*. (SS. Annunziata, Florence.)

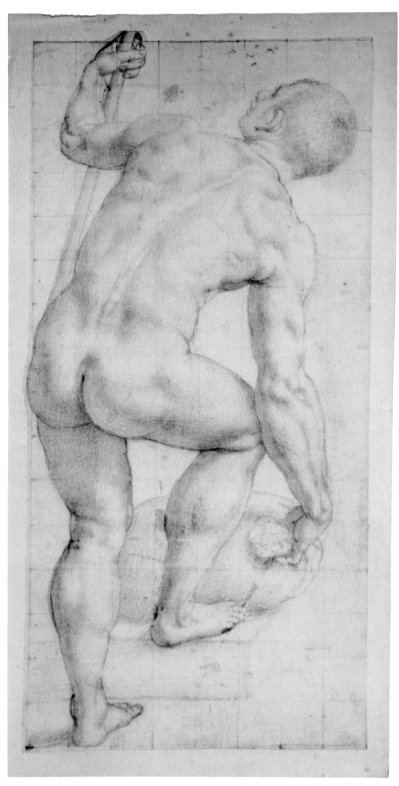

40. Study for the *Martyrdom of Saint Lawrence*. (Cabinet des Dessins, Louvre, Paris.)